ALBERTO MANGUEL is a writer, novelist, translator and editor, internationally acclaimed for his award-winning books, including *A History of Reading,* a bestseller translated into twenty-six languages that was chosen by the *Times Literary Supplement* as Best Book of the Year and won France's Prix Médicis. He is also the author of *The Dictionary of Imaginary Places* ("A book no self-respecting dreamer should be without," wrote *The Economist*), which won the Manheim Award, and *News from a Foreign Country Came* (winner of the McKitterick Prize for Best First Novel in the U.K.). He was born in Buenos Aires, has lived in Italy, France, England and Tahiti, and is now a Canadian citizen living in France.

# READING PICTURES

# R E A D I N G

Alberto
Manguel

# PICTURES

What We
Think About
When We
Look at Art

VINTAGE CANADA

Published in Canada by Vintage Canada, a division of Random House of
Canada Limited, Toronto, and simultaneously in the United States by Ran-
dom House, Inc., New York. Originally published in hardcover by Alfred
A. Knopf Canada, a division of Random House of Canada Limited,
Toronto, in 2000. Distributed by Random House of Canada Limited,
Toronto.

Vintage Canada and colophon are registered trademarks
of Random House of Canada Limited.

National Library of Canada Cataloguing in Publication Data
Manguel, Alberto, 1948–
    Reading pictures : what we think about when we look at art / Alberto Manguel.
Includes index.
ISBN 0-676-97435-X
1. Art appreciation.   I. Title
N7475.M36 2002   701'.1   C2002-902733-0

TITLE PAGE ILLUSTRATION:
Engraving from Francisco Aguilonius, *Optica,* 1611, Author's collection.

Pages 323–326 constitute a continuation of the copyright page.

www.randomhouse.ca

*Text design by Spencer Francey Peters*
*Typesetting by Gordon Robertson Design*

Printed and bound in the United States of America
2 4 6 8 9 7 5 3 1

TO CRAIG STEPHENSON

*Oh, whar shill we go w'en de great day comes,*
*Wid de blowin' er de trumpits en de bangin' er de drums?*

Joel Chandler Harris, *Uncle Remus*

*Painting should call out to the viewer . . .*
*and the surprised viewer should go to it, as if entering a conversation.*

Roger de Piles, *Cours de peinture par principes*, 1676

*But of works of art little can be said.*

Robert Louis Stevenson, *Books Which Have Influenced Me*, 1882

*After all, every picture is a history of love and hate*
*when read from the appropriate angle.*

Leopoldo Salas-Nicanor, *Espejo de las artes*, 1731

# Acknowledgments

*There is a North-west passage to the intellectual world.*

Laurence Sterne, *Tristram Shandy*

I AM AN INQUISITIVE and chaotic traveller. I like discovering places haphazardly, through whatever images they might have to offer: landscapes and buildings, postcards and monuments, museums and galleries that house the iconographic memory of a place. Much as I love reading words, I love reading pictures, and I enjoy finding the stories explicitly or secretly woven into all kinds of works of art — without, however, having to resort to arcane or esoteric vocabularies. This book grew out of the need to reclaim, for common viewers such as myself, the responsibility and the right to read these images and these stories.

My ignorance of vaster cultures has limited my examples to Western art, from which I have selected a number of images — painted, photographed, sculpted and built — that I've found particularly haunting or suggestive. I could have chosen a dozen other images: chance, private attractions and the suspicion of an interesting story prompted me to choose the ones that now make up this book. I have not attempted to devise or discover a systematic method for reading pictures (like those proposed by great art historians such as Michael Baxandall[1] or E. H. Gombrich[2]). My only excuse is that I was guided not by any theory of art but merely by curiosity.

My own shaky ability to read pictures, outside academic circles and critical theories, was tested at a number of institutions that kindly opened their doors to an amateur. Among these, I must thank Lynne

Kurylo at the Art Gallery of Ontario; Sherry-Anne Chapman at the Glenbow Museum in Calgary, Alberta; Carol Phillips at the Banff Centre for the Arts in Alberta; Kay Rader at the American Library in Paris; Simone Suchet at the Canadian Cultural Centre in Paris; Anthea Peppin, Rebecca McKie, Kathy Adler and Lorne Campbell at the National Gallery in London; and Professor Moira Roth at Mills College in Oakland, California. Peter Timms accepted a first draft of my chapter on Caravaggio for *Art Monthly*, Melbourne; Karen Mulhallen published early versions of my chapters on Picasso and Marianna Gartner in *Descant*, Toronto; many years ago, Barbara Moon printed an account of my first visit to Arc-et-Senans in *Saturday Night*, Toronto: to all three, my thanks for their confidence. A somewhat different piece on the Holocaust monument in Berlin appeared in the magazine *Sinn und Form*, Berlin, through the good offices of Joachim Meinert, as well as in the *Svenska Dagbladet*, Stockholm, thanks to Anders Björnsson, and in the *Nexus* revue of Tilburg University in the Netherlands, at the request of Rob Riemen and Kirsten Walgreen. The Markin-Flanagan Programme at the University of Calgary offered me a year's financial support, during which time I wrote part of this book: for its generous assistance, I am truly grateful.

Several friends and colleagues read the manuscript and gave me sound advice, unfortunately not always taken. My long-suffering publisher and dear friend, Louise Dennys, asked all the right questions and patiently reeled me back whenever I drifted too far from the reader; my editors, Courtney Hodell, Liz Calder, Marie-Catherine Vacher and Lise Bergevin, offered stimulating and intelligent comments; Alison Reid copy-edited the manuscript with the eye of a meticulous miniaturist; the index is the handicraft of Barney Gilmore — for that, many thanks; John Sweet proofread the pages with intelligence and care; Simone Vauthier, whose illuminating analysis of my *History of Reading* proved of the essence, was coaxed into doing this new book the same impeccable inquisitorial service; Lilia Moritz Schwarcz deftly guided me through the tangles of the Brazilian baroque; Professor Stefania Biancani kindly read my chapter on Lavinia Fontana; Dieter Hein found for me copious information on the Holocaust monument debate; Gottwalt and Lucie Pankow provided me both with friendly hospitality and recondite bibliography; Deirdre Molina at Knopf Canada proved invaluable in tracking down the copyright holders; Paul Hodgson and Gordon Robertson designed the book with their proven

elegance and creative wit, literally from cover to cover: to all of them, my heartfelt thanks. And as usual, my gratitude to Bruce Westwood and the team at Westwood Creative Artists in Toronto, to Derek Johns at A. P. Watt in London, and to Michelle Lapautre in Paris.

I began this book thinking that I would write about our emotions and how they affect (and are affected by) our reading of works of art. I seem to have ended up far, very far, from my imagined goal. But then, as Laurence Sterne so aptly put it, "I think there is a fatality in it — I seldom go to the place I set out for." As a writer (and as a reader), I believe that this, somehow, must have always been my motto.

# Contents

Acknowledgments     ix

1    The Common Viewer: *The Image as Story*     1

2    Joan Mitchell: *The Image as Absence*     19

3    Robert Campin: *The Image as Riddle*     39

4    Tina Modotti: *The Image as Witness*     65

5    Lavinia Fontana: *The Image as Understanding*     87

6    Marianna Gartner: *The Image as Nightmare*     117

7    Philoxenus: *The Image as Reflection*     151

8    Pablo Picasso: *The Image as Violence*     177

9    Aleijadinho: *The Image as Subversion*     197

10    C.-N. Ledoux: *The Image as Philosophy*     223

11    Peter Eisenman: *The Image as Memory*     245

12    Caravaggio: *The Image as Theatre*     263

*Conclusion*     287

*Notes*     293

*Plate Credits*     323

*Index*     327

The
Common
Viewer

The
Image
as
Story

*Every good story is of course both a picture and an idea,*

*and the more they are interfused the better the problem is solved.*

Henry James, *Guy de Maupassant*

Vincent van
Gogh, *Shipping
Boats on the
Beach at
Saintes-Maries.*

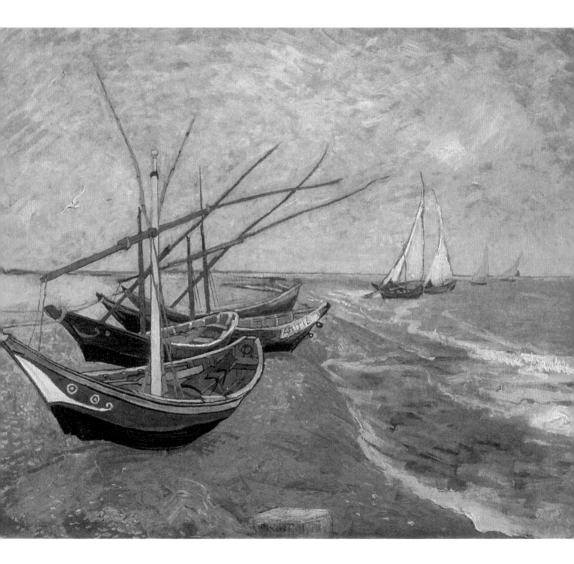

ONE OF THE FIRST IMAGES I remember, consciously aware that it had been created out of canvas and paint by a human hand, was a picture by Vincent van Gogh of the fishing boats on the beach at Saintes-Maries. I was nine or ten, and an aunt of mine, who was a painter, had invited me to her studio to see where she worked. It was summer in Buenos Aires, hot and humid. The small room was cool and smelled wonderfully of turpentine and oil; the stashed-away canvases, leaning one against the other, seemed to me like books distorted in the dream of someone who vaguely knew what books were and had imagined them huge and of single stiff pages; the sketches and clippings my aunt had pinned on the wall suggested a place of private thought, fragmented and free. In a low bookcase were large volumes of colour reproductions, most of them published by the Swiss company Skira, a name that, for my aunt, was a byword for excellence. She pulled out the one dedicated to Van Gogh, sat me on a stool and put the book on my knees. Then she left me.

Most of my own books had illustrations that repeated or explained the story. Some, I felt, were better than others: I preferred the reproductions of watercolours in my German edition of Grimm's *Fairy Tales* to the convoluted line drawings in my English edition. I suppose what I meant was that they better matched my imagination of a character or a place, or better lent details to fill my vision of what the page told me was happening, enhancing or correcting the words. Gustave Flaubert staunchly opposed the idea of words being paired with pictures. Throughout his life, he refused to allow any illustrations to accompany his work because he thought that pictorial images reduced the universal to the singular. "No one will ever illustrate me while I'm still alive," he wrote, "because the most beautiful literary description is devoured

by the most paltry drawing. As soon as a character is pinned down by the pencil, it loses its general character, that concordance with thousands of other known objects that causes the reader to say: 'I've seen that' or 'this must be so-and-so.' A woman drawn in pencil looks like a woman, that is all. The idea is thereafter closed, complete, and all words become now useless, while a written woman conjures up a thousand different women. Therefore, since this is a question of æsthetics, I formally refuse any kind of illustration."[1] I've never shared such adamant segregations.

But the images my aunt offered me that afternoon did not illustrate any story. There was a text: the painter's life, extracts from the letters to his brother, which I didn't read until much later, the title of the paintings, their date and location. But in a very categorical sense, these images stood alone, defiantly, tempting me with a reading. There was nothing for me to do except stare at those images: the copper beach, the red ship, the blue mast. I looked at them long and hard. I've never forgotten them.

Van Gogh's many-coloured beach surfaced often in the imagination of my childhood. Sometime in the sixteenth century, the illustrious essayist Francis Bacon observed that for the ancients, all the images that the world lays before us are already ensconced in our memory at birth. "So that as Plato had an imagination," he wrote, "*that all knowledge was but remembrance*; so Solomon giveth his sentence, *that all novelty is but oblivion*."[2] If this is true, then we are all somehow reflected in the many and different images that surround us, since they are already part of who we are: images that we create and images that we frame; images that we assemble physically, by hand, and images that come together, unbidden, in the mind's eye; images of faces, trees, buildings, clouds, landscapes, instruments, water, fire, and images of those images — painted, sculpted, acted out, photographed, printed, filmed. Whether we discover in those surrounding images faded memories of a beauty that was once ours (as Plato suggested) or whether they demand from us a fresh and new interpretation through whatever possibilities our language might offer us (as Solomon intuited), we are essentially creatures of images, of pictures.

Pictures, like stories, inform us. Aristotle suggested that every thought process required them. "Now, for the thinking soul, images take the place of direct perceptions; and when the soul asserts or denies that these images are good or bad, it either avoids or pursues them. Hence

the soul never thinks without a mental image."[3] No doubt, for the blind, other forms of perception, notably through sound and touch, provide the mental picture to be deciphered. But for those who can see, existence takes place in an unfurling scroll of pictures captured by sight and enhanced or tempered by the other senses, pictures whose meaning (or presumption of meaning) varies constantly, building up a language made of pictures translated into words and words translated into pictures,

through which we try to grasp and understand our very existence. The pictures that make up our world are symbols, signs, messages and allegories. Or perhaps they are merely empty presences that we fill with our desire, experience, questioning and regret. Whatever the case might be, pictures, like words, are the stuff we are made on.

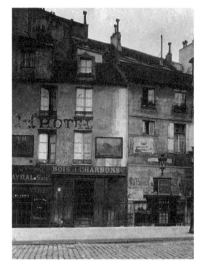

In André Breton's dreamlike novel *Nadja*, the poet Paul Éluard observes that seen from a certain angle, the sign "Bois-Charbons" reads "Police." (Eugène Atget, *Quai aux Fleurs*, 1902.)

But can every picture be read? Or at least, can we create a reading for every picture? And if so, does every picture imply a cipher merely because it appears to us, its viewers, as a self-contained system of signs and rules? Do all pictures allow for translation into a comprehensible language, revealing to the viewer what we might call their Story, with a capital *S*?

The shadows on the wall of Plato's cave, the neon signs in a foreign country whose language we don't speak, the shape of a cloud that Hamlet and Polonius both saw one afternoon in the sky, the sign *Bois-Charbons* that (according to André Breton) spells *Police* when seen from a certain angle, the writing that the ancient Sumerians thought they could read in the footprints left by birds in the mud of the Euphrates, the mythological figures that the Greek astronomers recognized in the connectable dots of distant stars, the name of Allah that the faithful have seen in an open avocado and in the logo for Nike sportswear, God's fiery writing on the wall of Belshazzar's palace, sermons and books that Shakespeare found in stones and running brooks, the tarot cards through which Italo Calvino's traveller read universal stories in *The Castle of Crossed Destinies*, landscapes and figures recognized by eighteenth-century travellers in the veins of

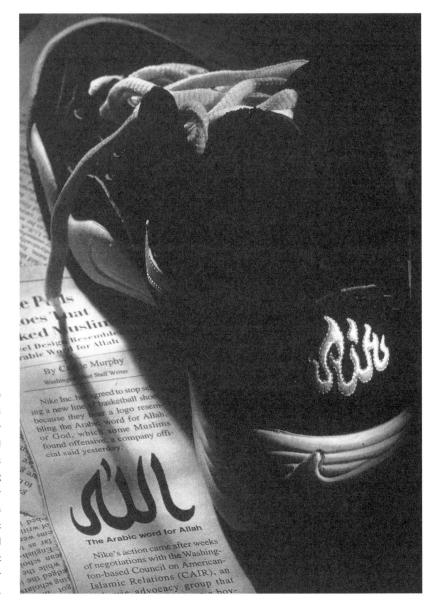

In 1999, the sporting clothes manufacturer Nike was forced to withdraw a line of running shoes after Islamic groups complained that Nike's stylized logo spelled out the word for Allah in Arabic.

marbled rocks, the ripped notice on a billboard reinstated in a painting by Tàpies, Heraclitus's river that is also the flowing of time, the tea leaves at the bottom of a cup in which the Chinese sages believe they can read our lives, the shattered vase of Lurgan Sahib that almost became whole in front of Kim's incredulous eyes, Tennyson's flower in the crannied wall, the eyes of Neruda's dog in which the unbelieving

poet saw God, the *He kohau rongorongo* or "speaking wood" from Easter Island that we know holds a message undeciphered to this day, the city of Buenos Aires that for the blind Jorge Luis Borges was "a map of my humiliations and failures," the stitches in the cloth of the Sierra Leone tailor Kisimi Kamala in which he saw the future alphabet of the Mende script, the wandering whale that St. Brendan took for an island, the three peaks of the Rocky Mountains that outline the profile of three sisters against the western Canadian sky, the philosophical geography

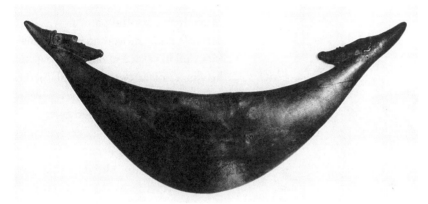

The mysterious *He kohau rongorongo* or "speaking wood" from Easter Island.

of a Japanese garden, the wild swans at Coole in which Yeats unriddled our transience — all these offer or suggest, or simply allow, a reading limited only by our own capabilities. "How do you know but ev'ry Bird that cuts the airy way, / Is an immense world of delight, clos'd by your senses five?" asked William Blake.[4]

If nature and the fruits of chance are susceptible to interpretation, to translation into ordinary words, into the utterly artificial vocabulary that we have constructed out of various sounds and scratches, then perhaps those sounds and scratches allow in turn for the construction of an echoed chance and a mirrored nature, a parallel world of words and images through which we can recognize the experience of the world we call real. "It may be startling to speak of the *Divine Comedy* or the *Mona Lisa* as 'a replication,'" says Elaine Scarry, the author of an exquisite book on the meaning of beauty, "since they are so unprecedented, but the word recalls the fact that something, or someone, gave rise to their creation and remains silently present in the newborn object."[5] To which we can add that the newborn object may in turn give birth to a myriad of newborn objects — the viewer's or reader's receptive experiences — that also, each and every one, contain it.

9

When I was fourteen or fifteen, our history teacher, who was showing us slides of prehistoric art, told us to imagine the following: a man sees throughout his life, day after day, the sun set, knowing that it marks the cyclical end of a god whose name his tribe will not pronounce. One day, for the first time, the man lifts his head and suddenly, vividly, he truly sees the sun sinking in a lake of fire. In response (and for reasons he does not attempt to explain), he dips his hands in red

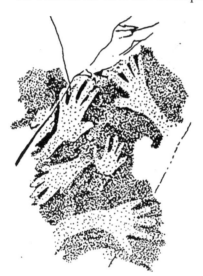

Prehistoric hand marks in a cave at Fuente del Salín, near Santander, Spain.

mud and presses his palms on the wall of his cave. After a while, another man sees the palm marks and feels afraid or moved or simply curious, and in response (and for reasons he does not attempt to explain) he sets out to tell a story. Somewhere in this telling, unmentioned but present, is the sunset first perceived and the god who dies every day before darkness, and the blood of that god spread over the western sky. Image gives birth to story, which in turn gives birth to image. "The relief of speech," said the melancholy philosopher Søren Kierkegaard (and he could have added "and of making pictures"), "is that it translates me into the universal."[6]

Formally, storytelling exists in time, pictures in space. During the Middle Ages, a single painted panel could depict a narrative sequence, incorporating the flow of time into the confines of a spatial frame, as in our modern comic strips, with the same character appearing repeatedly in one unifying landscape as he or she progresses through the picture's plot. With the development of perspective during the Renaissance, pictures froze into a single instant: that of the moment of the viewing as perceived from the standpoint of the viewer. The story was then conveyed by other means: through "symbolism, dramatic poses, allusions to literature, titles"[7] — that is to say, through what the viewer knew was taking place from other sources.

Unlike pictures, written words constantly flow beyond the framework of a page: a book's covers do not establish the boundaries of a text, which never exists entirely as a physical whole, only in snatches or summaries. We can, in one instant of thought, conjure up a line of "The

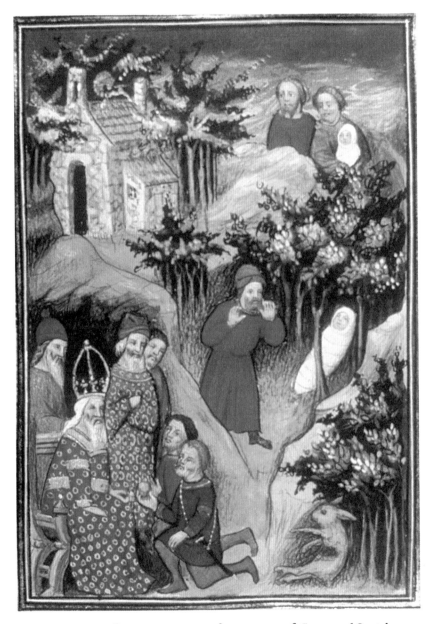

A sequence of events illustrating in one panel the medieval legend of Conrad le Salique, in the fourteenth-century *Chronicle of Bruges*.

Ancient Mariner" or a twenty-word summary of *Crime and Punishment*, but not the entire books: their existence lies in the steady stream of words that holds them together, flowing from beginning to end, from cover to cover, in the time we grant these books for their reading.

Pictures, however, present themselves to our consciousness instantaneously, held by their frame — a cave wall or a museum wall — within a specific surface. Van Gogh's fishing boats, for instance, were for me, on that first afternoon, immediately real and definitive. Over time, we may see more or less in a picture, delve deeper and discover further details, associate and combine images, lend it words to tell what we see, but in itself an image exists in the space it occupies, independently of the time we allot to gaze upon it: it wasn't until years later that I noticed that one of the boats bore the name *Amitié* painted on its side. Later too I learned that in June 1888, Van Gogh, who was staying in Arles, had walked the long stretch down to Saintes-Maries-de-la-Mer, a fishing village to which gypsies from all over Europe still make an annual pilgrimage. In Saintes-Maries he sketched fishing boats and houses, and he later transformed those sketches into paintings. This was the first time he had seen the Mediterranean. He was thirty-five years old. Six months later, he would cut off his left ear and offer it as a gift, wrapped in newspaper, to a prostitute at a nearby brothel. For me, all this information came afterwards — the minutiae, the geographical details, the chronology, the severed-ear incident that, like Giotto's freehand circle or the paintbrush Charles V picked up for Titian, was part of the conventional history of art lovingly taught to us in school — and it supported or questioned the validity of my first reading. But in the very beginning, there was nothing but the picture itself. That fixed point in space is where we start.

Histories and commentaries, labels and catalogues, thematic museums and art books attempt to guide us through different schools, different ages and different countries. But what we see as we walk through the rooms of a gallery, or follow pictures on a screen, or leaf through a volume of reproductions ultimately escapes such strictures. We see a painting as defined by its context; we may know something of the painter and of his world; we may have an idea of the influences that fashioned his vision; if conscious of anachronism, we may be careful not to traduce that vision through our own — but in the end, what we see is neither the painting in its fixed state nor an artwork trapped in the co-ordinates set by the museum for our guidance.

What we see is the painting translated into our own experience. As Bacon suggested, unfortunately (or fortunately) we can see only that which, in some shape or form, we have *already* seen. We can see only that for which we already have identifiable images, just as we can read

only in a language of which we already know the syntax, the grammar and the words. The first time I saw Van Gogh's brightly coloured fishing boats, something in me recognized something mirrored in them. Mysteriously, every image assumes my seeing it.

When we read pictures — in fact, images of any kind, whether painted, sculpted, photographed, built or performed — we bring to them the temporal quality of narrative. We extend that which is limited by a frame to a before and an after, and through the craft of telling stories (whether of love or of hate), we lend the immutable picture an infinite and inexhaustible life. André Malraux, who so actively took part in both the political and the cultural life of twentieth-century France (as a soldier, a novelist and France's foremost minister of culture), lucidly argued that by placing a work of art among the works of art created before and after it, we, the modern viewers, became the first to hear what he called "the song of change" — that is to say, the dialogue a painting or sculpture establishes with other paintings or sculptures from other cultures and other times. In the past, says Malraux, the viewers of a Gothic church portal could only have drawn comparisons to other sculpted church portals in the same cultural area; we instead have at our disposal countless images of sculptures from around the world (from the statues of Sumer to those of Elephanta, from the friezes of the Acropolis to the marble treasures of Florence) that speak to us in a common language of shapes and forms, allowing our response to the Gothic portal to be replayed in a thousand other sculpted works. This rich display of reproduced images, open to us on page and screen, Malraux called "the imaginary museum."[8]

And yet the elements of our response, the vocabulary we use to tease the story out of an image (whether of Van Gogh's boats or the portal of Chartres Cathedral), are determined not only by the world's iconography but also by a vast range of circumstances, private and social, casual and obligatory. We construct our story through echoes in other stories, through the illusion of self-reflection, through technical and historical knowledge, through gossip, reverie, prejudice, illumination, scruples, ingenuity, compassion, wit. No story elicited by an image is final or exclusive, and measures of correctness vary according to the same circumstances that give rise to the story itself. Wandering through a museum in the first century A.D., the dejected lover Encolpius sees the many images of gods painted by the great artists of the past — Zeuxis, Protogenes, Apelles — and cries out in lonely

anguish: "So even the gods in heaven are touched by love!"[9] Encolpius recognizes in the mythological scenes that surround him, which depict the amorous adventures of Olympus, reflections of his own emotions. The paintings move him because they seem to be, metaphorically, about him. They are framed by his apprehension and circumstances; they now exist in his time and share his past, present and future. They have become autobiographical.

Stendhal, in his account of a visit to Florence in 1817, described the effects of his encounter with Italian art in terms that later became symptomatic of a recognizable psychosomatic disease. "On leaving the Church of Santa Croce," he wrote, "I felt a throbbing in my heart. Life was draining out of me while I walked, and I was afraid I would fall."[10] The so-called Stendhal syndrome affects visitors (mainly from North America and European countries outside Italy) who see the masterpieces of the Renaissance for the first time.[11] Something in these colossal artworks overwhelms them, and the aesthetic experience, instead of being one of revelation and knowledge, becomes chaotic and merely bewildering, autobiography as nightmare.

The image of a work of art exists somewhere between perceptions: between that which the painter has imagined and that which the painter has put on the board; between that which we can name and that which the painter's contemporaries could name; between what we remember and what we learn; between the acquired common vocabulary of a social world and a deeper vocabulary of ancestral and private symbols. When we try to read a painting, it may seem to us lost in an abyss of misunderstanding or, if we prefer, a vast no-man's abyss of multiple interpretations. The critic can rescue a work of art to the point of reincarnation; the artist can dismiss a work of art to the point of destruction. Auguste Renoir tells of how, on his return from Italy with a friend, he called upon Paul Cézanne, who was working in the Midi. Renoir's friend was taken with violent diarrhea and asked for some leaves to wipe himself. Cézanne offered him a sheet of paper instead. "It was one of the finest of Cézanne's water-colours; he had thrown it away among the rocks after having slaved over it for twenty sittings."[12]

Critical readings have followed pictures since the beginning of time, but they never truly copy, replace or assimilate them. "We do not explain pictures," the art historian Michael Baxandall remarked wisely, "we explain remarks about pictures."[13] If the world revealed in a work

of art remains always outside that work, the work of art remains always outside its critical appreciation. "Form," writes Balzac, "in its representations, is what it is among us: just a trick to communicate ideas, feelings, a vast expanse of poetry. Every image is a world, a portrait whose model appeared once in a sublime vision, bathed in light, ascribed by an interior voice, stripped bare by a celestial finger that points, in the past of an entire life, to the very sources of expression."[14] Our oldest images are bare lines and smudged colours. Before the pictures of antelopes and mammoths, of running men and fertile women, we scratched lines or stamped palms on the walls of our caves to signal our presence, to fill a blank space, to communicate a memory or a warning, to be human for the first time.

By "oldest," of course, we mean "newest": we mean that which was seen for the first time, in the furthest remembered dawn, when these images appeared to our ancestors fresh and formidable, uncontaminated by habit or by experience, free from the vigilance of criticism. Or perhaps not entirely free, as Rudyard Kipling suggested:

> When the flush of a new-born sun fell first on Eden's green and
>     gold,
> Our father Adam sat under the Tree and scratched with a stick in
>     the mould;
> And the first rude sketch that the world had seen was joy to his
>     mighty heart,
> Till the Devil whispered behind the leaves, "It's pretty, but is it
>     Art?"[15]

For better or for worse, every work of art is accompanied by its critical assessment, which, in turn, gives rise to further critical assessments. Some of these become themselves works of art in their own right: Stephen Sondheim's interpretation of Georges Seurat's painting *La Grande Jatte*, Samuel Beckett's observations on Dante's *Divine Comedy*, Mussorgsky's musical comments on the paintings of Viktor Gartman, Henry Fuseli's pictorial readings of Shakespeare, Marianne Moore's translations of La Fontaine, Thomas Mann's version of the musical *oeuvre* of Gustav Mahler. The Argentine novelist Adolfo Bioy Casares once suggested an endless chain of works of art and their commentaries, beginning with a single poem by the fifteenth-century Spanish poet Jorge Manrique. Bioy suggested the erection of a statue to

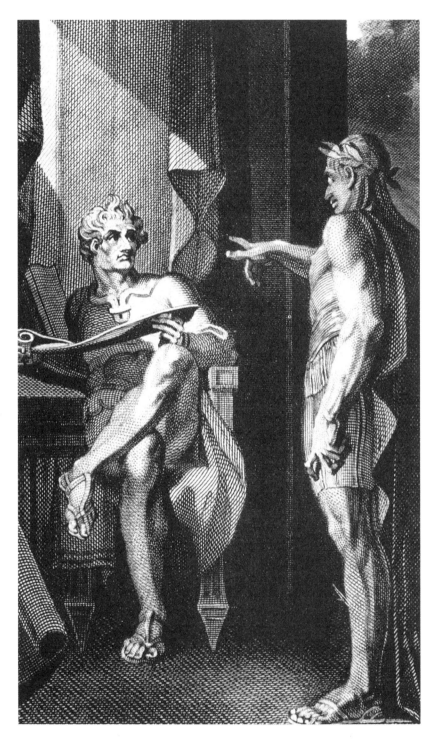

An illustration by the eighteenth-century Swiss artist Henry Fuseli for Shakespeare's *Julius Caesar*, in which Brutus sees Caesar's ghost on the night before the battle of Philippi.

the composer of a symphony based on the play suggested by the portrait of the translator of Manrique's "Couplets on the Death of His Father." Every work of art grows through countless layers of readings, and every reader strips these layers back to reach the work on his or her own terms. In that last (and first) reading we are alone.

Being able (and willing) to read a work of art is of the essence. In 1864, the English art critic John Ruskin, reacting with enlightened rage against the conformity of his time, delivered a lecture at Rusholme Town Hall, near Manchester, in which he harangued his audience for not caring sufficiently for art and caring too much for money. The purpose of the lecture was to convince the Rusholme worthies of the need for a good public library, which Ruskin considered an essential service in every major city of the United Kingdom. But in the course of his argument, Ruskin became more and more incensed and berated the worthies for having "despised Science," "despised Art," "despised Nature." "I say you have despised Art! 'What!' you again answer, 'have we not Art exhibitions, miles long? and do we not pay thousands of pounds for single pictures? and have we not Art schools and institutions, more than ever nation had before?' Yes, truly, but all that is for the sake of the shop. You would fain sell canvas as well as coals, and crockery as well as iron; you would take every other nation's bread out of its mouth if you could; not being able to do that, your ideal in life is to stand in the thoroughfares of the world, like Ludgate apprentices, screaming to every passer-by, 'What d'ye lack?'"[16] And since they cared nothing for the works of humankind and everything for financial profit and the encouragement of greed, Ruskin told them that they had become creatures who "despise compassion," dullards incapable of caring for their fellow human beings. Since they were unable to read the images art had to offer them, he accused his contemporaries of being morally illiterate as well. Ruskin had high hopes for the uses of art.

I don't know whether such a thing as a coherent system for reading images, akin to the one we have devised for reading script (a system implicit in the very code we are deciphering), is even possible. It may be that unlike a written text in which the meaning of the signs must be established before they can be set on clay, or on paper, or behind an electronic screen, the code that enables us to read an image, though steeped in our previous knowledge, is created *after* the image comes into being — in much the same way that we create or

imagine meanings for the world around us, bravely constructing out of such meanings something like a moral and ethical sense with which to live. In the last years of the nineteenth century, the painter James McNeill Whistler, allying himself with this notion of an inexplicable creation, summed his craft up in two words: "Art happens."[17] I don't know whether he said it with a feeling of resignation or of joy.

Joan
Mitchell

The
Image
as
Absence

*To restore silence is the role of objects.*

Samuel Beckett, *Molloy*

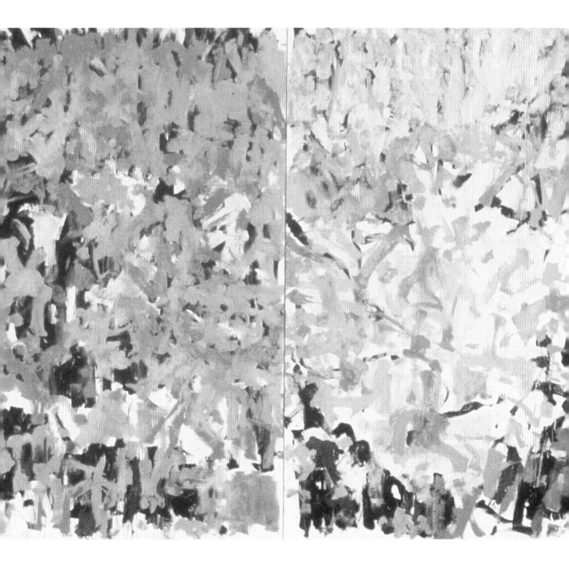

THE FIRST TIME I saw the work of Joan Mitchell was in 1994, at an exhibition in the Jeu de Paume gallery in Paris. I don't very much like mammoth retrospectives: like the fat volumes of a writer's collected works, they seem to ignore the piecemeal cadence of an artist's offerings, suggesting instead one single and colossal output, instantaneous, uninterrupted and all-encompassing. But the Jeu de Paume exhibition was different. Perhaps because I had not seen any of Mitchell's paintings before, I went from one to the next, discovering each on its own terms, and my sense of wonder at the joyful quality of her work was not diminished by the quantity. Canvas after canvas, I was astonished by the sheer happiness of so much colour, so much light, so much ecstatic freedom.

*Two Pianos*, which Mitchell completed in 1980, is a large diptych oil painting, almost three metres high and three and a half metres wide. Against a white background, visible only in isolated patches, a storm of vertical strokes covers the entire canvas in rich yellow and lilac tones — the yellow fading to lemon in some places, the lilac darkened almost to black in others. These darker strokes are closest to the background, apparent behind the yellow and the lilac as if crossed out or deliberately hidden, a script cancelled or deleted by a furious later hand, a hand that caused the yellow strokes, at their most intense, to overcome the canvas and to silence both the white and the dark. Under the influence of Joan Mitchell's title, I think I can recognize two vague piano-like shapes in the lilac patches left and right, one small and one much larger — but such recognition is not very convincing. All that is certain is the brilliance of the yellow, made even warmer by its association with the almost pink lilac, and the impression of movement or march created by the closeness and direction of the strokes.

The frame of the diptych does not appear to contain the painting fully; what we see is a moment of its passage, a still in a colour film whose entire scope escapes us. The writer Severo Sarduy once described the arrival of a travelling film projectionist in a remote Cuban village. The man set up his portable screen, instructed the villagers to sit on rows of wooden benches and then began to show a documentary film about new agricultural techniques. The villagers watched the bright, moving images but apparently saw nothing in them except the figure of a chicken projected onto the lower left-hand corner of the screen. That chicken was all that they had managed to decipher, since they had no experience of seeing cinema, and no knowledge of how to follow a series of long shots, close-ups and travellings, which, in their eyes, had become nothing but a jumble of shadows and light.[1] Is Mitchell's painting anything more than this mass of coloured strokes? Is there a context in which its confusion can be read? Is there a language (like the language of film for the Cuban villagers) with which the viewer must become familiar before the canvas relinquishes a meaning? Or is the attempt to go beyond the immediate emotional response one that is alien to Mitchell's creation, the imposition of a reading that, like a moral tag in a Victorian fable, distorts the very thing it is trying to comprehend?

In 1948, barely a year before a television tower was added to the Empire State Building in New York, the thirty-six-year-old Jackson Pollock exhibited his first "drip painting," a large canvas created a year earlier, on which the paint had been allowed to splash and dribble in a chaotic pattern. At a time when an unrelenting flow of predigested images had begun to stream into every American home, switching audiences from the word-centred culture of radio to the iconographic culture of TV, Pollock put forward an image that refused all attempt at narration, either as words or as picture, that rejected any control whatsoever, whether from the artist or from the viewer, and that seemed to exist in a constant present, as if the explosion of paint on the canvas were always at the point of occurring. "There was a reviewer," Pollock was later to recall, "who wrote that my pictures didn't have a beginning or an end. He didn't mean it as a compliment, but it was. It was a fine compliment."[2]

The artists of Pollock's generation, as well as of the one that followed, had begun their careers in the midst of social and moral chaos, during the Depression years in the United States and against

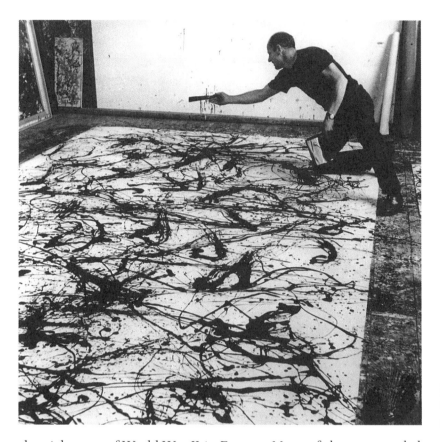

Jackson Pollock
in his New York
studio.

the nightmare of World War II in Europe. Many of them responded with social painting; their work, whether accusatory or self-deceptive, whether reflected in the loud murals of the Mexican tradition or in the Norman Rockwell covers of *The Saturday Evening Post*, seemed to Pollock and his colleagues either naive or hypocritical. They looked instead to France and the new art movements for guidance, but after the Nazi occupation in 1940 made communication with Paris practically impossible, they were forced to reassess their craft on home ground, though never forgetting the fact that (in Pollock's words) "the important painting of the last hundred years was done in France." Pollock rejected the notion of "national painting." "The idea of an isolated American painting, so popular in this country during the thirties, seems absurd to me," he wrote in 1944, "just as the idea of creating a purely American mathematics or physics would seem absurd." And he concluded: "The basic problems of contemporary painting are independent of any one country."[3]

Fortunately, despite the war, artistic ties to Europe were not en-
tirely severed: a number of avant-garde artists were driven into exile
from occupied Paris, and New York became the temporary home of
Marc Chagall, Roberto Matta, Salvador Dalí, Max Ernst, Yves Tanguy.
The Surrealism of the latter three did not elicit strong echoes among
the American artists, but Matta's automatic painting, an offshoot of
André Breton and Philippe Soupault's automatic writing, found in
New York an enthusiastic audience.

Inspired both by the "dictated" jot-
tings of spiritualist mediums and by
Freud's method of "free association,"
Breton and Soupault had published
in 1920 a first volume of automatic
writing, *Les champs magnétiques*. The
idea was to sit at a table, pencil in
hand, and enter "a receptive frame
of mind" in order to "write without
thinking." The Chilean Matta, who
had come to New York via Paris,
adopted this creative technique for
painting, and allowed the paint to fall
without guidance on the canvas or
paper. As in the case of automatic

An example of
automatic writing,
invented by André
Breton and
Philippe Soupault
at the Hôtel des
Grands Hommes
in Paris in the
spring of 1919.

writing, the aim was to avoid conscious control over the design, to
achieve an intense doodling of sorts. Not only pencil and paint were
used; Matta and his friends developed other methods of producing
automatic images: *fumage*, created by passing a piece of paper over a
smoking candle; *frottage*, a technique similar to that of brass rubbing;
decalcomania, in which paint is lifted from a surface by pressing a sheet
or canvas on it; and torn paper collage (invented by Hans Arp), where
paper is ripped randomly and dropped on a larger sheet brushed with
glue.[4] Pollock and his colleagues found in these techniques a solution
to their dilemma: how to respond emotionally to the world, not to
copy or improve it, or to communicate anything about it, but purely
to share its creative impulse, bringing artist and viewer into the paint-
ing itself. If a viewer chose to "read" the painting, the responsibility
for both the reading and the writing, the decipherment and the codifi-
cation of a cipher, lay not with the artist but with the viewer. In his
early work, Pollock had made use of mythology, animal sexuality and

ancient rituals; after 1948 he eliminated all conventional signs from his paintings. What Pollock created was a system of signs that he refused to imbue with message or meaning. The new style became known as Abstract Expressionism.

The attempt not to communicate is at least as complex as the attempt to communicate, and undoubtedly as old. But the formalized acceptance of this refusal, of this enshrinement of silence — whether through words, gestures or signs — is a modern phenomenon that, in the Western world, began no more than a century ago. The unwillingness of the Cynic philosophers to enter into dialogue in ancient Greece, the desert fathers' withdrawal from the world of social interchange in the early years of Christianity, Hamlet's coining of the much-abused phrase "the rest is silence" foreshadow our realization of the impossibility to tell. But it is only in the twentieth century that the poet Stéphane Mallarmé presents, despairingly, the empty page, Eugène Ionesco decrees in his plays that "the word prevents silence from speaking,"[5] Beckett sets on stage an act without words, John Cage composes a musical piece called "Silence" and Pollock hangs a splattered mute canvas on a museum wall.

The roots, however, of the specific will to silence images lie with the iconoclastic philosophers of the eighth century. The Jewish mistrust in pictures of living things was inherited by the early Christians, who nevertheless continued the Roman tradition of decorating with religious images catacombs and temples. At the end of the third century, the Synod of Elvira made explicit the prohibition to introduce images in the church, "lest what is reverenced and adored be painted on the walls."[6] Rather than depict Christ as Himself, the Son of God was usually represented as a shepherd, and God the Father as a disembodied hand descending from Heaven. By the sixth century, however, the Synod's prohibition had fallen into oblivion, and images of Christ and His saints became common throughout the Christian world. Forgotten but not gone: the prohibition resurfaced two centuries later, when the emperor Leo III of Byzantium ordered the destruction of a popular image of Christ that decorated the Chalke Gate, thereby sparking a furious riot.[7] But it was Leo's successor, Constantine V, who rigorously enforced iconoclastic decrees. Constantine's theologians, basing their arguments on the Second Commandment that forbade the making of graven images, concluded that all representations of Christ as man were heretical. Since God is uncircumscribable (they

argued), a picture of Christ either implies that Christ's human nature can be separated from the divine, or even worse, it denies His divine nature by showing Him only as man. On the other side of the argument, and in defence of pictorial representations, the iconophiles explained that the Commandments had been intended for the Jews, not for the redeemed Christians, and that the Incarnation solved the problem of separating Christ the God from Christ the man, since He could now be accurately represented in His human guise. But the iconoclasts remained adamant: the divinity could not be represented in any material way. God and His saints, and the manifestation of God in the world, in the infinity of His creatures, had only one identity, that of Itself, and could not be imitated in paint or wood and stone. For these custodians of the faith, divine knowledge should be carried as an image in the heart, not to be demeaned by external representation. In other words, God and His world were ineffable, beyond the scope of human craft, and any attempt to represent them was an act of both arrogance and ignorance.[8]

Jackson Pollock embodied this ancient refusal to depict what can't be depicted. He intuited (or believed he intuited) the oldest, deepest perceptions of humankind; he also realized that such perceptions must, if true, be uncommunicable, since any language that attempted to express them, in sounds or shapes, would necessarily constrain or transform them through the very nature of that particular language. To put on canvas these ancestral perceptions, he needed to work outside language, or within the absence of language.

There exists in the engraver's craft (though the term appears in other forms of printing) something called *reserve*, the area carved out on a block of wood that when stamped translates into an empty space on the paper.[9] Unlike the *pentimento* — the erasure or reworking of a section of the image of which the artist has "repented" — the *reserve* signals an idea not yet fully come into being, left in suspense, perhaps to be completed at some later time. The poet Rainer Maria Rilke, one of the first to recognize the genius of Paul Cézanne, wrote about a still life in which the master had left half an apple unfinished (in *reserve*, as it were), that Cézanne had painted only the parts of an apple he knew; the parts that were still a puzzle to him, he left blank. "He only painted that which he utterly understood," Rilke concluded.[10] Pollock's splattered canvases are another version of Cézanne's absence of language, another *reserve* leaving room for that which lies beyond understanding.

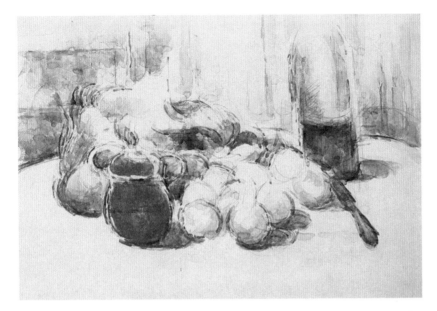

Paul Cézanne,
*Blue Pot and*
*Bottle of Wine.*

The terrible paradox, as Pollock realized, was that through what the Italian critic Giovanna Franci has called "the anxiety to interpret,"[11] eventually even the absence of language becomes language in the eye of the beholder.

Joan Mitchell belonged to the generation that immediately followed Pollock's and shared or inherited a similar artistic credo (though she refused to be labelled an Abstract Expressionist). The essential elements of her story can be briefly told. She was born in Chicago in 1925, the daughter of a deaf poet, Marion Strobel, who as the co-editor of the literary magazine *Poetry* had been the first to publish Ezra Pound and T. S. Eliot in the United States, and a family doctor, Herbert Mitchell, a fiercely competitive man who would continually taunt Joan with his own achievements. "You'll never speak French as well as I. You can't draw as well as I. You can't do anything as well as I because you are a woman."[12] Father and daughter would go out on sketching expeditions; Mitchell remembered his red and green watercolours, and the animals he drew at the zoo, but nothing of her own early work. The family vacationed in a house overlooking the western shore of Lake Michigan, and the vast lake, capable of violent changes of colour and mood, became a commonplace in her imagination. "I carry it around with me," she later confessed.[13]

During the fifties, she lived in New York, where she became acquainted with the work of Pollock, Willem de Kooning and Franz

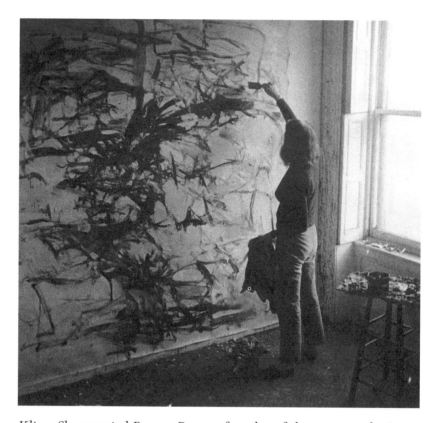

Rudy Burckhardt,
*Joan Mitchell,* 1957.

Kline. She married Barney Rosset, founder of the avant-garde Grove Press, and through him met many of the new writers; at about the same time, during a trip to France, she also met Samuel Beckett, who became her lifelong friend. Her relationship with Beckett was a revealing one. Beckett had taken up residence in Paris in 1937 and, seeking exile within exile, preferred the out-of-the-way cafés and bistros of the fifteenth *arrondissement* to the more artistic places of the Left Bank. Here he liked to drink Irish whiskey, which he introduced to what then was an eminently *quartier ouvrier*, and would not see any of his friends unless fortified with alcohol.[14] In these cafés he would meet the young Joan, and they would talk or sit in silence for hours on end. Beckett liked her vast capacity for drink, her refusal to explain her art, her "relentless quest for the void." He sometimes visited her studio, and there, without saying a word, he would examine her canvases, study her bursts of colour, follow the lines of her brushstrokes. Mitchell's companion, the Québécois artist Jean-Paul Riopelle with whom she had begun a new relationship after her divorce from Rosset in 1952, found their reunions

exceptionally depressing and would often become exasperated with their long brooding sessions. One night, when the three were sitting in gloomy silence at the Dôme café in Montparnasse with the sculptor Alberto Giacometti, the exasperated Riopelle got up and stormed out through the revolving doors. Mitchell went after him and Beckett tried to follow her, but he was so drunk that he could not extricate himself from the door. "Round and round he whirled, while Giacometti, like a giant, brooding toad with hooded eyes, sat and watched and said nothing, and while tourists pointed at the poet of nothingness and despair."[15]

Mitchell shared Beckett's fascination with nothingness, but not his despair. She was, at heart, a romantic and tried to paint, as Pollock had wanted, "without being conscious of the act." "I want to make myself available to myself. The moment I am self-conscious, I cease painting," she once explained.[16] From her point of view, nothing "happens" in her paintings, nothing is "represented." In works such as *Two Pianos*, her colours fall, like Eliot's shadow, "Between the idea/ And the reality/ Between the motion/ And the act."[17] What we, the viewers, receive when looking at the canvas is not a narrative but something on the edge of motion, the promise of an identifiable presence that will never be fulfilled. In an interview with the critic Yves Michaud, Mitchell explained: "If the painting works, the motion is made still, like a fish trapped in ice. It is trapped in the painting. My mind is like an album of photographs and paintings. I do not conceive."[18]

Even though Mitchell does not set off from a predetermined or shared code, her colours carry their own significance for the viewer. As in the illuminated letters of medieval manuscripts, where the decorations both exalt and hide the alphabet, her use of colour seems to enhance or conceal a skeletal script. No such alphabet, of course, exists, but our tendency to read, to seek significant signs in all artistic creations, transforms her bursts of colour, in our eyes, into iconographic texts on the verge of meaning. Far away on the island of Tahiti, Paul Gauguin wrote in 1891: "Since colour itself is mysterious in the sensations it gives, we can logically enjoy it mysteriously . . . not as drawing, but as a source of . . . sensations proceeding from its own nature, from its inner, mysterious, enigmatic force."[19] This force can be nameless: the poet Miguel Hernández, writing about the horrors of the Spanish Civil War, attempted to describe through unnamed colours the war's ghastly spectrum: "Painted and not empty, painted is the house,/ The colour of all great passions and misfortunes."[20]

And yet, we can hardly distinguish that which we cannot name. While all languages carry distinctions of light and dark, and most languages have words to denote the primary and secondary colours, not every language is colour-specific. The Tarahumara language of northern Mexico does not have separate words for green and blue; consequently, the Tarahumaras' capacity to distinguish shades between these two colours is far less developed than that of an English or Spanish speaker.[21] A Tarahumara reading of a painting in blue and green would necessarily be altered by the viewer's linguistic capabilities. The American psychologist William James, writing in 1890, suggested that colours can be felt only in contrast with other colours; if we cannot identify the contrast, we cannot have a real sense of its opposite or its complement. "Black can only be felt by contrast to white," he noted, "and in like manner a smell, a taste, a touch, only, so to speak, *in statu nascendi*, whilst, when the stimulus continues, all sensation disappears."[22] What the example of Tarahumara people seems to suggest is that up to a point, what we see will be determined neither by the reality on the canvas nor by our intelligence and emotion as viewers but by distinctions provided by the language itself, in all its arbitrary majesty.

Since every colour is recognized in words (whether individually, "green" or "blue," or in groups, "green and blue"), no colour, no sign is innocent. We lend colours both a physical and a symbolic reality, or (as medieval scholars would have it) a representation of itself and a manifestation of the divinity. In other words, colours are physically pleasing in themselves (that is to say, in our perception), but they are also emblems of our emotional relationship to the world through which we intuit the numinous. The Middle Ages codified several times the chromatic spectrum, attributing symbolic values to the different recognized colours. Though these attributions varied greatly, blue was often considered the colour of the Virgin Mary, the colour of the sky after the clouds of ignorance have been dispelled; the grey of ashes symbolized mourning and humility and became the colour of Christ's mantle in depictions of the Last Judgment; green, the colour of resurrection, which for the illustrious theologian Hugh de St. Victor was "the most beautiful of all colours,"[23] was attributed to John the Baptist, while John the Evangelist was often shown clad in red, the colour of blood and fire, to suggest his love of action.[24] According to a medieval Talmudic commentator, the four principal colours were red, black, white and green, the colours of the dust out of which man was created: red for the blood, black for the

A chromatic scheme based on the colours of the sky in the early sixteenth-century alchemical treatise *Aurora consurgens*.

bowels, white for the bones and green for the pale skin.[25] A short Irish tract from the sixth century, preserved in the encyclopedic *Liber Flavus Feregusiorum*, defines eight colours, said to be used in ancient priestly vestments, according to their mystical significance. The religious treatise *De sacro altaris mysterio*, written in 1193 by the future Pope Innocent III, lists colours according to their liturgical significance: white for Christmas, Epiphany, Candlemas, Easter, and other feasts of life and light; red for apostles, martyrs, feasts of the Cross and All Saints; black for Advent and the period from Septuagesima to Holy Saturday; and green for all other holidays.[26] The Renaissance developed yet other chromatic value systems. The many-talented Leon Battista Alberti, prototype of the Renaissance man, imagined a colour scheme based on the elements: red for fire, blue for air, green for water and grey for earth;[27] other codes relied on alchemy or mythology, and the Marquis of Ferrara, Lionello d'Este, even dressed according to an astrological colour code that dictated what hue was favourable on what day.[28] The eighteenth century

shifted the spectrum into the realm of science, putting forward systems according to Newton, Diderot, Goethe and Locke. In the early twentieth century, the colour code became determined by physical characteristics such as hue and chroma, dependent on wavelength, brightness and purity, as categorized in the systems of the American physicist Albert Munsell (1913) and the Russian-German chemist Friedrich Wilhelm Ostwald (1915).

In our time, when traditional symbolic vocabularies have been largely forgotten or replaced by the superficial and transitory jargon of commercial and political advertising, certain atavistic notions remain attached to the colour spectrum. Red, notwithstanding its banal political connotation, still retains its meaning of danger and blood; green, beyond ecological publicity, still signifies renewal and safety; blue, in spite of military uniforms, still stands for truth and probity. Colour psychologists explore these ancestral associations, and their findings are routinely used not only by advertisers but also by architects, cooks, interior designers and transport authorities to choose the colours of schools and hospitals, food combinations, living spaces, cars and planes. A coloured wall or a coloured instrument conveys a message of security or a warning, a sense of calm or of excitement.

Unlike a patch of colour, a white space, however, seems to demand filling, tempts us with intrusion. The emptiness created by a frame presents itself to us in the past tense, suggesting that it is about to become something else, that it will acquire an identity through a stroke of ink or a dab of colour, that it will not remain blank forever. The blank page, in front of which Mallarmé felt the horror of the void, contains or convinces us that it holds implicit the lines that will justify its existence. Mitchell associated this primordial white, visible in the background of her *Two Pianos*, with the deafness of her mother. "I think of white as silent," she said. "I often tried to imagine what kind of silence must be inside a deaf person."[29] All these different codes (or their vestiges), all these emotional responses to colour, all these personal preferences or dislikes lend the illusion or promise that canvases such as those of Joan Mitchell can be deciphered or read.

*Two Pianos* was painted in Provence, months after her twenty-five-year-long relationship with Riopelle had ended. She tried to overcome her unhappiness by working, painting canvases such as the ironically titled *La vie en rose*, a triptych with black strokes almost entirely obliterating pink. It is tempting (and perhaps naive) to see in the burst of

yellow light in *Two Pianos* an effort to overcome the darkness behind it, an attempt to find, through colour, a way out of depression, dejection and the foreshadowing of the illness that would soon overwhelm her (she was diagnosed with cancer of the jaw four years later).[30] It is equally tempting to associate the wheat-like yellow and brooding black with similar wild colour strokes in one of her favourite pictures, Van Gogh's *Wheat Fields with Crows*, painted days before his death in July 1890. In Van Gogh's painting, the darkness of the sky, seemingly shredding itself into a flock of crows, weighs down on the burst of yellow wheat that leaps upward from the ground. In *Two Pianos* the darkness lies below and behind the yellow surge, and seems to be overcome by it, while the lilac strokes appear carefully distilled or plucked from the faintly purple shades that follow, in the very centre of Van Gogh's painting, the streaks of brown-red earth.

Both these elements — Mitchell's mood and her admiration for Van Gogh's picture — belong to the circumstances of the painting's creation and are, as it were, part of its history. But how far should these circumstances affect our reading of *Two Pianos*? If the facts of her biography are to be considered, what of the biographies of those who surrounded her? What of the history of the places in which she lived? What of the trends and movements and changes that affected the world during, and even before, her lifespan? Are they all an integral part of the picture we are meant to see? And if they are, if the circumstantial evidence surrounding any act of creation is part of that act, can any reading ever be said to be final, even if not conclusive? Can a picture ever be seen in its contextual entirety? And if it can't, is our position the same as that of Samuel Beckett's reader who must respect the credo found in *Molloy*, that "there could be no things but nameless things, no names but thingless names"?[31]

In the final pages of his novella *Le chef-d'oeuvre inconnu*, Balzac describes the painter Frenhofer showing his long-awaited masterpiece to his friends. The old man, who once painted astonishing nudes and splendid portraits, has been working for years on a painting that he considers the pinnacle of his craft, deepening and darkening a female form with brushstroke over brushstroke in order to capture that which cannot be captured, the collusion of impression, physical reality and emotional response. "Some of these shadows have demanded intense labours," he says proudly. "Look, there on the cheek, under the eyes, there's a faint dimness which, if observed in

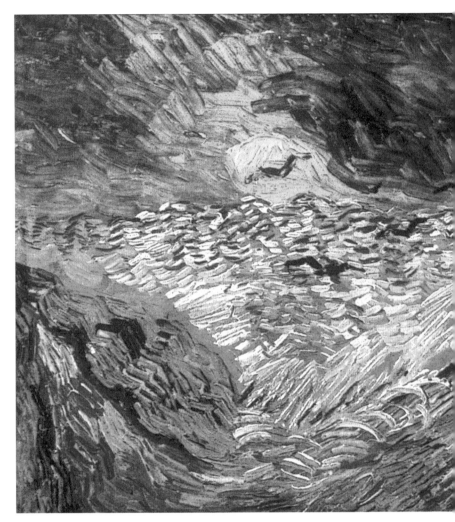

Vincent van Gogh,
*Wheat Fields
with Crows.*

nature, would seem untranslatable to you. Ha! Don't you think it cost me unspeakable pains to reproduce it?"[32] But, as the painter soon discovers, the untranslatable cannot be reproduced except as untranslatable, and what Frenhofer offers his viewers is something they simply cannot grasp, a creation they cannot even see, because it has no equivalent in any other language, a blurring of colours that seems all madness and no method. "In this state nothing can be seen that can be called sight, nor can it be perceived with the imagination," said St. Teresa in the mid-sixteenth century, trying to explain her vision of the soul's encounter with Christ.[33] Like St. Teresa, Frenhofer has seen the numinous in the quotidian, he has perceived that which cannot be

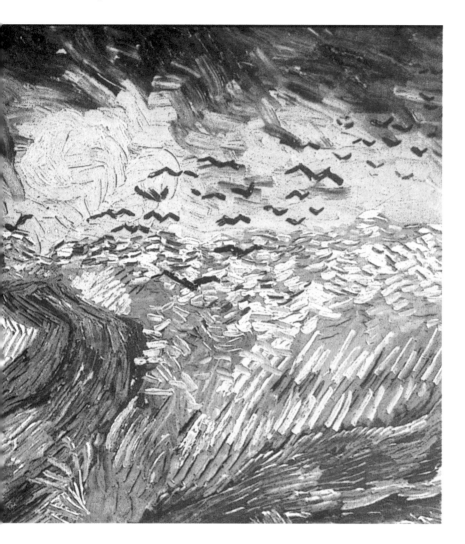

perceived except as a mystical experience, and he has attempted to reproduce that experience not through symbolic shapes or colours, not in a vocabulary of references and allusions, but as its own blinding self. After all the labours and pains, the result is only a muddy patch of "nothing! nothing! And to have worked ten years on this!" "This" is an absence.

*Two Pianos* suggests a script deleted or revised through colour. The elements that went into its creation simply add possible layers to our intuited and yet inconclusive reading; because our attempt, as viewers, to read what is in its essence unreadable merely fills the deliberate absence of a decipherable code with a meaning that we both invent and unravel.

And yet this method of reading a painting, which usurps for us the prerogatives both of a writer and of a reader — a method akin to the superstitious recognition of signs in playing cards or omens in the burnt shell of a tortoise — is the only one by which we, the viewers, can aspire to enter the image set in front of us. It may be an ineffectual method, poor in scope and lame in its achievements, allowing us barely the ghost of the shade of a reflection, glimpsed in the dimmest of all possible mirrors, of that which for want of a better term we call the creative act. It is said that a minor god, wishing to imitate the Lord Buddha, tried to create a racing horse and produced the camel instead.[34] It may be that in following this method we delude ourselves, imagining that our reading comprehends, even approaches, the work of art in its essence, when all it does is allow us a feeble reconstruction of our impressions through our own corrupted knowledge and experience, as we tell ourselves stories that convey, not the Story, never the Story, but allusions, intimations and new imaginings. The English Prayer Book of 1662 lovingly confuses the act of seeing with the act of thanking, asking to "shew the voice of thanksgiving: and tell of all thy wonderous works."[35] When we are confronted with a work of art, this may be our only possible response: the equivalent of a prayer of thanks for that which allows us, with our limited senses, an infinite multitude of readings, readings that, at our best and fondest, hold the possibility of enlightenment.

Joan Mitchell once said that she had tried to replace Jackson Pollock's metaphysics with "overtones of love,"[36] and her paintings have, no doubt, an amorous quality, a thankful love for life that touches the viewer before any attempt at reading. It comes as no surprise that one of her last paintings (perhaps her last), finished barely a few weeks before her death, bore the title *Merci*.

Robert

Campin

The

Image

as

Riddle

"*In a riddle whose subject is chess, what is the only forbidden word?*"
*I thought for a moment and answered:* "*The word* chess."

Jorge Luis Borges, *The Garden of Forking Paths*

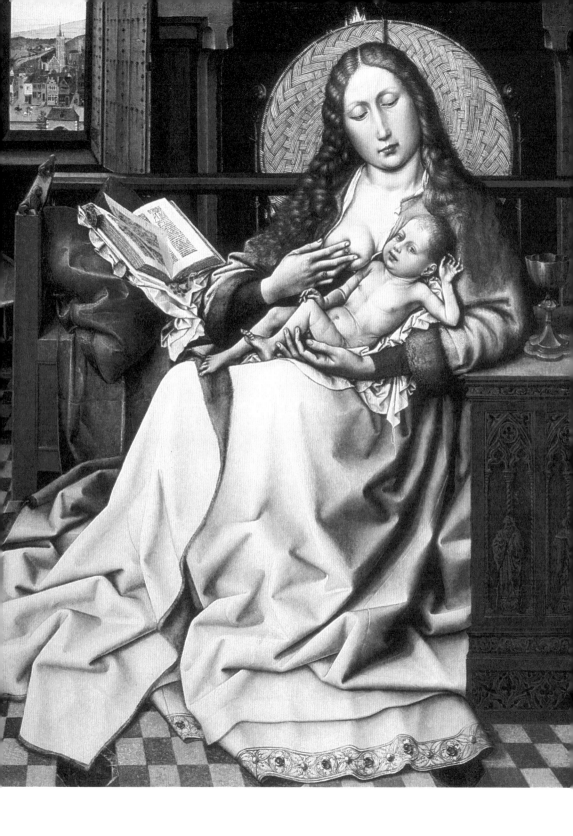

FIVE CENTURIES before Joan Mitchell's attempt to depict a view of the world through the absence of language, an artist familiar with the new currents of Netherlandish art painted a Virgin and Child that is, in some sense, the opposite of Mitchell's: a composition in which every element acts as a secret word that the viewer is coaxed into deciphering as if unravelling a rebus. We don't know his name; the work has been variously attributed to Roger van der Weyden, perhaps the major artist of Flanders in the mid-fifteenth century, or to his teacher, Robert Campin, among others.

The Virgin and Child before a Firescreen, as the painting is plainly known, depicts an intimate domestic scene. The woman is the Virgin Mary, the Mother of God, nursing her divine offspring. But she is also very much of this world, a young mother offering her breast to a fretful or merely uninterested baby. Recent cleaning uncovered minuscule and precise details: effects of light on the furniture, a metal ring above the Virgin's head, the fireplace's lintel — all showing how keen the painter was to convey a sense of ordinary reality.

Whoever the artist might have been, he seems to have felt unsatisfied with the traditional uses of Christian iconography. Obviously curious about the possibilities of an art that was able to mimic reality, as Netherlandish painting was so painstakingly proving, he transformed the everyday objects of a domestic setting into symbols of symbols: from the most obvious (the woven firescreen mimicking the Virgin's halo) to many others of greater subtlety. By using certain objects in place of those traditionally depicted in religious scenes, the painter achieved two purposes simultaneously: he elevated a human mother in ordinary surroundings to a holy place in the Christian pantheon, depicting her as the Mother of God, and he humanized the divine by

reducing or comparing the sacred attributes of the Virgin to objects in a mortal household.

Undoubtedly, the Mother — not the Child — is the subject of the painting. The Child looks out at us with conniving eyes, His artificially long limbs in a languorous pose, His left hand as if holding an invisible flower. The Mother, instead, is looking inward, awkwardly offering her right nipple less to her Son than to the viewer, drawing us toward her self-centredness. She is neither quite seated nor standing. Like the Living Torso of roadshow fame, she floats, mysteriously grounded and yet not of this earth, the upper part of her body — wavy hair, pouting lips, round breast — absolutely present, her lower half (the site, according to St. Augustine, of our fallen nature)[1] absent under the folds of her dress, since Mary is without fault, immaculate as a lily. The entire scene revolves around her. Who is she, we want to know, and the painter seems to have placed throughout the room clues for us to construct her identity.

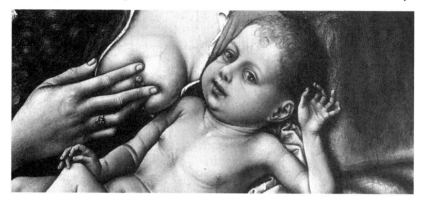

The mothering breast, offered to both the Child and the viewer.

Can we read those clues from a distance of over four centuries?

The exposed breast, the firescreen halo, the three-legged stool, the book she is reading, the tip of the flame behind the screen, the ring on the ring finger of her right hand, the coloured jewels embroidered in the hem of her white gown, the mysterious pair of octagonal tiles half hidden by her dress, the scene outside the window: each of these seems to reveal something of who she is meant to be, in both the world of God and the human world, and we are tempted to read her as we would a book of riddles.

The first image of the Virgin and Child that has come down to us dates from the third century. It was painted on one of the walls of the catacombs of St. Priscilla in Rome and shows (what we can still see after centuries of damp and mould) a veiled mother holding a child on her

knees, the child's face turned toward us, His left hand on her breast, while another figure, perhaps an angel, points to a star above them.

The depiction of the nursing goddess is ancient and universal: Ishtar in Mesopotamia, Dewaki nursing Krishna in India, Isis in Egypt and many more. The image of the Christian Virgin and Child no doubt owes much to these more ancient images. In the Middle Ages, however, a curious explanation was found for these obvious similarities. According to the thirteenth-century *Golden Legend* by Jacobus de Voragine, the prophet Jeremiah had told the priests in Egypt that their idols would fall to pieces when a virgin bore a son. "For that reason," writes de Voragine, "the priests made a statue of a virgin holding a male child in her lap, set it up in a secret place in the temple, and

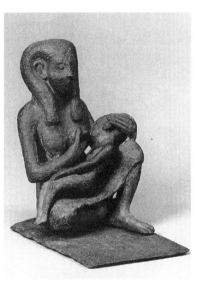

An Egyptian bronze from the Middle Kingdom (c. 2040–1652 B.C.), thought to represent Isis breast-feeding Horus.

there worshipped it. When King Ptolemy asked them the meaning of this, they told him that it was a mystery handed down by the fathers, who had received it from a holy man, a prophet, and they believed that what was foretold would really happen."[2] The image, probably of Isis nursing Osiris, was for de Voragine not endemic to Egyptian culture but an anachronistic response to Jeremiah's biblical prophecy.

In many of these traditions, the image of the good nursing mother is counterposed to that of the destroying mother. In Mesopotamia, for instance, the goddess Lamastu was portrayed as suckling a dog or a pig, and was thought to cause puerperal fever and infant diseases.[3] In later times, this wicked mother becomes Medea and Lady Macbeth, plucking her nipple from the boneless gums and dashing her child's brains out; in more recent times, she becomes the evil screen goddess Joan Crawford, or the splendidly strict Madonna painted by Max Ernst in 1926.

Like the mother herself, the mother's breast carries a multiplicity of meanings that are, or can seem, contradictory: such symbols were described by Talmudists as the richest of all, since they embrace the totality of meaning.[4] In its positive connotation, the breast establishes a

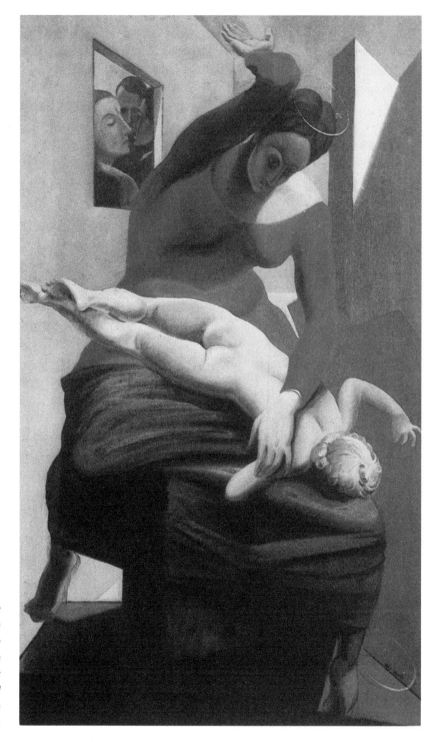

Max Ernst, *The Blessed Virgin Chastising the Infant Jesus before Three Witnesses: André Breton, Paul Éluard and the Artist,* 1926.

46

link of parenthood: offering the breast
is one of the gestures through which a
child is adopted. For instance, in
Greek, Roman and Etruscan mythol-
ogy, Juno (Hera or Uni) adopts Her-
cules (Herakles) by giving him milk
from her breast; the Milky Way was
formed when she plucked her nipple
from his overeager lips and spurted
milk across the heavens.[5] In its negative
connotation, the severed breast de-
notes the relinquishment of mother-

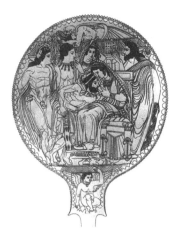

A sketch from the
back of a Greek
silver mirror,
depicting Hera
feeding Hercules.

hood: the Amazons cut off their right breast in order to draw their
bows and shoot their arrows more efficiently, and become better war-
riors, trading the role of Venus for that of Mars.

The nurturing breast also carries a deliberate erotic connotation.
A contemporary of our painter, the French artist Jean Fouquet, por-
trayed toward 1450 an astoundingly sensuous Madonna, using as his

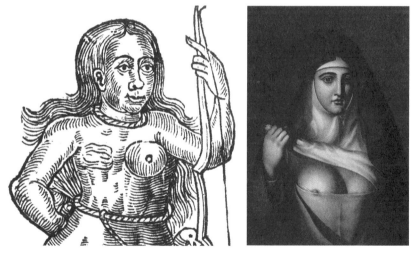

(left)
An anonymous
portrait of an
Amazon, in
John Bulwer's
*Anthropomorphosis*,
London, 1653.

(right)
Jean-Jacques
Lequeu's
*And We Too Shall
Be Mothers,
Because . . .*

model the notorious Agnès Sorel, mistress of King Charles VII. Fou-
quet's Virgin is defiant, self-possessed, fiery and pays little attention to
the child by her side. It is no doubt this erotic motherhood that the
French architect Jean-Jacques Lequeu had in mind when he conceived
an etching calling for the emancipation of nuns in 1794. Wishing to
ally himself to the recent legislation of the French Revolution that had
confiscated ecclesiastical property and banned all monastic vows

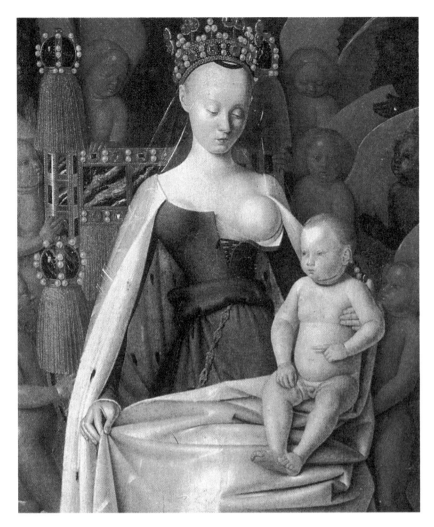

Jean Fouquet,
*Madonna and*
*Child.*

(while at the same time appointing new Church authorities elected by the Assembly rather than by the French Crown), Lequeu became one of the advertising artists for the Republic.[6] The title of his etching, strongly subversive and highly popular, was *And We Too Shall Be Mothers, Because*...[7] The implied answer was self-evident: because the erotic breast can lead back to the image of nursing Mother.

Mary's milk was Christ's food, and in this sense her milk becomes one of the aspects of Christ's humanity, since, a baby like all babies, He too was needful of His mother for nourishment. Remarking on the Virgin's role of "feeding the Feeder," the scholarly Amadeus of Lausanne sometime in the twelfth century wrote in his praise of Mary: "Happy she

to whom it was given . . . to suckle the child who fills the very breasts he sucks, to feed the all-provider who gives even the birds their food!"[8] But milk is not only nourishment; it is the gift of life itself, offered by the Mother to the divine Child so that He may grow into a man, an image extended by St. Peter to describe the gift of God's word: "As newborn babes, desire the sincere milk of the word, and ye may grow thereby."[9] Both Mary as the nourisher and Mary as the life-giver to all humankind are alluded to in a hymn written by St. Anselm in the eleventh century:

> Mother of our lover who carried him in her womb
> And was willing to give him milk from her breast —
> Are you not able or are you unwilling
> To grant your love to those who ask it?[10]

Sometime in the twelfth century, St. Bernard de Clairvaux, founder of the Cistercian order and known in his time as the "honey-sweet teacher" for his mellifluous style (his emblem became a beehive), had an extraordinary vision in which he saw the Mother of God nourishing his own sinful soul with her loving milk. This powerful image was present throughout the next three centuries in depictions of Purgatory, where the suffering souls were shown saved by Mary's generous breasts. An echo of this "loving drink" persists today in the German wine known as Liebfraumilch or "Our Lady's milk," often associated with a much earlier legend illustrating the Roman virtue of *caritas* or charity. In his *Memorable Events and Anecdotes*,[11] the first-century Roman historian Valerius Maximus tells the story of Pero, a virtuous woman whose aged father, Cimo, was unjustly sent to prison, where he was condemned to starve. She supported his life by giving him suck as if he were her own child, and this image of the grown woman suckling a grown man became commonplace in both medieval and Renaissance art, sneaking into Caravaggio's painting *The Seven Acts of Mercy*, where she is taken to represent the merciful act of feeding the hungry.

Mary's milk was considered, together with her tears, among the most precious effusions of Christianity. Marina Warner, in her exhaustive book on the Virgin Mary, *Alone of All Her Sex*,[12] lists the cities that possessed relics of Mary's milk: Walsingham, Chartres, Genoa, Rome, Venice, Avignon, Padua, Aix-en-Provence, Toulon, Paris and Naples. In Bethlehem, tourists can still visit the Milk Grotto, where Mary spilled a few drops while she was nursing, and where, to promote lac-

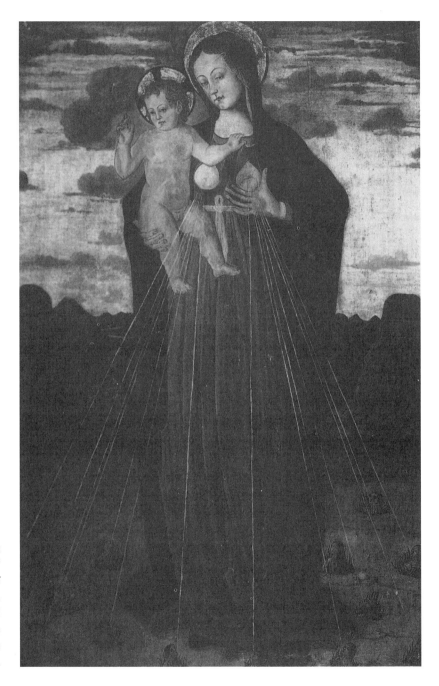

In this painting by Filotesi dell' Amatrice, of c. 1508, Mary, as the Merciful Mother, feeds with her milk the souls in Purgatory.

tation, cakes made of the milky soil can be bought.[13] Erasmus, the eminent sixteenth-century humanist, made fun of these sites in which Mary's milk was venerated, attended, he said, by custodians "holding

50

out a begging-board like those used in Germany by toll-collectors on bridges."[14] The Protestant reformer John Calvin raged too against this surfeit of milk: "There is no town so small, nor convent ... so mean that it does not display some of the Virgin's milk.... There is so much that if the holy Virgin had been a cow ... all her life she would have been hard put to it to yield such a great quantity."[15]

We can lend one other symbolic reading to Mary's naked breast. In fifteenth- to seventeeth-century depictions of the Last Judgment, Mary bares before her Son the breasts that nursed Him, in order to draw His compassion and make Him more lenient, while He duplicates her gesture, baring His own breast to show God the Father the wounds of His Son's Passion.[16] Both appear, side by side, in a diptych by an anonymous Zurich artist, painted in 1503: portrayed high up on the left-hand panel, God the Father seems to be siding with His Son. The Latin caption below ends with the words: "Both these are signs of love."[17]

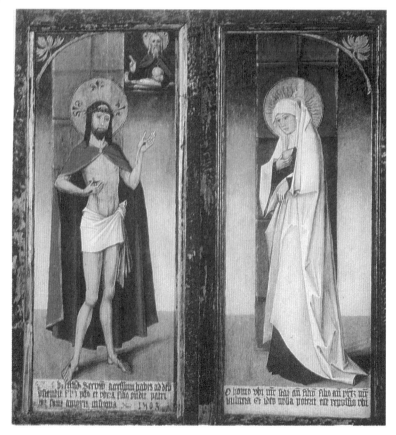

Mary and Jesus before the Lord, a tempera on wood by the Zurich Master of the Carnations, 1503.

Mary's infinite compassion is one of the qualities of her holiness, a holiness symbolized traditionally by a halo. As we have seen, behind

The woven firescreen becomes, as if by chance, the Virgin's halo. The flame signals both the hearth and the presence of the Holy Spirit.

her, in our painting, stands a firescreen of woven hemp. To the Christian eye, the halo effect is unmistakable, a visual pun recognizable since the earliest days of the Christian Church. In the later Roman Empire, the rays of the sun used to crown the head of Apollo, the sun god; this fiery image became the emblem first of the emperor Constantine, the first Christian emperor (an emblem borrowed later by Louis XIV, the Sun King, at Versailles), and then of Christ Himself. After Christ, the Lamb of God, the angels and the saints all inherited this particular sign of divinity: the radiant halo. And in one of the few cases of an artistic trait moving from West to East, the halo travelled through the Middle East and India, finally crowning the Lord Buddha.[18]

(left)
In 1556, the Renaissance scholar Vincenzo Catari published a compendium of the ancient gods that included this image of Apollo, crowned with a halo, inspecting several vases containing his attributes.

(right)
A tenth-century Chinese ink drawing of *The Incommensurable Buddha of the Forty-Eight Wishes.*

But halos were not always round. A triangular halo, for instance, symbolizing the Trinity, sometimes crowned the head of God the Father, the Holy Spirit in the shape of a dove and God the Son. The circle, however, the most perfect of geometrical shapes, was used to symbolize the perfection of God Himself. A square halo, imperfect as opposed to the perfection of the circle, was worn by someone still

A still from the 1983 feature film *The Fourth Man*, by Paul Verhoeven.

alive when the picture was painted, while rare hexagonal halos were used to crown allegorical figures.[19] Sometimes, however, the halo can be a natural element in the painting, a detail that just "happens" to recognize the sanctity of the sitter, as when the mother "accidentally" crowns her child with an apple peel in the 1983 Dutch film *The Fourth Man*, turning the scene into recognizable Christian icon.

One other domestic detail in *The Virgin and Child before a Firescreen* completes the Mother's holiness. The light of the scene is on the feed-

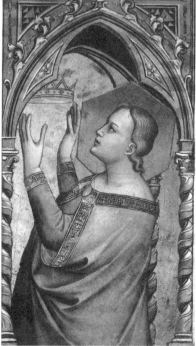

(left)
An early eighth-century mosaic fragment portraying Pope John VII.

(right)
Alesso di Andrea, *Allegory of Hope*, a fourteenth-century fresco in Pistoia cathedral, Italy.

ing Mother, her shadow outlining her shape in the folds of her dress and on the furniture behind her, subtly adding "a sense of presence"[20] to the room. But behind the firescreen, a flame can be seen, flickering brightly. The medieval iconographic convention is that a flame burning above the crown of a head signals another presence, that of the Holy Spirit.[21] Mary is blessed by this haunting presence, which infuses the domestic scene with an otherworldly sense.

Our painting contains several other clues to be deciphered. For instance, lurking in the back in a dark corner stands a humble three-legged stool. Its presence is meant to remind us of the presence of the Holy Trinity. The notion of three in one, beyond theological

The mysterious three-legged stool.

conundrums, presented painters with serious iconographic problems from the very beginnings of Christian art. The concept of the Trinity, that one God exists in three persons equally as one substance, is the central tenet of Christian theology. Even though the word does not appear in the Bible and was first used, in the Christian sense, more than a hundred years after the birth of Christ by Theophilus of Antioch, the Trinity quickly became an essential element of the Church dogma. By the end of the thirteenth century, the Oxford scholar John Duns Scotus, famous for his commentaries on Aristotle and the Bible (though ridiculed centuries later during the Reformation, when his name was turned into the insulting term "dunce"), was able to teach that the Trinity was the only possible way God could be.[22] Since God is perfect love — that is, the lover, the beloved and the act of love itself — He could only be represented as each of these and all in one. The difficulty of rationally comprehending this concept (according to Robert Grosseteste, a contemporary of Duns Scotus's) lies not in its impossibility but in our fallen nature: original sin prevents us from perceiving the concept of the Trinity through natural reason, just as it disallows us from understanding Time, that ineffable mystery.[23] But if reason cannot make the Trinity clear to us, then in what way can this incomprehensible Trinity be depicted?

Painters and sculptors responded with many ingenious devices. The most common image of the Trinity is of three simultaneous characters: the Father, the Son and the Holy Spirit, usually in the shape of a dove. This arrangement was conveniently — and perhaps subversively — also used to incorporate Mary and her mother, Anne, into a secondary trinity that associated them with Christ and revealed the female component of the godhead.[24] But the Trinity was also represented in a number of other ways: as three interlocking circles, for instance, as three identical figures like triplets and even as a three-headed animal, like the ibis and the salamander in Hieronymus Bosch's *Garden of Earthly Delights*.[25] In the fifteenth century,

Masaccio,
*The Virgin, Anne and Child.*

St. Antonino, Archbishop of Florence, raged against these excesses: "Painters," he said, "are to be blamed when they paint things contrary to our Faith — when they represent the Trinity as one creature with three heads, because such a creature is a monster."[26] This monstrous representation of the three in one has ancient roots, at least as far back as Sumeria and Egypt.

It is possible that certain of these earlier images were meant to represent not merely a three-headed god or monster but also the simultaneous fluidity and unity of time. Attempting to explain the presence of a three-headed beast — lion, wolf

(middle)
The three-headed salamander and (bottom) the three-headed ibis, two representations of the Holy Trinity in Hieronymus Bosch's *Garden of Earthly Delights*.

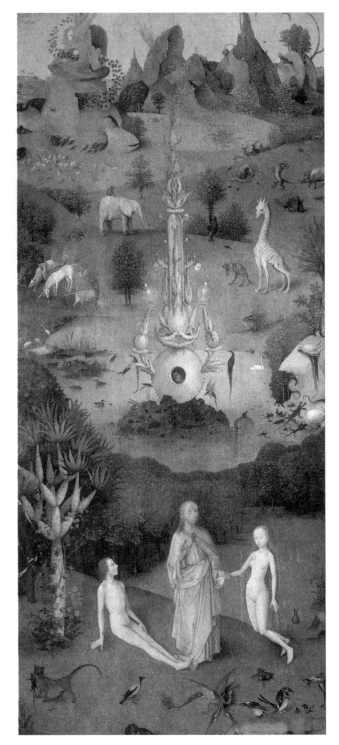

Left panel of
*The Garden of
Earthly Delights*
(Hieronymus
Bosch).

(left) The Egyptian god Serapis and his three-headed beast, in Vincenzo Catari's 1556 mythological compendium.

(right) A three-headed creature representing the multiplicity of peoples to be evangelized, in a fifteenth-century Syriac manuscript.

and dog — that accompanied the Egyptian god Serapis, the Latin historian Macrobius offered, in the fifth century A.D., this reading: the lion, he wrote, denoted the present, which is strong and fervent; the wolf the past, devouring memory and carrying away whatever might remain of our present; and the dog, eager to please, represents the future "of which hope, though uncertain, always gives us a pleasing picture."[27] This notion, of three-headedness representing the three stages of time, became popular in the Renaissance, and was used in Titian's *Allegory of Prudence*.[28] In this painting, the three-headed beast is superseded by three human heads: that of old Titian himself, representing the past; of his son, representing the present; and of a young relative whom Titian had more or less adopted, representing the future. That simultaneous all-encompassing and yet sequential quality of time is shared, of course, by the Holy Trinity.

Did our unknown painter hope to represent this temporal and paradoxical quality of the Trinity by means of a humble three-legged stool? Perhaps. One corner stands in the light, clearly visible to us, like the present. Another can be dimly seen in the back, set in shadows, like the past. The third is hidden from us, like the mysterious future.

This simultaneity of time has another presence in the room. On the bench behind where Mary sits is the open book that she has been reading. Though traditionally the book or scroll belonged to the male deity, God the Father or God the Son, a book was usually present in depictions of the Annunciation. Sometimes Mary reads from a Book of

Titian, *Allegory of Prudence*

Hours, sometimes she's reading Isaiah prophesying her own advent: "Behold, a virgin shall conceive and bear a son, and his name shall be called Emmanuel."[29] Sometimes she reads the so-called Wisdom Books of the Bible — Proverbs, Job and Ecclesiastes. Sometimes her book is open on a page of the Apocrypha, the Wisdom of Jesus or the Wisdom of Solomon.[30] In all these texts there are passages that, as Christian commentators were eager to point out, foretell or echo the birth and Passion of Christ. Reading her life to come, in one of the Old Testament books, Mary learns, with tragic irony, her fate and that of her Son. Sometimes an image of Christ's Passion will appear on the wall of the young Virgin's room as an eerie reminder of the inexorable future, or sometimes the Child will be shown tearing a page from the book (a common allegory of the New Testament superseding the Old).

In *The Virgin and Child before a Firescreen*, the book is lying open on what looks like a silk book bag, used to protect precious volumes. The Mother has interrupted her reading to attend to her Child, because the Word become flesh takes precedence over the mere written word: the uttered word of God that was in the begin-

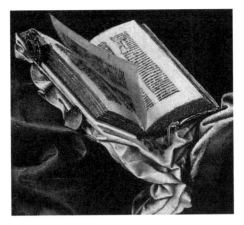

The Book that contains the Word of God, revealing the future to the Mother and Son.

ning, *verba*, takes on the shape of a child; the word on the page, *scripta*, remains locked on the page, between the covers of the book. However, the written word doesn't disappear. Reverently protected, it occupies the same room as the flesh, telling us that we still need words to name even the holiest of experiences, however extraordinary and seemingly beyond words that experience may be. Our anonymous painter was a believer in the power of the written word.

Firescreen, stool, bench, book: Mary lives in the real world, a world shown outside her window. As W. H. Auden famously remarked, the Old Masters knew of suffering and how life continues in the presence of the miraculous.

> They never forgot
> That even the dreadful martyrdom must run its course
> Anyhow in a corner, some untidy spot
> Where the dogs go on with their doggy life and the torturer's
>     horse
> Scratches its innocent behind on a tree.[31]

The scene outside, painted in scrupulous detail, like a miniature, depicts a city scene: the blue mountains behind, a winding road leading to them, and the church standing proudly in the city centre, pointing to Heaven — the Church that will be born from Mary's suckling, from the agony and death of her Child. People come and go, unaware that the "martyrdom must run its course,"

Outside the window, an ordinary scene of city life that is also a clue to the picture's riddle.

unaware of the great drama that has begun to unfold. A woman stands idly at her door, two riders pass leisurely by, strollers stand and chat in the street, another couple gossips at a window. Only two men seem active: they are climbing a ladder placed against a house, working to fix the roof. Ecclesiastes 10:18 warns against the sin of sloth that causes a building to decay and the roof to cave in. This warning echoes in this scene: we, the world, must not give in to sloth; we must be aware and ready to witness the coming of Christ, and as in Auden's indifferent crowd, two men at least seem to busy themselves with the building's upkeep. For the contemporary viewers of the painting, the body was like that building, a sacred temple, built in the image of God, and was not to be neglected.

Inside the room, Mary sits as if barely conscious of her holy state. It is we, the viewers, who are given clues to her divine identity, as in the richness and colour of her costume, for instance. Mary's dress changed throughout the ages, shedding certain symbolic values and acquiring others, but the sky-blue colour remained hers as the sky goddess. As late as 1649, Velázquez's teacher, the Spanish artist Francisco Pacheco,

The bejewelled
hem of
Mary's dress.

in his *Art of Painting* argued that her cloak should be blue and of no other colour;[32] her dress in the picture has a wonderful, eerie blue sheen. Adorned with gold embroidery and precious stones, Mary is depicted as clothed in finery from heaven, wearing a wedding ring as bride to both Joseph and God, and even (as St. Augustine suggested) wife to her own Child, the "Infant Spouse."[33] In spite of such finery, our painter portrayed the surroundings as less aristocratic than the ones we see today: the Gothic cupboard and the chalice to her left were added in the nineteenth century by an overzealous restorer, who also saw fit to hide in shadow the Child's all too human genitals, only recently revealed during the cleaning of the painting.[34]

I'm intrigued by this prudery. Obviously, the fifteenth-century audience would have noticed such a carefully painted detail, accustomed as they were to seeing the naked Child who had by then long shed the robes in which the artists of Byzantium had clothed Him. His genitals confirm Christ's humanity. As an eternal being, He experiences neither death nor sexual desire. As man, He suffers both. Therefore Christ's genitals appear at the two ends of His mortal life, as a child and as a dead man, in the latter case often cupped by His stigmatized hands. As Leo Steinberg notes in his important book *The Sexuality of Christ*, "Renaissance art, both north and south of the Alps, produced a large body of devotional imagery in which the genitals of the Christ Child, or of the dead Christ, receive such demonstrative emphasis that one must recognize an *ostentatio genitalium* comparable to the canonic *ostentatio vulnerum*, the showing forth of the wounds."[35] By the nineteenth century, such nakedness was clearly offensive.

Our painter obviously intended Christ's genitalia to be seen. X-ray inspection of *The Virgin and Child before a Firescreen* has revealed that he

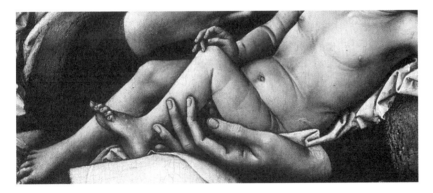

The revealing triangle.

lowered the Mother's left hand so as to allow him to show the Child's penis, visible now once again in the triangle between her left hand and His knee. In a number of religious paintings,[36] Christ's penis is shown quite evidently tumescent, and there has been much discussion regarding the possible symbolism of this detail. Perhaps the erection of the flesh is meant to foreshadow the resurrection of the flesh. St. Augustine, in Book XIV of *The City of God*, argues that the involuntary erection of the penis is a sign not of our human but of our fallen nature.[37] For Augustine, the shame felt by Adam was not due to his nakedness or to Adam's sight of his genitalia (he notes that Adam had not been created blind) but by his organ's new unruliness. From the

earliest medieval scriptural glosses until long into the Renaissance, commentators argued whether Adam before the Fall had or had not felt pleasure in copulation, and decided that he had. Shame came not from pleasure, but from the loss of control over his body. Since Christ suffers none of the frailties brought on by Adam's sin, the representation of Christ's penis as erect in childhood or in death must suggest an act of will (this is Steinberg's conclusion), proving the triumph of His chosen body over sin.

In our painting, Christ's penis clearly appears uncircumcised. Another symbol in the painting indicates that future circumcision, the ceremony to come. That symbol is the pair of mysterious octagonal black tiles peeping out from under the Virgin's dress.

Circumcision, according to Jewish law, takes place on the eighth day after the child's birth; the octagonal tiles are partly hidden under the dress because that day has not yet arrived. Circumcision represents God's covenant with Abraham, and also (according to the third-century

The octagonal tile may be a reference to the day of Christ's circumcision.

Rabbi Oshaia the Elder) a "finishing-off" of the created male. "Mustard needs sweetening," wrote Rabbi Oshaia, "vetches need sweetening, wheat needs grinding and even man needs finishing."[38] This, added the twelfth-century Spanish scholar Maimonides, is because "the flesh of a boy child only seven days old is still as tender as it has been in the mother's womb, but by the eighth day it becomes stronger and more solid."[39] The eighth day (or "octave," as it is called in Jewish lore) is further proof that Christ became a man, since on that day He was circumcised and bled, and only a human body can bleed. It also demonstrates His covenant with humankind, made explicit in Colossians 2:11: "[Christ] in whom also ye are circumcised with the circumcision made without hands [i.e., in the spirit], in putting off the body of the sins of the flesh by the circumcision of Christ."

The eighth day celebrates Christ's humanity. Until that day, only two names were given to Him: Son of God at the Annunciation and Christ at His birth.[40] The name Jesus was given to Him at His circumcision, a name that, according to St. Bernard, suggests nourishment, like mother's milk. "The name Jesus is food," says St. Bernard. "Are you not strengthened every time you recall it? What else builds up the spirit of

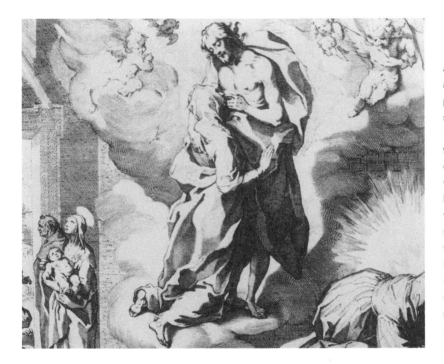

According to the *Legenda Major*, a popular book of saints' lives of 1597, the fourteenth-century St. Catherine of Siena had a vision in which Christ suckled her with the blood from His wounds. (Late sixteenth-century engraving after a painting by Francesco Eugenio Vanni.)

the one pondering it, as this name does? What so refreshes the tired heart, strengthens the virtues, fosters chaste loves?"[41] After the circumcision and under the name of Jesus, Christ becomes the nurturer, assuming, as is clear in a number of depictions of His risen body, the role of a maternal Christ, His own offering gesture that of His nursing mother, neatly bringing the image full circle.

*The Virgin and Child before a Firescreen* is at least two paintings: one shows a comforting interior and an ordinary domestic scene; another tells the story of a god born to a mortal woman, assuming in His human guise both the sexuality of the flesh and the knowledge of a certain end. This story threatens to be infinite, since every new reading adds other layers to its plot. Reading it today, we bring to the painting a wealth of curious details (the halo that travelled eastward, the ancestral images of mothering, the effects of nineteenth-century prudery) of which the artist could not have been aware; we ourselves, of course, can't know what new chapters will be added to the story in future readings. The riddle remains the same: only the answers vary.

A painting like that of Joan Mitchell, which deliberately eschews a language we are meant to decode, suggests the possibility of its contrary: a painting in which every element is a code, a system of signs put

forward for the express purpose of translation, a puzzle for the viewer to solve. It may be that every painting is, in some sense, a riddle; that every painting can assume the posing of a question concerning subject, lesson, plot or meaning. Not every painting, however, offers as precisely as *The Virgin and Child before a Firescreen* the possibility of composing, in the viewer's eye, a different or revived image from the one depicted within the picture's frame.

Tina
Modotti

The
Image
as
Witness

*. . . to be only the lens of my camera,*

*something fixed, rigid, incapable of intervention.*

Julio Cortázar, *Blow-Up*

SOMETIME IN THE MIDDLE of the first century A.D., in the thirty-fifth book of his *Natural History*, the erudite Pliny the Elder wrote that though the Egyptians claimed they had invented the arts of painting and sculpture before they crossed into Greece, while the Greeks argued that the invention had taken place in either Sikyon or Corinth, there was a universal agreement that the craft of reproducing human figures had begun "by the outlining of a man's shadow."[1] According to Pliny, a certain potter's daughter fell in love with a foreign youth. When the time came for her lover to leave, she traced the outline of the shadow of his face on a wall, and asked her father to fill in the lines with clay, thus creating an image of her absent love.[2]

To capture reality faithfully through the contrast between shadow and light seemed to Pliny the goal of art, and he praised, for instance, the *trompe-l'oeil* of the artist Zeuxis who created such a successful representation of grapes that birds flew up to peck at them. (Pliny notes that Zeuxis was outwitted by Parrhasius, who painted a curtain that Zeuxis asked be drawn aside, believing it hung in front of the real picture.)[3] The point of Pliny's story, which quickly became a cliché of art history, was that pictures could hold a faithful mirror to the world. Subjectivity, Pliny thought, was detrimental to the work of art. And yet we know that what we read in a picture varies according to

David Allan,
*The Origins of Painting*, 1775.

69

who we are and what we have learned — a fact that lends little assurance to the belief that we could ever share a common vision of the world. Perhaps for this reason, the history of art runs parallel to that of the notion of objectivity. Plutarch made fun of those nationalists who bragged that the moon of Athens was better than the moon of Corinth;[4] unwittingly, he may have been stating a deeper truth, since it may be impossible for two separate pairs of eyes to see the same pale moon.

Not for want of trying. Nineteen centuries later, in Paris, the brothers Claude and Joseph Nicéphore Niepce, with the aid of a *camera obscura* and sensitized paper, developed a procedure for a hot-air, engine-powered lithographic press that allowed them to produce faithful pictures of reality, which were, however, tonally reversed, that is to say, black for white — what we would today call negatives. Eventually this method produced a plate that could be etched to create a positive print. A few years later, Louis Jacques Mandé Daguerre perfected the Niepces' invention, and it was considered so successful that the French government bought it in 1839.[5] The new technique, under the name of daguerreotype, became universally popular, and barely a year later, in January of 1840, Edgar Allan Poe, after reminding his readers that the process itself was called "photogeny" ("from Greek words signifying sun-painting [light-made]"), praised the French invention as "the most important, and perhaps the most extraordinary triumph of modern science."[6]

H. N. & E. H. Manchester, *Edgar Allan Poe*, daguerreotype portrait, 1848.

A full century after Poe's endorsement, the poet Paul Valéry recognized in photography the possibility of reviving, if not rejuvenating, "the ancient and difficult problem of *objectivity*."[7] Walter Pater, the shy nineteenth-century Oxford aesthete, in a famous passage of his book on the Renaissance, argues that art is "always striving to be independent of mere intelligence, to become a matter of pure perception, to get rid of its responsibilities to its subject or material."[8] According to Valéry, photography held that possibility of "pure perception."

He gave this example: hundreds of people swore that a fakir had performed the trick of climbing a miraculously suspended rope that he had just flung into mid-air; a simple snapshot revealed that nothing of the sort had occurred and that the crowd had been collectively deluded. For Valéry, the snapshot "rectified our errors both of deficiency and of excess," showing us what we would see "if we were uniformly sensitive to everything that light imprints on our retinas, and nothing else." The camera had become, at last, Pliny's faithful mirror.

Not every one was convinced. The eminently modern Charles Baudelaire, in a letter published in the magazine *Le Boulevard* on September 14, 1862, derided this new art. Concerned that the pretension of photography — to portray reality accurately and objectively — would distract audiences from the artistic *refusal* to copy reality and "confirm fools in their faith," Baudelaire wrote: "In the domain of painting and statuary, the present-day credo of the worldly wise, especially in France, is this: . . .

A BAS LA PHOTHOGRAPHIE !!!

*TEXTE ET DESSINS PAR MARCELIN.*

A nineteenth-century cartoon against the evils of photography.

'I believe that art is, and can only be, the exact reproduction of nature. . . .' An avenging God has heard the prayers of this multitude; Daguerre was his messiah."[9]

In spite of Baudelaire's caveat, photography quickly became our society's purveyor of images, conquering space and time. As never before, we became witnesses to what had once taken place: war, momentous and private events, the landscape of foreign places, the face our grandparents had in their childhood were all offered by the camera for our inspection. Through the eye of the lens, the past became contemporary and the present whittled down to a shared iconography. For the first time in our long history, the same image

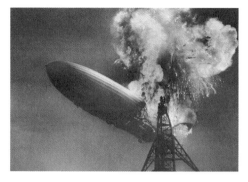

Sam Shere,
*The Burning of the
Hindenburg.*

(the burning of the *Hindenburg* or the tragic face of a migrant Californian worker), in all its exact details, could be seen by millions all over the world. News was not news unless there was a picture to back it. Photography democratized reality.

Or did it? "A photograph," writes the English novelist and art critic John Berger, "whilst recording what has been seen, always and by its nature refers to what is not seen."[10] Unlike a photograph, the world is not framed: the eye wanders and can take in what lies beyond the margins. We know the limits of a photographic document, we know that it shows only what the photographer has chosen to frame and what a certain light and shade have allowed him to reveal, and yet the factual mirroring that Pliny called a virtue overpowers such restrictions and hesitations. On the contrary: photography's claim to faithfulness has allowed (and allows still) for it to be manipulated without protest, a manipulation that electronic techniques have now made even more seamless. From Stalin's infamous removal of any *persona non grata* from his official pictures to the selective portrayal of war scenes in everyday reporting, from the artificially arranged representation of celebrities to the airbrushed portraits of fashion models, from cropped documentary scenes to abstract or fantastical compositions, photography allows, perhaps more than any other art, for manipulation and censorship to

Dorothea Lange,
*Migrant Mother,*
*1936.*

become an integral part of its own creative process. A piece of writing, a sculpture or a painting may suppress (does suppress) information from within the work itself, through the restrained hand of the artist, and also, on occasion, from without, through the restrictive hand of an official censor. But all these art forms — writing, sculpture, painting — deliberately define themselves as subjective, accept their own fictions, require in order to exist (as Coleridge pointed out) the audience's "willing suspension of disbelief." Photography however, though acknowledging the subjectivity of the camera, relies on our conviction that what we, the viewers, see was actually once there, that it took place at a certain precise time, and that *as reality* it was captured by the eye of the beholder. Any photograph, whether deliberately censored or unconsciously manipulated, whether expressly artificial (as in the work of Man Ray) or elaborately fake (as in the faux-stills of Cindy Sherman), and though it may offer itself as "fixed, rigid, incapable of intervention,"[11] wholly depends on this necessary deception.

In a brilliant short novel, *Indian Nocturne*, the Italian writer Antonio Tabucchi has a photographer describe the blown-up detail of a picture she has taken. It "showed a young black man, just his head and shoulders, a sports singlet with a commercial slogan, an athletic body, an expression of great effort on his face, his arms raised as if in victory; obviously, he's breasting the tape, in the hundred metres, for example." Then she describes the whole photograph. "On the left there's a policeman dressed like a Martian, a Plexiglas helmet over his face, high boots, a rifle tucked into his shoulder, his eye fierce under his fierce visor. He's shooting at the black man. And the black man is running away with his arms up, but he is already dead."[12] Every photograph (blown up, cropped, taken from a certain angle, lit in a certain way) misquotes reality.

In an attempt to avoid such "misquotations," the American photographer Edward Weston insisted on "visualizing" his subject beforehand (that is to say, he attempted to "see" his subject with the least possible interference), and he refused to crop his final prints. For him, the eye had to record as faithfully as possible whatever the natural world had to offer, without enclosing it in a visual comment; after the photographer had "visualized" the shot, nothing was to be altered if the resulting print was to be "truthful." Weston's codes essentially opposed, long before they were stated, the principles of postmodernism. "False fronts to buildings, false standards in morals, subterfuges and mummery of all kind," he wrote, "must be, will be scrapped."[13] He was wrong.

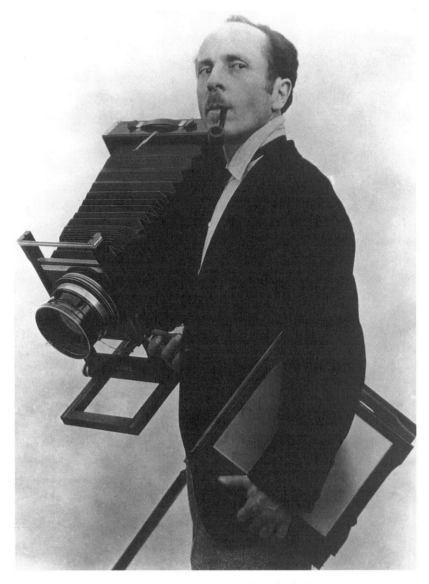

Tina Modotti,
*Edward Weston
with Camera.*

The group he formed in 1932 (which included Imogen Cunning-
ham, Henry Swift, Ansel Adams and others) was called "f.64," after
the small aperture of his lens, which allowed him to obtain a highly
focused image. Curiously, while Weston demanded absolute exactness
in his renditions of reality, he delighted in manipulating reality in
his private life. He enjoyed "subterfuges and mummery,"[14] disguises,
make-believe and elaborate fabrications. His sister remembered that as
a child, he enjoyed sitting stock-still on the curb with a rat on his head

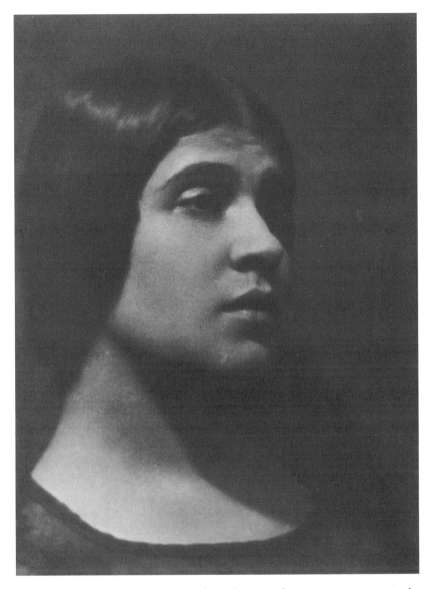

Edward Weston,
*Tina Reciting [VIII]*,
1924.

in order to surprise passersby when they saw his cap move seemingly on its own; later, as an adult, he was notoriously fond of dressing up in women's clothing.

In 1920, Weston met the actress Tina Modotti. Modotti had left her native Italy for America in 1913, at the age of seventeen, and become one of the stars of the local Italian theatre in San Francisco; shortly afterwards, she began what was to be a brief Hollywood career: her only major role was in a silent five-reeler, *The Tiger's Coat*,

Still from the 1920 silent film *The Tiger's Coat*, starring Tina Modotti.

made in the year she met Weston. They quickly became lovers, though both artists were married at the time (or so it was assumed, since Modotti's wedding to the eccentric Canadian-American poet Roubaix de l'Abrie Richey, who was to die of smallpox in Mexico a few months later, was recently proven to be fake, a means of mollifying Richey's straitlaced mother).[15] At first Modotti modelled for Weston, but soon she asked him to teach her how to become a photographer herself. Weston obliged. In a letter written several years later, on January 8, 1928, she confessed to Weston: "You don't know how often the thought comes back to me of all I owe to you for having been the one important being, at a certain time of my life, when I did not know which way to turn, the one and only guidance and influence that initiated me in this work I have come to love with great passion."[16]

California soon became too stifling for the couple, and they moved south, to Mexico. Here she blossomed, both artistically and politically. She became friends with several revolutionary artists — Diego Rivera, Frida Kahlo, David Siqueiros — as well as with many of the exiled revolutionaries from other Latin American countries.[17] Kenneth Rexroth, the American poet, described her as "a most spectacular person": "a photographer, artist's model, high-class courtesan, and Mata Hari for the Comintern."[18]

In the stark Mexican landscape, Modotti used the bright sunshine to create contact prints, placing the negative directly on sensitized paper and exposing it to light. In 1926, she began to use silver gelatin paper, which lent her work a warmer, more tactile impression. In the beginning, Modotti photographed architectural details and close-ups of flowers, like the arches of the Convent of Tepotzotlán and the sensuous opening of a calla lily, capturing stark effects of light and shadow, and drawing the viewer's attention to the rigour of natural geometrical forms. Seeing her intense, almost blank compositions drawn from popular Mexican architecture, her friend the French critic Jean Carlot argued that her "whitewashed adobe walls will be rediscovered in time as precursors of the minimalists."[19]

Soon, however, her attention was drawn not to the pure shapes
and patterns of light dear to Weston but to the Mexican people them-
selves, and she became more and more involved in political activism,
questioning a life that seemed to her boxed between the lens of the
camera and the prison of the darkroom. When Weston returned to
California in 1924, leaving the studio in Modotti's hands, she wrote to
him: "I cannot, as you once proposed to me — 'solve the problem of
life by losing myself in the problem of art.' In my case, life is always

Tina Modotti,
*Convent of
Tepotzotlán*, 1924,
silver gelatin print.

Tina Modotti,
*Calla Lily*, 1924–26,
silver gelatin
print.

struggling to predominate and art naturally suffers." Eerily echoing
Oscar Wilde's tragic dictum that he had put his talent in his work but
his genius in his life, she concluded: "I put too much art in my life . . .
nd consequently I have not much left to give to art."[20] For Weston,
Modotti was essentially a model, a woman's body to be photographed
or made love to, less a colleague than a clever pupil. For Modotti,
Weston and later lovers such as Diego Rivera were fellow artists. This
distinction is of the essence.

Many of her friends were members of the Communist Party; it
wasn't long before she joined the newly formed Mexican branch of the
International Red Aid, a Communist version of the Red Cross, founded
in 1922 to provide assistance to all those oppressed by political power,
no matter what their affiliation, and whose Central Committee
included personalities such as Albert Einstein and the French anti-war
novelist Henri Barbusse. Modotti's work for the Red Aid impinged on
her photography: a few months later, she was complaining that she was
producing less than one print a month.[21] In spite of the small output, by

1926 she was being recognized as "an exquisite artist of formative sensitivity"[22] and her art, compared to Weston's, as "more abstract, more ethereal, and even more intellectual" (this according to Diego Rivera).[23] Unlike Weston's, her artistic goal was now "to transform the tangible into the intangible, to transmute matter into ideology."[24] Modotti realized, as Susan Sontag was later to state, that "photographs cannot create a moral position, but they can reinforce one."[25] Modotti's moral position became crystal clear after her arrival in Mexico: she believed in the individual's right to a decent life; she opposed injustice.

Modotti's untitled photograph focusing on a man's feet and hands, taken around 1927, plainly exemplifies this new credo. What we see when we look at this grainy gelatin print is unequivocal: the sandalled feet of a Mexican peasant dressed in white working clothes, nails broken and skin embedded with dirt, while his hands cross over his knees and hold on to one another, strong-veined and old. Above the knees, the upper frame of the photo cuts off the rest of the man's body: the only other element in the picture is a glimpse of another man's foot and leg, barely visible on the left side, preventing the composition from becoming too comfortably symmetrical. I find this image inexplicably moving.

The representation of feet changes meaning throughout the long history of art. In the early Middle Ages, whenever feet are shown in equal positions, side by side, they lend the character majesty and equilibrium, suggesting wisdom and virtue.[26] But because feet also touch the dust of the earth, they symbolize humility and willing servitude as

An illumination from the Ingeborg Psalter, showing Jesus as he washes his disciples' feet.

well, as illustrated, in Christian iconography, in depictions of Mary Magdalen washing Christ's feet with her tears, and of Christ Himself washing His disciples' feet at the Last Supper. More important, feet represent our covenant with the earth, the promise of belonging somewhere, however far we might stray.

Feet claim the land under their soles, assert possession. The dispossessed Oedipus (his name means "Swollen Foot") had his feet pierced as a child by order of his father, who feared the son would kill him, and Oedipus was strung high above the earth that was no longer his to inherit. The Spanish conquistador Hernán Cortés tells that the feet of the Aztec emperor, the great Montezuma, were not allowed to touch the ground outside the palace because anything they touched immediately became his property.[27] This tradition was also observed within the Ottoman Empire: after the Muslim conquest of Constantinople in 1453, it became the custom of Mehmet the Conqueror, respectful of freedom of worship within his newly recaptured city, always to meet the Greek patriarch at the door of the Greek church, not for fear of polluting himself by entering an infidel place of worship, but for fear of consecrating it, since his followers believed that wherever Mehmet set his feet became at once hallowed ground, and they would have used his entry as an excuse to turn the church into a mosque.[28]

Our feet assert our presence. In a *Madonna of Loreto*, finished in 1605 in Rome, Caravaggio depicted a strong, youthful Virgin holding up her Child for the veneration of two pilgrims: the pilgrims are old and visibly poor, their filthy clothes and large gnarled feet thrust into the viewer's face at the bottom right of the canvas, clearly intended to offend by claiming their right to be in the presence of the sacred. Feet come to the down-and-out painter Gulley Jimson, the hero of Joyce Cary's novel *The Horse's Mouth*, as an epiphany, jumping out at him as he conceives the masterpiece he will paint on the rich man's wall, a picture of humankind attending the *Rising of Lazarus*: "a yellow pair, long and stringy, with crooked nails; then a black pair, huge and strong, with muscles like lianas; a child's pair, pink and round, with nails like polished coral; an odd pair, one thick and calloused, with knotty toes curled into the dust, one shrunk and twisted, its heel six inches from the ground, standing on its toes, a cripple's feet, full of resolution and pain; then a coffee-coloured pair with a bandage, an old woman's feet, flat, long, obstinate, hopeless, clinging to the ground with their bellies like a couple of discouraged reptiles, and

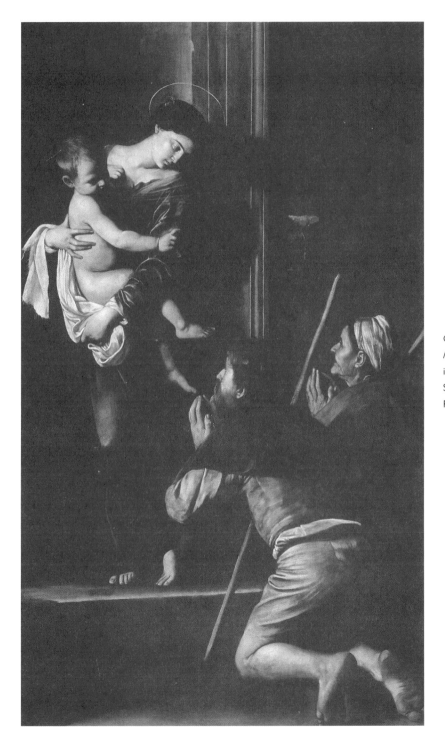

Caravaggio, *The Madonna of Loreto*, in the church of Sant'Agostino, Rome.

gazing at the sky with blind, broken nails; then a pair of Lord's feet, pink in gold sandals with trimmed nails and green veins, and one big toe raised impatiently."[29]

When Modotti chose to portray in loving detail the pair of ancient, world-weary feet, she was (consciously or not) placing her Mexican peasant in a long tradition of earthbound sufferers and conquerors, some illustrious and many (like her peasant) anonymous, all profoundly human in their attachment to the dust to which, we are told, we must return.

The Christian overtones of Modotti's image are deliberate: rural Mexico at the time was overwhelmingly Catholic, though its beliefs were (and still are) deeply rooted in Native tradition. In 1926, reacting to a law that violently enforced the religious restrictions of the 1917 Constitution, the peasants of central and western Mexico staged a massive insurrection whose battle cry was "¡Viva Cristo Rey!" and whose iconography associated the revolutionaries with the sandalled soldiers of Christ. The leaders of the insurrection asserted the peasants' right to worship and, at the same time, their ownership of the land they worked.[30] For the Mexican peasants, for whom the teachings of Christ blended almost indistinguishably with many of the ancient Native traditions that the Spanish conquistadores had not entirely managed to wipe out, the doomed feet that appear in the gospel story (washed in tears by Mary Magdalen and nailed to the Cross by the Romans) were foreshadowed in a legend told in the annals of Nahuatl literature, in which the feet of a young man are compared to those of a hunted deer, praised for their speed and yet broken in the chase. "Are you a deer," the narrator-poet asks the man, "not to know where you are going? You have been granted the gift of seeing the road you must take: you alone will be to blame if you don't follow it."[31] The young man's feet, firm on the earth, give him authority over his own life, a responsibility that he cannot ignore, even in the presence of imminent death. The feet of Modotti's peasant have this same self-assertive quality. Unequivocally set on the ground, the right foot slightly rising toward the viewer from a small pool of shadow, these feet make no apologies, offer no excuse for their being.

The photographs she took at that time — the ancient feet, the close-up of a pair of worker's hands clutching the handle of a spade, her portraits of peasant women and sad children, her images of people waiting outside pawnshops or lying in the filthy streets, her stills of workers' pickets and of political rallies — display for us a reality that

Detail from Diego
Rivera's mural
*Distributing Arms*,
showing Frida
Kahlo in the
centre and Tina
Modotti in the
right-hand corner.

Tina Modotti,
*Mexican Peasants
Reading* El
Machete, 1928.

includes its own commentary. Modotti has no need for the brutality of
certain documentary photographers to elicit the viewer's sympathy or
"reinforce" a moral position. It is the quiet exactness of her observa-
tions that renders them convincing, passionate, eloquent.

The American critic Geoffrey Hartman, commenting recently on the surfeit of brutal images on television newscasts, warns of the danger of being entertained by "useless violence" (a phrase coined by the Italian novelist Primo Levi to describe Nazi brutality). For Hartman, the hyperrealist imagery with which popular culture bombards us "not only makes critical thinking more difficult" but both fosters and demolishes an illusion: "that reality could be an object of desire rather than of an aversion overcome."[32] This wisdom also applies to the "hyperreality" of Modotti's images. Unlike most television images, her photographs both denounce the misery of her subjects and embrace their humanity as common to ours, achieving what Hartman calls "thinking with grief," an attitude that does not allow for either absence of meaning or for meaning too rapidly assigned. The image of the peasant's hands and feet becomes, framed by Modotti's camera, a kind of *memento mori*, an object for reflection in which we, far from the subject's suffering, are nevertheless reflected.

But merely seeing and portraying the social reality of Mexico's people failed to satisfy Modotti. She needed a clearer, more immediate action, a task in which she would not only be "a witness." Giving up photography, she knew, was "a sacrifice and it hurts me to even think of that."[33] To Weston she wrote: "I cannot afford the luxury of even my sorrows today — I know well this is no time for tears; the most is expected from us and we must not slacken — nor stop halfway — rest is impossible — neither our consciences nor the memory of the dead victims would allow us that."[34] Finally, in 1929, after months of trying to stop her political activities, the Mexican police managed to frame her for the murder of a Cuban revolutionary who had also become her lover, and the Mexican press raised a public scandal by publishing nude photos of her (taken by Weston) in order to prove, through the very medium she had used to denounce social injustice, that she was "a woman of easy virtue."[35] Bullied by the police and hounded by the press, Modotti was expelled from Mexico. Denied entry into the United States, she travelled to Berlin and to the Soviet Union, where she worked for the Communist Party on clandestine "rescue missions." In Berlin, she took a few last photographs of pale, prim children and obese elderly couples at the zoo. Then, after she settled in Moscow, she decided not to take any more. The poet Pablo Neruda, who met her a few years later, said that "she had thrown her camera into the River Moskva and sworn that she would dedicate her life to the Party's

humblest tasks."[36] In 1936, she left for Spain, where she assisted the Republicans, and became friends with André Malraux, Ernest Hemingway and John Dos Passos. The war photographer Robert Capa tried to encourage her to take up her camera once more. She refused.[37] After the fall of the Spanish Republic in 1939, disenchanted with the squabbles within the Party, she returned to Mexico City under an assumed name. Three years later, she died in a taxi in unclear circumstances, steps away from the apartment she had rented. Though she was probably suffering from heart disease, there were wild rumours that she had been murdered by her ex-comrades, angry at her disillusionment with Communism. She was only forty-five years old.

Her body was displayed in an open casket at La Moderna, a paupers' funeral parlour, and from there driven to a fifth-class cemetery plot in the Panteón Dolores. Although, since her return to Mexico, she had no longer considered herself affiliated to the Communist Party, her bier was draped with a cloth on which the hammer and sickle had been painted, and to the cloth was pinned a portrait Weston had taken of her many years earlier, when they were both still in California.[38] The artist who had been, throughout her career, so deeply concerned with remaining the sole mistress of her life and her art would no doubt have appreciated the irony of having a political emblem that was no longer hers and a photograph taken by someone else crowning her departure.

Pablo Neruda composed an elegy in her honour, now engraved on her tombstone. It contains these lines:

Sister, a world advances to the place you are going,
The songs from your mouth spring forward every day
From the mouths of the wonderful people you loved.
Your heart was brave.[39]

Lavinia
Fontana

The
Image
as
Understanding

*Man is only man on the surface. Lift the skin, dissect:*
*here the machineries begin. Then you lose yourself*
*in an unfathomable substance, alien to everything you know*
*and yet of the essence.*

Paul Valéry, *Cahier B*

Lavinia Fontana,
*Portrait of Tognina.*

TO A MODERN EYE, the figure hovers on the edge of fiction. Against a darkened background, a young girl's round and slightly pouting face draws you to the centre of the canvas: pink full lips and baby-fat cheeks perch over the delicate lace collar of her embroidered dress, ink-black eyes stare back at you unabashedly. She is holding up a letter for you to read, but it is not the letter or the lips or the eyes or even the sumptuous dress that holds your attention, but the layer of hair that covers her skin as if she were a species of wild animal. The contrast between the aristocratic setting and the wolf-like features seems scandalous: the shaggy face rising from the satin or silk, the frail garland of flowers sitting delicately on her head.

Who is she? She holds up a letter of introduction, for our inspection. Though several words can no longer be read, the letter lends her a voice across the centuries:

From the Canary Islands, was brought
To Lord Henry II [?] of France
Don Pietro, the wild man.
From there he settled at the court
Of the Duke of Parma, as did I [?],
Antonietta, and now I am
At the household of Signora Donna
Isabella Pallavicina, Marchioness of Soragna [?].[1]

Who is the painter? Until 1577, she signed her name *Lavinia virgo Prosperi Fontana filia*, that is to say, Miss Lavinia, daughter of Prospero Fontana. That year, we know she married one of her artist father's other pupils, a dull young Bolognese called Giovan Paolo Zappi. From

Tognina
Gonsalvus.

then onward she signed herself with her full married name, Lavinia Fontana De Zappis.[2]

For the hairy girl (as for the woman artist), the documentation available is sketchy and scattered. As far as can be patched together from a few other portraits and a number of brief references, the girl's name was Antonietta Gonsalvus (or Gonsalus), but she was better known by the diminutive of Tognina. She was born in the Netherlands in 1572, the year when the Dutch began their war of liberation from Spain. Her father, Petrus Gonsalvus, from the Canary Island of Tenerife, suffered from a skin disease known as *hypertrichosis universalis congenita*, which caused hair to grow all over his body, including his hands.[3] As a child, he was taken to Paris and put on display at the court of Henry II, where he "unlearned his savage customs, and learned fine arts and to speak Latin."[4] Sometime before his twentieth birthday, he met and married a pretty Dutch woman with whom he had four children, all of whom inherited the same disease. After spending some time in Namur, at the court of Margaret of Austria, Regent of the Netherlands and Duchess of Parma, the family moved to Parma in 1583.[5] It was about that time, in the house of the Marchioness of Soragna, that Lavinia Fontana painted Tognina's portrait.

Tognina and her family were painted several times. The first known portraits of the Gonsalvus clan were in all likelihood executed after 1576. A series of four paintings by an anonymous Bavarian artist (now in the castle of Ambras, near Innsbruck) show Tognina aged five or

Tognina's father.

Tognina's younger brother.

six, her mother and father, and her younger brother aged two or three. Except for the mother, who sits against a black velvet background, each member of the family is portrayed in front of a rock or cave, drawing attention to the contrast between their bestial faces, features of nature untamed, and their elegant dresses, emblems of civilization. A few years later, in 1582, in Munich, the artist Joris Hoefnagel, using the Ambras paintings as his model, drew them in pairs (Tognina and her brother, Petrus and his wife), in two decorative medallions for an album on the four natural elements: earth, air, water and fire. The Gonsalvus family were included in the chapter on fire, the wildest of the four, the element that, according to Aristotle, lends humans their irascible nature. Both in the Ambras painting and in the Hoefnagel copy, Tognina seems sullen or angry: we can guess at a frown under the hair on her forehead, and at something dreadful about her expression, with more than a touch of the cornered and menacing wolf about her. Her lupine eyes are blazing: in his *Natural History*, Pliny the Elder noted that "in Italy people believe that to see wolves is dangerous, and that if a wolf looks at a man first it renders him momentarily speechless."[6]

Tognina's mother.

Two medallions (*Animalia Rationalia et Insecta [Ignis]*: Plates I and II) by Joris Hoefnagel, portraying the Gonsalvus family.

About the same time, probably in 1580, under instructions of the melancholy emperor Rudolph II who, cloistered in his palace in Prague, had assembled around him many of the finest artists and scholars of his day to bring him images of the world outside, the court painter Dirk de Quade van Ravestyn[7] painted the Gonsalvus couple and two of their children for an illustrated catalogue of the emperor's collection of curiosities. The catalogue, which records many of the fantastical and wonderful objects with which Rudolph sought to dispel his

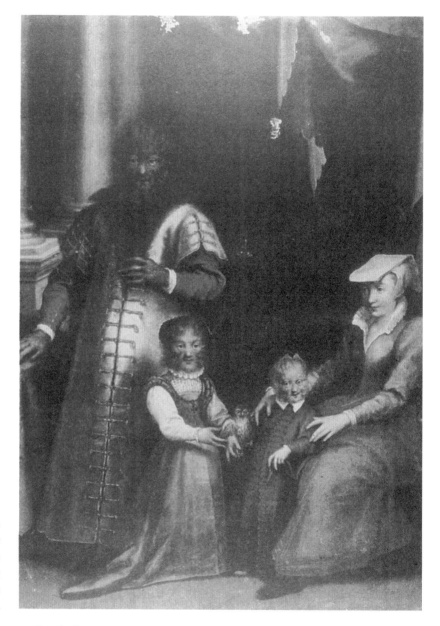

The Gonsalvus family by Dirk de Quade van Ravestyn, in Rudolph II's *Bestiary*.

melancholy, attempts to bring order into the disorder of the universe: specimens of monstrous human beings — the Gonsalvus family — naturally lead this sampler of the "errors of Nature." Here, in Van Ravestyn's rendering, Tognina's demeanour is less aggressive. She and her brother hold between them a small pet owl (*athene noctua*), and it is the owl's bewildered, somewhat vacant expression that is reflected in

Tognina's face: the same round eyes, the same radiating circle of feathers or hair brushed outward. If the Ambras portrait depicted her as a wild animal caught in front of its lair and dressed up like a performing cub, the image in Rudolph II's bestiary shows her now living in captivity, incongruous against a background of green curtains and marble columns, staring back at the viewer with the dazed look of a caged animal.

It is certain that for the vast majority of those who saw them, the members of the Gonsalvus family were an example not of the wonders but of the horrors of nature, God's bungled creations in which the angelic had given way to the demonic and through which the baser, bestial essence of humanity was revealed — monsters of the kind the celebrated French surgeon Ambroise Paré, in his published collection of monstrosities, called in 1573 "examples of the Wrath of God."[8] Before the Fall, when nature was whole, Adam and Eve's innocence had been made explicit in their smooth skin; they had no navel, the signature of the body; they were, in St. Jerome's phrase, "virgins in Paradise."[9] After the Fall, when nature cracked open, God Himself made them "coats of skins"[10] to remind them what side they had chosen. An early medieval commentary of the Bible adds that as a punishment, God deprived Adam of six things: the first was "splendour of visage."[11]

As aberrations, then, the Gonsalvuses were much sought after specimens, and scientists throughout Europe strove to make their acquaintance. Stopping over in Basel on their way to Parma, the mother and two of the children were examined by a doctor, Felix Plater, who also had their portrait made (now unfortunately lost);[12] a year or so later, the father, the eldest brother, Tognina and her younger sister were examined by the famous Bolognese scientist Ulisse Aldrovandi.

Born in Bologna in 1522, of an aristocratic lineage, Aldrovandi studied mathematics, law, philosophy and medicine. While he was still a student, his progressive views led to his arrest for heresy, and he was sent to Rome, where he was able to exonerate himself, probably due to his family connections. Back in Bologna, and as a result of his lectures in which he presented a systematic study of natural history, he was made full professor at the university at the age of thirty-nine. Under the auspices of Pope Gregory XIII, who also gave him financial aid for his scientific publications, he was appointed inspector of drugs and pharmacies, and wrote an official *Pharmacopoeia Antidotarii Boboniensies Epitome* (1574), which became the model for such pharmaceutical books. With his extensive collection of rarities and medical

wonders, he established a biological museum and Bologna's first botanical garden, which, after his death in 1605, he left to his native city.

Of Aldrovandi's many scientific writings, only four volumes appeared in his lifetime. His students published several others posthumously, from a portion of his manuscripts: among them was an impressive *History of Monsters*,[13] in which he describes, in scientific terms, a vast collection of prodigies real and imaginary. Page 16 of the quarto volume shows an engraving of Petrus and his eldest son; page 18 depicts Tognina's younger sister, aged eight; on page 17 is a portrait of Tognina herself, aged twelve.

Portrait of Tognina, in Ulisse Aldrovandi's *History of Monsters*.

To Aldrovandi and his circle, the Gonsalvuses were exceptions to the rules of nature and, as such, of great scientific interest, since through these negative examples a scientist could best learn that which constitutes the main. Aldrovandi's concise Latin descriptions accompanying the woodcuts in his *History of Monsters* list the unique features of his subjects (the varying degrees of hairiness, for instance, and their ages) but give no indication of their behaviour or response. Only one line, written at least ten years after the woodcuts were commissioned, lends Tognina a moment of personal history: "News has just reached Parma, at the august court of the Farnese, that the young girl with the hairy face, who had gotten married, has given birth to several hairy children."[14]

Tognina was exhibited in anatomical theatres, presented at refined gatherings, invited to palaces and villas. What did the audience, the people of Bologna and of Parma, Munich and Basel see when they looked at her?

Dressed as she was in the finery of the courts she visited, her arms, legs and torso hidden except for her soft and (unlike her father's) hairless hands, it was certainly Tognina's face that caught and scandalized the eye. The face was for Aristotle (whom the Renaissance scholars so meticulously studied) the seat of humanity's finest features, as the head was its "noble crown." In *De partibus animalium* he writes: "If

we consider high and low, then that which is superior and most noble tends to be up high; if we consider front and back, it tends to be up front; if right and left, on the right."[15] By our faces we are judged.

What shocked Tognina's viewers was that her fantastical face had a visible and tangible reality wonderfully unlike their own; there in front of them, made of skin and blood, was a live link to what lay outside the borders of civilized humanity. If the human face was (as the Church taught) the chapel of the body's holy edifice, then Tognina's face, overgrown with hair, was like the chapel's sacred ruins engulfed by the wild jungle, an example of evil nature encroaching on human civilization, a place for those who saw her to recognize their own ambivalent being, both bestial and human, revealed as in a witch's mirror.

In 1586, Giovanni Batista Della Porta, in his celebrated treatise on human physiognomy,[16] declared that any judgment we might make of a person, when looking at that person's face, must be based on universal or archetypal notions. "The face represents the whole of a person's features, just as it represents the movements, and passions, and customs," wrote Della Porta. "Therefore, it is possible to judge it at any given time, but only after the particular emotions and passions of that soul have subsided." There exists (Della Porta seems to imply) an acquired and common social language that enables us to read a face much as we read a book, a language that has certain traits (which animals share with humans) denoting specific characteristics identifiable by any man or woman. For Della Porta, who helpfully provided a series of animal and human comparisons, a face with canine features, for instance, always denotes the negative qualities of the human soul, qualities borrowed from their animal counterparts: "as annoying and unpleasant as a dog," "as evil as a hyena," "as deceitful as a fox," "as harmful as a wolf." Some fifty years later, the French artist Charles Le Brun would sketch a long series of contrasting animal and human faces, including a man with wolf-like traits that gave him a cunning and deceitful air.[17] Already in the early fourteenth century, Dante had condemned to the eighth circle of his Hell those guilty of "the sins of the wolf":[18] seducers, hypocrites, conjurors, thieves and liars.

But a person need not become a wolf (as the ancient werewolf legend has it) in order to be wolfish. Jean de Sponde, in his *Commentary upon Homer* of 1583, writes that "the general opinion is that the human frame cannot be metamorphosed into the animal bodies of beasts: but most hold that although there is no real shape-shifting, the Devil can so cheat

The *Wolf-Man*, in
Charles Le Brun's
topology.

and deceive men's eyes that by his power they take one form, which
they seem to see, to be quite another thing from what it actually is."[19]

No doubt Tognina's face appeared to have such animal qualities, to
embody a transgression of human boundaries, even to overreach the
limits of Della Porta's emotional vocabulary. Though every face (as
Della Porta noted and Le Brun illustrated) has animalistic features that
help us identify its owner's secret defects and virtues, Tognina's face
seemed to exceed the common mortal share and to blur the definitions
of human and inhuman. For the early fathers of the Church, the distinc-
tion between humans and animals was trenchant, a division between
those creatures with souls, made in the image of God, and all others,
soulless and savage.[20] It was St. Francis who, in the early thirteenth cen-
tury, brought the animal kingdom closer to the human realm by calling
"all creatures, no matter how small, by the name of brother or sister,
because he knew they had the same source as himself."[21] For Francis,
animals were not wild because they were inferior to us but because they
had rebelled, in brutish indignation, against Adam and Eve's first sin.
Even wolves were capable of goodness, as when Rome's legendary she-
wolf suckled Romulus and Remus,[22] or as Francis himself proved when
he converted the fierce wolf of Gubbio, rendering him as meek as a
lamb. A few decades later, however, the practical St. Thomas Aquinas
decreed animals were indeed soulless, and graded them according to

their utility to humans. Wolves, bears and foxes, hairy beasts useless to human comfort, were demonic.

Human fear of wolves and their hairy kin is a very old and ambivalent fear. In 1914, Freud famously described the case of the patient he called "the Wolf Man," a disturbed young man who had dreamed as a child of a tree full of white wolves staring at him through his bedroom window.[23] Though the wolves did not look threatening but rather appealing, "more like foxes or sheep-dogs," the boy woke up screaming, "in great terror, evidently, of being eaten up." Freud suggested that his patient's animal terrors had replaced a fear of the father, whom the child sexually desired and by whom he feared being killed. Only grudgingly did Freud concede that the equivocal emotion "expresses itself by the help of the fairy tale," which provides the dream's ancient iconography of death and lust. The fierce "evening wolves" of the Old Testament,[24] the "ravening wolves" of the New,[25] Chaucer's "deueles wolues that stranglen the sheepe of Ihesu crist,"[26] Charon, Hell's ferryman, dressed in a wolf's skin,[27] speak of our deathly dread.

Freud's Wolf Man's dream, as drawn by himself.

*Werewolf Attacking a Man*, sixteenth-century German woodcut.

The Greek epigrammatist Strato mocking the wolf-like older man who preys on the "lamb-like" son of a friend,[28] Juvenal in second-century Rome depicting greedy whores as "painted she-wolves,"[29] the thirteenth-century word "*louve*" (or "she-wolf") used to describe lustful women in the allegorical poem *Le Roman de la Rose*,[30] the word for brothel in Latin, *lupanarium*, meaning "the place of wolves," Pliny's account of hair from a wolf's tail used as an aphrodisiac,[31] the modern term "wolf" to describe a womanizer — all draw on the wolf's erotic attraction. "The Seven Little Goats" (whom the wolf killed) and "Little Red Riding-Hood"[32] (who "undressed herself and went into bed" with the wolf) echo both sides of our response to the wolf and his coat of hair — and, consequently, our response to Tognina's hairy features.

Fifteenth-century woodcut of Mary Magdalen in Conrad Fyner's edition of Jacobus de Voragine's *Golden Legend*.

Not all hair on the human body is read equally. Length and texture, place and surface, sex and age denote different and even contradictory meanings. Hairiness can stand for innocence and humility, as in the long hair that grew to cover the nakedness of the repentant Mary Magdalen, and for devilry, as when St. Jerome translated the demons in Isaiah as *pilosi*, the hairy ones, in the Vulgate version of the Old Testament.[33] A head of hair can denote beauty or coarseness, meekness or power, sensuality or holiness. The Egyptian pharaohs shaved their heads as a symbol of authority. Buddhist monks do so as an emblem of holiness. The shaved head of an ultra-Orthodox Jewish woman is meant to curb her attractiveness to men other than her husband. Skinheads display shaved heads as sexually and politically aggressive markings. After World War II, women who had collaborated with the enemy had their heads shaved as a mark of humiliation. Some Hindu fakirs never cut their hair, as a sign of devotion. Venetian prostitutes let their hair grow to inordinate lengths in order to be more seductive. Lady Godiva's hair became (like that of Mary Magdalen) a sign of modesty, covering her naked body on her ride to Coventry. In the eighteenth century, Alexander Pope's *Rape of the Lock*[34] parodied the amorous conventions that held the beloved one's hair as worthy as a holy relic.

Unlike a head of hair, a body of hair can waken, in those confronted with it, the fear of crossing back to the animal realm where they might lose their mind among the brutes; at the same time, the hairy body has the dangerous appeal of unbounded physicality. In medieval iconography, the punished king Nebuchadnezzar, who was condemned to "eat grass as oxen, and his body was wet with the dew of heaven, till his hairs were grown like

*St. John Chrysostom as a Wild Man*, a fifteenth-century woodcut in Conrad Fyner's edition of Jacob de Voragine's *Golden Legend*.

eagles' feathers, and his nails like birds' claws,"[35] was commonly represented as a wild man, hair covering his body as a sign of his newly

Early seventeenth-century French woodcut illustrating the story of Valentin and Orson.

acquired brutishness. The figure of the wild and hairy man, innocent and also dangerous, has even earlier sources: in the most famous of Babylonian epics, Gilgamesh, the civilizer, meets Enkidu, the uncivilized and hairy beast-man, and what begins as a fearful encounter ends in a loving friendship that enlarges the character of the hero, rendering his masculinity complete, strength and intellect combined.[36] Gil-

gamesh's baser self echoes throughout the ages through changing sexes and stories: the *valet sauvage* in Chrétien de Troyes's *Perceval*,[37] the bear-like brother in the late medieval romance "Valentin et Orson,"[38] the wild woman known as Raue Else in the thirteenth-century German epic *Wolfdietrich*,[39] the love-lorn savage in Diego de San Pedro's fifteenth-century *Cárcel de Amor*,[40] the kind-hearted wild man in Spenser's *Faerie Queene*,[41] the Beast in Mme Leprince de Beaumont's "Beauty and the Beast"[42] (who in Jean Cocteau's 1946 film[43] acquired, over the traits of

Jean Marais in Jean Cocteau's film *La Belle et la Bête*.

the actor Jean Marais, Tognina's face) — all were redeemed from their wildness by the civilizing affection of a man or a woman, the threat of death overcome by the power of love.

The wild man lived beyond the city walls, outside the body politic; but the body within, the civilized body, also had its own wilderness to explore. In its joyful rediscovery of this private body, secreted away after the days of Greece and Rome, the Renaissance rendered visible the parts that early medieval sensibility had left hidden. The naked human form, allegorized in medieval vanities as *memento mori*, returned to inhabit canvases and marble in its own right, and the body's private parts, condemned to shame and therefore excluded from cultured language, were called back from iconographic and linguistic exile. The body's landscape was lit up again — especially the mysterious female body. Men began once more to explore women's geography with its wild caverns, soft mountains and secret forests, where, according to Lord Herbert of Cherbury, "Two alabaster pillars stand, / To warn all passage from that land; / At foot whereof engraved is / The sad *Non ultra* of man's bliss."[44]

In 1559, in *De re anatomica*, the Venetian doctor Renaldus Columbus announced that he had discovered a landmark of this *Non ultra* and given it the name of clitoris (though the verb *kleitoris*, meaning "to touch the pudenda lasciviously," appears as early as the second century, in a text by Rufus of Ephesus).[45] In a somewhat self-congratulatory mood, Columbus explains: "If it is permissible to give names to things discovered by me, it should be called the love or sweetness of Venus. . . . And this, most gentle reader, is that: pre-eminently the seat of woman's delight."[46] Though no doubt women, in spite of male unawareness, had long been cognizant of the clitoris's existence and had given it one or several names (just as the natives of America had long known and named the land the other Columbus had "discovered" a century earlier), Renaldus Columbus's "scientific" exploration reflected his century's diminishing reluctance to look behind the skins God had given His fallen children and see the hidden groves in the antipodes of Aristotle's "noble crown."[47] (Three centuries later, in 1866, Gustave Courbet painted for the Turkish collector Khalil Bey a naked woman covered above her breasts with a sheet so that, faceless, she became her

Gustave Courbet,
*The Origin of the
World.*

The lovely front
and hideous back
of Lady World, on
the facade of
Worms cathedral.

body's landscape: legs apart, her sex topped with a dark reddish copse of hair, open to the viewer in what the Spanish call "a vertical smile." For Courbet, this was the other, the hidden, face.)

Some three or four decades before Columbus's book was published, there appeared in France a new poetic form, the *blason*, a lyrical description of one of the parts of the body. Together with the traditional features for which the beloved had been praised in troubadour poetry — the face, the hands, the neck, the eyes, the mouth and teeth — there emerged now the *cul* and the *con* — the ass and the cunt. A sixteenth-century anonymous *blason* extolling a maiden's *con* describes it as a "gentle garden ... dressed in rich fleece/ Of fine golden hairs in its true season."[48] (In contrast, few *blasons* describe the beauty of the male body, which led the fiery poet Louise Labé to ask ironically, "What height makes a man venerable? What weight? What hair? What colour?")[49]

The *blason* sang the body of divine proportions. But too far beyond or below these ideal measurements and hues, the human figure became a monster: too big or too small, not enough arms or legs or too many, too fat or too hairy. A Babylonian treatise of the third millennium B.C. divides monsters into monsters by excess, monsters by default and double monsters.[50] Excess could also mean acquiring features that did not normally belong on a face. The bearded women of circus fame had several celebrated ancestors. One such prodigy was painted in Naples by Jusepe de Ribera in 1631.[51] Her name was Magdalena Ventura, and it was rumoured that after she got married, she grew a beard overnight, a feature that apparently (to her husband's annoyance) drove men wild

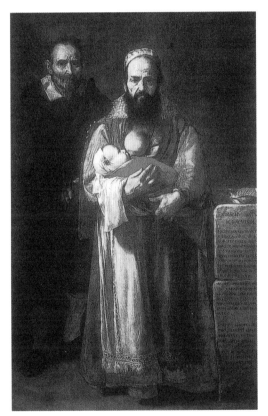

with desire. In Ribera's painting, Magdalena is shown in all her grim beauty, one breast bare, nursing her infant child, while her husband (also bearded) stands behind her, a duplicated image that underlines her monstrosity, her appropriation of a patriarchic feature. In the medieval leg-end of St. Wilgefortis or Uncumber, this appropriation was regarded as a divine gift. Unwilling to marry the heathen groom her father had chosen for her, the Christian maiden Uncumber prayed to God, who caused her hair to grow all over her face and body, thereby mak-

Jusepe de Ribera, *Portrait of Magdalena Ventura.*

ing her unattractive to her suitor (who obviously did not share the taste of Magdalena's admirers).[52]

From what we can tell, Tognina was neither masculine nor unattractive. Tognina's face — the visible, the permissible, the nobler part of her body — was, like that of Magdalena or Uncumber, monstrous

by excess but strangely appealing. Those who met her, instead of being merely repulsed, probably attempted to read her features as they would normally read those on any face. It must have proved a frustrating task. In one of the many random notes he wrote throughout his life, Leonardo da Vinci remarked: "It is true that the face shows indications of the nature of men, their vices and temperaments. The marks which separate the cheeks from the lips, the nostrils from the nose, and the eye-sockets from the eyes, clearly show whether men are cheerful and often laugh. Men who have few such marks are men who engage in thought. Men whose faces are deeply carved with marks are fierce and irascible and unreasonable. Men who have strongly marked lines between the eyebrows are also irascible. Men who have strongly marked horizontal lines on their foreheads are full of sorrow, whether secret or admitted."[53] Such readings would be almost impossible on a face where most of the traits were hidden by shaggy hair.

Whether imagined or not, certain emotions *seem* readable in the portraits made of Tognina. It is said that when Greta Garbo in the unforgettable final shot of *Queen Christina*[54] was meant to stare into the open sea, full of conflicting feelings, the director Rouben Mamoulian's only instructions to her were "Think of nothing." In that emotional vacuum, in the empty canvas of that perfect face, we, the viewers, lose ourselves. Tognina's face is the contrary of Garbo's: it is its own covering, skin over skin, hiding something perhaps too awful to be revealed behind a face almost too terrible to see. In the portraits by Van Ravestyn, by Hoefnagel, by the anonymous Bavarian painter of Ambras, there is something disturbing, something between fear and anger, something monstrous against which not Tognina but the viewer is defined.

If, before the reinvention of Arcadia, society and its cities stand for civilization, and the wilderness around it — forests, deserts, mountains — for that which is inhuman or alien, then who are these creatures, such as Tognina, who cross over from their savage place of

Greta Garbo in
*Queen Christina*,
1934.

birth and breach with their wild selves the city walls? Tokens of the
world beyond, exemplars of the dangerously foreign, marvels from
places subject to nature's whimsical laws, they are the irruptions that
serve to remind us, as a society, of what we have chosen to relinquish
in order to survive. Perhaps because of this, St. Isidore called mon-
sters "necessary miracles."[55] The historian David Gordon White
has chronicled the myths of the dog men worldwide, creatures with
canine heads or faces who come to us (like the primitive wolf who
first approached humans in an exchange of hunting against shelter)
from the edge of wonder. The literatures of Egypt, India, China and
medieval Europe, and further ahead, in our time, from Anubis to the
werewolf, abound with their examples.[56] Demons, barbarians, errors

The inhabitants of the Angaman Islands, according to a fifteenth-century French manuscript of Marco Polo's *Book of Wonders*.

of God or nature, wild men and wild women, these creatures from outside civilization are the others, the strangers, those who are not us, a shape of our shadow. "Ultimately," says White, "we cannot understand what it means to be human without having some experience of the inhuman." And, I would add, without recognizing in what might seem inhuman a common, perhaps deeper, humanity.

When Lavinia Fontana painted the twelve- or thirteen-year-old Tognina, she herself was in her early thirties and had acquired a certain reputation as portrait painter among society ladies who liked her choice of colours and her meticulous eye for clothing details. As a contemporary chronicler said, perhaps with a touch of envy: "They all want her to paint them, and make a pet of her."[57]

Lavinia Fontana was born in 1552, the daughter and pupil of the painter Prospero Fontana. When Prospero was still a young apprentice, he had travelled to Rome with an introduction to Michelangelo, and the old master had generously presented him to Pope Julius II. Impressed by his talents, Julius made him "Pittore Palatino" and allotted him a pension of three hundred *scudi* a year.[58] He stayed on in Rome until his fortieth birthday; then he returned to Bologna and married. According to contemporary gossip, in Rome he acquired a smattering of classical learning, which made him cut, in the more reserved Bolognese society, a somewhat pedantic figure. But such criticism apparently did not trouble him, and Prospero became the centre

A seventeenth-century Chinese drawing of an English sailor as "the Other": hairy, exhaling the smoke of his pipe, with tattoos on his chest and a beak-like nose.

of an intellectual and artistic circle that met regularly at his house.[59] As soon as she was old enough, Lavinia was permitted to attend.

Prospero's return to his native Bologna conveniently coincided with the city's renaissance. Around 1560, Carlo Borromeo, nephew of Pope Pius IV and papal legate to Bologna, began building a new home for the University of Bologna, which was becoming too small to hold the institution's growing prestige, and also, in the process, providing work for the city's poor. Both the Bolognese senate and many of the university professors opposed the project, arguing that the expense was too great and that the chosen site would render impossible the completion of the adjoining Church of San Petronio. In spite of the opposition, a papal bull gave authority for the building in 1561, and architects, artists and craftsmen flocked in from the other city-states. Two years later, the building was quickly completed — so quickly, in fact, that at

the opening ceremony the officiating bishop quipped, "*Dixit et factum est*" (said and done).[60] The poet Torquato Tasso was among its first students. Pius V, elected pope in 1566, died in 1572, and Ugo Buoncompagni, the pre-eminent Bolognese cardinal, succeeded him to the throne, taking the name Gregory XIII. Under his reign, Bologna would become one of the greatest cultural centres in Europe.[61]

In 1577, the year of her marriage, after having completed only a handful of small portraits and a few sacred subjects, Lavinia Fontana painted her first self-portrait, which she still signed with her unmarried name.[62] It shows her at the spinet, dressed in a soft red gown and a white lace-collared blouse, an empty easel far behind her by a sunny window, while at her back a maid keeps open a book of sheet music.

Lavinia Fontana,
*The Artist at the*
*Spinet*, 1577.

The twenty-five-year-old Fontana holds the viewer's gaze, with the faint hint of a smile on her small lips.

Though her family life was riddled with difficulties (her husband was a fool, her only son suffered from some kind of mental retardation, the elder of her two daughters was blinded in an accident and her father underwent great economic hardship in his old age), Fontana's career prospered, and in her middle years, her talents began to be recognized outside the Bolognese circle. Through a series of remarkable circumstances (perhaps due, at least in part, to the fluctuating conventions of the late Renaissance and the first responses of the Counter-Reformation), the sixteenth century allowed a few women a certain measure of artistic freedom. St. Caterina Vigri, an accomplished Bolognese musician and miniature painter who died in 1493 and was canonized in 1712, inaugurated what Professor Vera Fortunati has called "the legend of the women artists," such as the Venetian Barbara Longhi and the Cremonese Sofonisba Anguissola.[63] The unpleasant Giorgio Vasari, faced with their work, comments in his *Lives of the Artists*: "Since women know full well how to create live men, it is little wonder that those women who so desire can also create full well men out of paint."[64] In fact, though a few of the women artists had official commissions for large works, most of them (Fontana included) were considered curious rarities. The Bolognese poet Giulio Cesare Croce, a contemporary of Fontana, speaks of her as "A shock to people and to nature/Lavinia Fontana, great painter,/ Is as unique in the world as the Phoenix."[65] The phoenix, we should remember, is a monster among birds.

Like her father before her, Fontana began to establish intellectual relationships abroad, and through the recommendations of several Roman notables, she was appointed painter to Gregory XIII and to his family, the Buoncompagni. Shortly afterwards, she was invited to the Buoncompagni estates of Sora and of Vignola, and there "she was received as a princess, being formally welcomed by the customary militia lining the street for her arrival."[66] For a whole year, from 1603 to 1604, Fontana worked in Rome, mainly as a portrait painter, though she also executed several large religious works of great distinction. In 1614, Lavinia Fontana died in Bologna at the ripe old age of sixty-two.

Fontana had no doubt been warned of the monster she would encounter. At the time, the main talk of Aldrovandi's scientific circle in Bologna and of the gossipy Pallavicina household in Soragna was of the

Gonsalvuses' aberrations, and there must have been a certain amount of encouragement from Aldrovandi himself to have this portrait done as a scientific recording of the prodigy. We have no record of their first meeting: Fontana walking into the draped and gilded room, Tognina pushed forward by smirking and prurient courtiers eager to show their prize catch to the visiting celebrity, their eyes meeting, the first cautious words. Dr. Nico H. Frijda, in his classic study on the emotions, defines emotions as "changes in action readiness,"[67] that is to say, changes that denote a preparation for action or cognition, or for establishing relationships, or for enjoyment. What emotions, then, were bred by their strange meeting? What changes overtook Tognina, what changes did Fontana suffer in that encounter? How did they read each other across the room? Can we even begin to guess what Tognina thought or felt among the finery in Soragna, as she stood there, quietly posing for Fontana at her easel? We have one side of the story: Fontana's portrait of Tognina, the canvas on which the bristles of Fontana's brushes mimicked Tognina's bristles, and where the painter's colours formed Tognina's colours. It is impossible, of course, to see clearly through the layers of countless generations of eyes that inspected the portrait, even back to Fontana's herself, darting from the hairy child's face to the one she was painting and back to the face, translating it, in the to-and-fro, into meaningful shapes and pigments. Did they talk about their loneliness, the burden of their uniqueness, one monster to another, wolf child to woman painter? Did the middle-aged Fontana tell her that she too had been a girl? Did she confess how she too had known the terrors of adolescence at that age when the greatest curse is to be different, to be set apart from one's peers in a place with no identity, with no recognizable name? Did Tognina speak of her dreams, and maybe of the face she dreamed she had, not on the surface of the skin she touched, not in the mirrors that encroached on her in the houses of the rich, not in the reflecting faces of her sister, her brothers, her sad father? Did she ask Fontana if she, the older monster, could see that face and if, being a painter, she could paint it?

And did the fear bred by that face bring to Fontana's mind the fear her fellows felt at her own talent: the fear of transgression and its attendant loss of safe conduct? Dr. Johnson, two centuries later, would quip that "a woman's preaching is like a dog's walking on his hind legs. It is not done well; but you are surprised to find it done at all."[68] Did Fontana, too, feel that she was seen as a performing dog,

condescendingly paired with the dressed-up cub, both eccentric because the centre could not hold them, both attempting, in spite of the rules and vocabulary made for others, to grow and change and create?

Fontana's paintings offer one small clue. Often, in her society portraits, which were her bread and butter, a small domestic dog peeks out from a dark corner, between the legs of a chair or a fold of clothing. The sitters show themselves with all the marks of their place in the world, with the trappings of their sex and age and status, but the dog, cowering or snarling, nuzzling for attention or baring its teeth, usually sitting right in the middle of the canvas — that dog tells another story.

Lavinia Fontana,
*Portrait of the*
*Gozzadini Family,*
1584.

In what is perhaps Fontana's most famous society portrait, that of the Gozzadini family,[69] the small dog in the middle insists on drawing our attention away from the somewhat uneasy emotions in each sitter's face. The dog sits, pampered and sociable, in a tangle of hands, not obviously menacing. But far back, beyond the door and down the hall, barely visible in the fading light, is another dog, its distant shadow, no longer displaying itself merely as the domestic pet, but all alone, separated from the civilized and official gathering, the black dog, as it were, of the family, the holder and the keeper of secrets, the one outside the circle of acceptable social behaviour.

Fontana's genius lies in this: in her portrait of Tognina, public sitter and secret familiar, girl and dog, beauty and beast are split no longer. The freak need not hide, the social being need not pretend, lit side and dark side can both be lived out in the open. In Fontana's marvellously compassionate painting, both sides blend into one and stare back at the viewer past, present and future, in absolute affirmation of her own manifold being.

Marianna

Gartner

The

Image

as

Nightmare

*My purpose is to tell of bodies*

*that have been changed into shapes of different kinds.*

Ovid, *Metamorphoses*

Marianna Gartner,
*Four Men Standing.*

IN LAVINIA FONTANA'S TIME, in the ebullience of sixteenth-century Bologna, a painting, whether a portrait or a scene, whether religious or allegorical, historical or private, was *meant* to be read. This was an inherent and essential feature of the aesthetic act: the possibility, through a shared vocabulary, of communication between the viewpoint of the artist and the viewpoint of the audience. A picture could be venerated for its craft or its matter, but beyond veneration was the promise of something to be learned, or at least recognized. As early as the sixth century, Pope Gregory the Great had declared, "It is one thing to worship a picture, it is another to learn in depth, by means of pictures, a venerable story. For that which writing makes present to the reader, pictures make present to the illiterate, to those who only perceive visually, because in pictures the ignorant see the story they ought to follow, and those who don't know their letters, find that they can, after a fashion, read. Therefore, especially for the common folk, pictures are the equivalent of reading."[1]

Paradoxically, in our time, when images are once again given priority over the written word, we lack that shared visual vocabulary. We have allowed advertising and the electronic media to privilege the image in order to deliver information instantaneously to the largest number of people; we forget that this very speed makes them the ideal communication tool for all manner of propaganda since, manipulated by the media, these images don't allow us time for paused criticism or reflection. We "worship pictures" but we don't "learn in depth, by means of pictures." Superficially, we hold in common certain basic images: of efficiency and profit, of sexiness and contentment, all of which have their commonplaces in the utterly banal advertisements for Ralph Lauren or Volvo, or for the cancer-prone Marlboro Man. A car

commonly signifies success, a cigarette, self-assertion; beaches offer a lost Eden, and designer clothes define identity. But the reading of older and wiser images escapes us. We lack a common language that is both profound and meaningfully rich. We are living, once again, in the unfinished Tower of Babel.

And yet the images that surround us, whether more or less effective, whether banal or transcendent, continue to obey laws, even when these remain secret or unspoken. Attempting to explain his own haunting, dream-like paintings, René Magritte pointed out that they were never random, that the encounter of unexpected elements was never totally unexpected. Commenting on his picture *The Elective Affinities*, he suggested that though we know that birds normally occupy a birdcage, the image becomes more interesting (that is, more tempting to a viewer) if instead of a bird we see a fish or a shoe in that cage. "But though these images are strange," Magritte goes on to say, "they are unhappily accidental, arbitrary. It is possible to obtain a new image which will stand up to examination through having something final, something right about it: it's the image showing an egg in the cage."[2] We are aware that certain images or certain combinations of images are "right" or "wrong" (to use Magritte's troubling terms: the French *"juste"* and *"pas juste"* are more instructive). We know that they convey a certain sense and a certain meaning. But we lack the vocabulary that denotes that sense and that meaning — at least in any useful, communal way. "My investigations," writes Magritte, "resembled the pursuit of the solution to a problem for which I had three data: the object, the thing connected with it in the shadow of my consciousness, and the light wherein that thing would become apparent."[3] How can we, the viewers, use that light wherein things "become apparent"? How can we direct it so that it will enable us to read an image whose ciphers are secret even to the artist who created it?

René Magritte, *The Elective Affinities*.

In 1996, the Alberta Treasury Branch in Calgary, in western Canada, commissioned the artist Marianna Gartner to paint the domed

Marianna Gartner in front of two sections of her Alberta Treasury mural.

ceiling of its 8th Avenue building. The mural, divided into eight triangular sections, consists of a series of portraits meant to represent the population of Alberta. Executed in shades of grey against a brown and blue background of mountains and clouds, the mural shows various faces looking down at the viewer. Obviously, they represent the different origins of the people of the province — Native, African, European, Chinese — but this is merely the convention. The monochromatic colours have the early photographic quality of a documentary; the old-fashioned costumes of the sitters lend historical authority; the changing skies behind them suggest the passage of time, an unfurling chronicle in which the protagonists alone are static, frozen in a past moment, captured by a camera-like eye. The sitters themselves, however, are anything but obvious.

Two taciturn children, a stern and formally dressed black man, a grizzled Chinese elder, a handsome young white man in a beret, a thoughtful woman in black awkwardly holding up her baby, a sad young woman in a flowered hat, a classic bourgeois family, a somewhat sardonic Native man: Gartner borrowed these faces from old photographs, some copied from early police records kept in the Glenbow

Museum in Calgary, others found in flea markets and junk shops in North America and Europe.

That tells us something of their place and time, but little of their meaning. Staring the viewers in the eye, they all seem deep in thought, as if on the point of speaking their minds, of revealing something that we think we understand but that remains nevertheless on the threshold of our awareness. Because these are portraits, not merely characters in a pictorial narrative, we confront them with a particular sense of responsibility, an uncomfortable intimacy. The sitters occupy a space of recognizable prestige, a framed space usually reserved for historical or familiar figures. Between them and us, Gartner has created visible bridges that both sides seem unable to cross and that link and distance them forever — past and present (from our perspective) or present and future (from the perspective of the sitters). In this sense, portraiture occupies a privileged position in the story of figurative representation: it is the depiction not of communality but of identifiable uniqueness, not of a species but of an individual. Such singular representations have not been, and are not, universal.

In the year 1516, in order to prevent the Jewish population from mixing indiscriminately with the Christian citizens of Venice, a small area of the city was set aside and shut off from the rest, with watchmen to prevent free passage. The several Jewish communities, constrained to the area of this first ghetto, built a number of synagogues to satisfy their various customs. The synagogue built for the Sephardi community, perhaps the richest of all, included among its adornments several coloured bas-reliefs of images from the Bible: Noah's ark on a curling sea, the sheafs of wheat bending to an invisible Joseph, Mount Sinai on which Moses heard the Word of God speaking from the Burning Bush. Following Exodus and Deuteronomy, which clearly forbade such depictions, the Palestinian Talmud warned transgressors that a graven image is destined "to come spit in the face of those who worship it and put them to shame, then bow down before the Holy One (blessed be His Name) and cease to exist."[4] In a brilliant book about our relationship to our bodies, Elaine Scarry pointedly remarks that the punishments for the makers of graven images (punishments specified in the Second Book of Kings and in Ezekiel, Zechariah and Jeremiah)[5] are inflicted on "the sentient human body that must be shattered because it has made an artifact ... described as though it were itself an artifact or object of craft."[6] The punishment inflicted by the Creator on the artist

A drape for the Holy Ark, from the Sephardi synagogue in Venice.

for attempting to create is meant to teach him that he too is nothing but a creation. In spite of such proscriptions, the elders of the Sephardi synagogue felt that they could justify images of Mount Sinai and the Ark, for example, since these were of inanimate objects, not of living beings. On the rare occasions when living beings were pictured, as in certain illustrated manuscripts, they would be shown with either birds' heads (so that, at least, the artist was not attempting to depict the likeness of God, who had created man in His image) or veiled to conceal the human features.

This debate about the representation of recognizable things, living or not, has continued across the centuries for varying and sometimes contradictory reasons put forward by all kinds of authorities: from the dogmatic censors of Byzantium to the despoilers of England's churches, from the ascetic theologians of Islam to the theorists of abstract art. Essentially, these iconoclasts all echo the injunction delivered by Hugh Latimer, Lenten preacher to King Henry VIII, in a famous sermon of June 9, 1536, according to which images were "only to represent things absent."[7] Those who believed otherwise and freely attempted to reproduce the world as God had made it, usurping the

divine prerogative of creation, were guilty not only of an act of hubris, but also of assuming that the artist had the right to reinterpret reality.

There are cultures where only the common, not the individual, traits merit representation. Not prohibition but simply a different aesthetic norm dictates the absence of identifiable faces in many societies around the world. The artists of Nepal or Congo, the ancient makers of Himalayan funeral figureheads or the eighteenth-century carvers of Kwele masks, for instance, were not interested in portraying recognizable singular characteristics. What was represented was something closer to the archetype of face, a masculine or feminine face, a demon's face and so on. But in many other cultures, faces are imitations of

A Kwele mask in
pigmented wood.

the real thing for very specific purposes, whether religious, political or personal. Arguing for the strength of naturalistic representations, that is to say, realistic "slices of life" presented to the viewer with no attempt at a moral judgment, the eminent British art historian E. H. Gombrich suggests that meaning did not depend on "likeness." "The Egyptian who looked at a picture of a hunting party in the lotus swamps might easily have had his memories and imagination stirred, much as it may happen to us when we read a verbal description of such a party; but Western art would not have developed the special tricks of naturalism if it had not been found that the incorporation in the image of all the features which serve us in real life for discovery and testing meaning enabled the artist to do with fewer and fewer conventions." And Gombrich adds, with a touch of bravado: "This, I know, is the traditional view. I believe it to be correct."[8]

Naturalistic depiction is, however, also a set of acquired conventions:[9] a two-dimensional surface representing three dimensions, white paint suggesting light and dark paint suggesting shadows, the much-reduced figures on a canvas meant to represent life-size persons. A stick figure on a traffic sign or a "happy face" button on a greeting card serve their purpose admirably; only when the portrayed face must also serve as documentary evidence will a stylized or imagined face not do: the recognizable face must have the weight of proof, much like the photographed

face in a passport. These "factual" faces are meant to represent a politician or a celebrity, a god or a figure in authority, a relative or a friend, in whose presence we must behave as if confronted by the god or authority itself. Sometimes these faces are meant to honour someone who has died or a hero from the past, and here again the function of the portrait is to make the absent present, to bring the dead back to life in the eye of the beholder. From the sarcophagus paintings of Fayum to the official busts of Imperial Rome, from the miniatures of Elizabethan England to the covers of *People* magazine, portraits carry a representation beyond the image it-

self, meant to be read not only as the identity of the sitter, as historical or private record, but also as symbol of what that person stood for: authority, love, friendship.

It is in this sense that portraiture, which appears to confirm or represent its subject, can also subvert it. It can, for instance, usurp the subject's reality by replacing the authority of real flesh and blood with a phantasm of paint and wood, then granting pre-eminence to the symbol, not as symbol but as reality.[10] In Greek theatre, the mask used to represent the god became, as it were, the god himself, and therefore a holy object that was hung after its use in a shrine dedicated to that god inside the

A Roman-style second-century portrait of a woman from an Egyptian sarcophagus.

theatre. In Andalucia, images of different Madonnas, each with its own identity (the Virgin of the Rosary, the Virgin of the Carmen, the Virgin of the Assumption), are paraded by the faithful during Easter, sometimes causing bloody battles between the followers for whom each Madonna is an individual divinity, not merely a different representation of the same Mother of God. In Argentina, after the death of Evita Perón, the entire population of Buenos Aires was expected to pay homage to her remains, which had been laid out in a coffin at the headquarters of the Central Workers Union; since it was difficult for

people to travel from the countryside, dolls meant to represent Eva were placed in makeshift coffins in the distant villages, and a stand-in for President Perón, sitting next to the dummy, would receive the condolences due to the widower.[11] The novelist Josef Škvorecký tells of an incident during the Nazi occupation of Czechoslovakia: a confectioner, eager to please the invader, made a chocolate bust of Hitler to display in his shop window; the heat of the sun caused the chocolate to melt, transforming the bust into a caricature, and the confectioner was arrested for showing disrespect to the führer thus incarnated in the chocolate.[12]

Portraits and scene paintings set up different relationships with the viewer. Northrop Frye suggested that in Canada, traditionally the question to ask is not "Who am I?" but "Where is here?" since for Canadians the identity of their country is more baffling than their own. The representation of a scene, a landscape or a story, setting up a narrative in the third person, also asks the viewer "Where is here?" A portrait instead, in which the sitter introduces himself or herself directly to us, demands a more dynamic relationship between subject and viewer: it shifts the narrative into the first person, into a story in which the subject addresses the viewer on tantalizing and intimate terms of apparently shared conventions. "Who am I?" the sitter asks. The "Where is here?" hardly matters.

In what is perhaps the most elaborated-on of all portraits, Velázquez's *Las Meninas*, the painter (whose manipulation of our view of the scene is central to the composition) deliberately plays with our expectations. Painted in 1656, four years before Velázquez's death, it captures a fleeting moment in the artist's studio, as he is painting a portrait of the King and Queen whose reflection can only be glimpsed in the secondary frame of a mirror at the back of the studio. From our own assumed position, Velázquez forces us to decide who the sitter of the portrait is supposed to be. Is it the mirrored royal couple whose portrait the Velázquez in the picture is painting? Is it Velázquez himself, painting the picture? Is it the "Meninas," the young girls, who give the portrait the title by which we have come to know it? Is it the fascinating midget who imposes her presence on the ensemble? Is it the anonymous visitor entering or exiting behind the distant curtain of a threshold? Or is it us, the viewers whose presence Velázquez has foreseen, as he stares at us from his position in the painting? Who, in fact, is the protagonist? The question, of course, has no answer.

Diego Velázquez,
*Las Meninas.*

Velázquez plays on the fact that a portrait takes for granted the pres-
ence of a viewer, a viewer who agrees to a dialogue in which the words
are put forward by the subject but in which the meaning must be
invented by the viewer. The exchange is an intimate one: the portrait is
held up for the viewer's contemplation, as if it were an old, vaguely
familiar family photo to which the viewer must attach a name, a
history, a kinship. In *Las Meninas*, Velázquez subverts our dialogue by
constantly shifting the question "Who am I?" from one character to
another. In an action scene, this shift would be part of the dynamic lent
by the viewer to the painting. In a portrait, the absence of focus contra-
dicts the very premise on which a portrait is based.

With photography, the twentieth century's emblematic art form, portraits acquire a firmer factual tone, but one that can, at the same time, be even more strongly subverted. In the playgrounds of my Argentine childhood there was always an itinerant photographer who, setting up his three-legged camera in the midst of a crowd of pigeons, would cover his head with a cloth, lift the shutter button and cry out to the passersby, *"¡Un recuerdo!"* (a memento). In the presence of these artists of the camera, proud mothers and impatient children, courting couples and wandering tourists would stiffen up, uneasily face his camera and wait for the trigger to click. Looking at such portraits, we now have the impression of absolute nakedness, as if something deeply hidden in their souls were suddenly revealed through their very effort not to reveal anything, to "hold still." Peering into those grey and earnest faces, we have the sense of knowing the subjects intimately without even knowing who they are. We invent stories for them around the features that they (or their portraits) provide.

Old photos are the inspirational basis for many of Marianna Gartner's canvases. What seems to interest her is the absolute *presence* of the photographed subjects and the persistent, haunting quality that comes from it. Usually their eyes, but many times their postures as well, betray a range of emotions aimed at something that is no longer there (the seductive lens) and that is now directed at us, their future viewers. From that point in the past, they are plucked and transformed on the canvas into something else. And it is in this sense that Gartner subverts the traditional art of portraiture.

Though trained as both a painter and a photographer at the University of Calgary, Gartner soon abandoned photography and dedicated herself exclusively to painting. Born in 1963 in Winnipeg, Manitoba, of immigrant Hungarian parents, she travelled as a child to Central Europe and was taken to see the great art collections in Budapest. She recalls the impression made on her by the large court portraits, the realistically depicted worthies and noble ladies with their attendant emblems (picture postcards of which she still keeps in her Calgary studio). Perhaps because of her early interest in European art, the landscape painting and folk-oriented crafts of the Canadian prairies did not hold her attention. Instead, she studied the classic Italian and German masters and, among the moderns, Otto Dix, Egon Schiele and Balthus, all of whom renewed or changed the course of portrait painting in Europe.

In 1925, the Spanish philosopher José Ortega y Gasset, in a classic text, argued that a work of art is such only in so far as it is not flesh and blood. "In order to enjoy the equestrian portrait of Charles V by Titian," he writes, "the indispensable condition is that we don't see Charles V in person, authentic and alive, but that instead, in his place, we see a portrait, an unreal image, a fiction."[13] For Ortega y Gasset, confrontation with the source, with the real thing, invalidates the contemplation or reading of the work of art. In Gartner's painting, the subverted re-creation *supersedes* the formal original. After her version, the original ceases to exist. Gartner's version becomes the original.

For example, her *Diablo Baby* gains nothing by being compared to the baby in the anonymous photo that inspired it. Seen on its own, a doll-like creature sitting in a stunned pose, its pouting lips frozen in time, the baby enters into Gartner's canvas in something like a state

Marianna Gartner,
*Diablo Baby.*

of suspended animation. It seems to hold its breath, waiting for the long-vanished camera (now replaced by Gartner's brushes) to breathe life into it again, like in a fairy tale. Through Gartner, these trivial babies acquire, in the passage from photo to canvas, a different iconographic vocabulary. Her babies float through clouds, take on the attributes of tattooed devils, sit on sinfully scarlet rugs, are transformed from innocent cherubs into disturbing outsiders.

What has happened? To the conventional art of portraiture, Gartner has added her own nightmarish commentary. Medieval scribes surrounded their main text with doodles that, in indirect ways, transformed the subject matter through allusions, hints, half-suggested symbols. If we (as Ortega y Gasset suggested) deliberately ignore the original models, can we, who are not privy to the scribe or painter's interior world, read these doodles, these scribbles, these annotations, these symbols? Can we read Gartner's paintings?

*Sailor Boys* was painted in 1999, ten years after Gartner's first solo exhibition. Combining two bland and conventional poses — that of the sailor on leave and that of the ubiquitous baby on a blanket — Gartner creates a double portrait in which the adult carries the perceived innocence of the child, while the baby is covered with the ritual tattoos of the adult. The title of the painting — in the plural — emphasizes their pairing. Man and baby are equals here, the adult foreshadowed in the child, the child illuminated by the adult. Our mythology associates sailors with travel and adventure, risky sexuality, promiscuity. In Gartner's painting, the physical emblems of the sailor — the tattoos — have been transferred to the baby, symbol of inoffensiveness and lack of experience. Disturbingly, this transference, as in Oscar Wilde's *Picture of Dorian Gray*, suggests that the baby has become a scapegoat for the sailor's sins. Or perhaps it is merely the underside of each character that is being revealed here: the purity of the philandering sailor dressed in heavenly blue, the devilishness of the baby, seated on a scarlet drape. The "meaning" that these characters suddenly acquire comes from the startling yet seemingly logical juxtaposition of the sitters and their familiars: the unsettling proximity of immaculate adult and tattooed child, domestic sailor and subversive baby.

But as Magritte made clear, proximity of unexpected elements is not necessarily satisfying or unsettling. Take for instance the woman and a parrot in a portrait painted by Édouard Manet in 1866. The scene is

Marianna Gartner,
*Sailor Boys.*

Édouard Manet,
*Woman with
a Parrot.*

perfectly tranquil, slightly amus-
ing, even, because a parrot is a
funny, not a tragic, bird, associ-
ated with innocent exoticism.
Think of Robinson Crusoe's par-
rot, think of Long John Silver's
parrot endlessly calling "Pieces
of eight," think of the parrots
depicted in conventional South
Seas landscapes, so very much
present in the nineteenth-cen-
tury colonial imagination. Now
compare that relationship with
Gartner's *Girl with Parrot.* The set-
ting is certainly uncomfortable
— and not least because it takes
place on a tightrope. The model
is a bewildered-looking, vaguely

disturbing girl from an old flea-
market photograph. And the
parrot — the free, colourful bird
of the Noble Savage — is here
harnessed like a dangerous beast,
restrained by a leather leash. The
poet Gérard de Nerval (who
committed suicide by hanging
himself in 1855) carried a lobster
on a leash, and the Surrealist poet
Alfred Jarry (creater of Ubu)
once walked a shoe on a leash
through the streets of Paris. The
gesture of carrying a leashed
pet is one that seems to invite
disruption (like the monkey on a
leash in Georges Seurat's famous
painting of *La Grande Jatte*), per-
haps because it is so prim: the
artless bourgeois holding the ani-
mal realm in captivity. But in

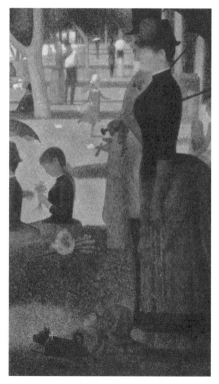

Monkey on
a leash, a
detail from
Georges Seurat's
*A Sunday on La
Grande Jatte,* 1884.

Marianna Gartner,
*Girl with Parrot.*

Gartner's painting, everything is poised as if to collapse at any minute:
the civilized bourgeois world might topple from its precarious perch on
the tight-rope, the bird might escape and turn on us, seeking revenge.
And her genius is that it is not a conventional bird of doom that she has
painted — not a crow or a raven — or a bird of pride and power — an

eagle or a falcon. It's a parrot, and the wrath of the parrot is probably much greater than that of any ordinary animal. In Flaubert's "Un coeur simple,"[14] the parrot of the simple old woman who loves it, the parrot that has died and that she has had stuffed, comes back to her at the moment of her death as a huge triumphant bird that she confuses with the Holy Ghost, covering the entire sky.

Marianna Gartner's paintings are not allegorical, nor do they have a perceivable plot. *Girl with Parrot* is not part of a story. It is static, a moment deliberately pulled out of time. The girl and her parrot disturb us because they are not an episode in a narration we can follow, they are not a symbol or a fable, and the relationship between the seemingly innocent girl and the tethered bird is one *both* of love and of hate, neither banal nor casual.

A nineteenth-century magic-lantern slide showing Robinson Crusoe and his parrot.

Velázquez, Lavinia Fontana, the anonymous painter of *The Virgin and Child before a Firescreen* could assume a shared vocabulary with the viewer. A number of basic mythological, historical and religious images would be immediately readable by almost anyone, so that the artist could work from an elementary and well-known story up to his or her own particular elaboration. Gartner, aware that we share no such common stories, wisely refuses to interpret her paintings, and with few exceptions, her titles are merely descriptive. Medieval theologians approved only of images that could be explained, thus assuming control over the images with words. Gartner refuses such authoritarian methods. Her characters and the objects through which these characters appear to be defined demand no other "story" than that accorded by the limits of their canvas: they stand, like the subjects who stood for the itinerant photographer, now long turned to dust, as *recuerdo*, as memory of a moment that could not take place and that yet, as her canvases prove, in all their disturbing ordinariness, indeed did take place.

Ordinariness is not a quality of all her paintings. Her sitters are not all conventional figures whose eccentricity comes less from themselves than from how she perceives them. In a series from 1994, collectively titled *Myths and Images*, Gartner explored the world of circus freaks. Midget clowns, elastic-skinned men, legless freaks and (above all) a

superb portrait of a leopard family display for our observation something similar to the album of curiosities of Rudolph II: anomalies of nature through which the viewer can assume a selfish code of normality. Gartner's freaks, however, are not presented as curiosities: like Tognina in Lavinia Fontana's portrait, they too are observers, they too face the viewer from their sober surroundings, enlarging with their presence the definitions of what is human. Confronted with Alice, a human child, in Wonderland, the Unicorn suggests to her, "Well, now that we have seen each other, if you'll believe in me, I'll believe in you. Is that a bargain?"[15] Gartner forces the unwilling viewer into just such a bargain.

Throughout the history of Western art, the human body has been regarded as an object to be puzzled over. In Fontana's age, it was daringly opened for exploration by artists and scientists; in Modotti's, it was closed once again by the custodians of society's morals. Today, in Gartner's time, we do both: we expose the naked body both externally and internally, in sexually explicit films and publicity photographs, and in graphic operations on TV medical shows that invite us to be voyeurs in a hospital; but we also hide the body behind the strictures of fashion and the conventions of advertising art. The picture of a naked model in a Sunday tabloid causes no public reaction, while that of a naked pregnant woman (the American actress Demi Moore photographed by Annie Leibovitz for the cover of *Vanity Fair*) provokes a scandal.

A variety of creatures from Ulisse Aldrovandi's *History of Monsters.*

Marianna Gartner,
*Leopard Family.*

In the Judaeo-Christian tradition, the body created in God's image, "out of the dust of the ground," needed to be externalized in order to be seen — in fellow human beings, in mirrors, in paintings and in sculptures, in spite of the scriptural prohibitions. The body that encases the observing "I" must be inspected, watched in action, taken apart, contemplated in death and its freakish variations, all in order to extract (or attempt to extract) meaning out of matter. As Elaine Scarry notes,

this Judaeo-Christian externalizing of the body was taken up and expanded in the writings of Karl Marx.[16] According to Scarry, both the Judaeo-Christian and Marxist systems are concerned with the production of material values — creating objects, creating work, measuring productivity and recompense — and though Marx angrily opposed what he perceived to be the injustices of the Judaeo-Christian system, he too embraced its materialistic premises and its "impulse toward material self-objectification."[17] I find this notion (that we must externalize the body in order to objectify it, "returning it to God,"[18] according to St. Augustine, or to save it from "the existence of mere artifact,"[19] according to Marx) useful in attempting to read Gartner's work. Her characters not only exemplify the wide range of God-reflecting images made out of the same common dust, but she also saves them from being "mere artifact," iconographically elevating them to the highest rank of the human condition. Objects of contemplation who in turn contemplate us, the viewers, these posed bodies are granted by Gartner the trappings with which society glorifies authority and rewards power — trappings that she perhaps remembers from her encounters as a child with European court portraiture: gold backdrops, regal poses, expensive adornments.

*Leopard Family* is the largest of the *Myths and Images* series. Based on an archival circus photo, the portrait shows a standing woman, a seated son, a young daughter perched on a draped table and a second son by the girl's side, all of whom show brindled "leopard" skin beneath their conventional clothing, black features with patches of white, and even half-black, half-white hair. Here Gartner uses the official severity and solemnity of such bourgeois family portraits (the buxom matron, her posed children and so on) to emphasize the utter strangeness of these people: the outsider, the monster (meaning "he to whom we point with a finger"),[20] claiming a variety of racial traits and (as Fontana did for Tognina) victoriously usurping the place of those whom society sets up as exemplary.

But we need not be limited by the iconography of our time: we can borrow from the older sources in order to read a contemporary painting. In a medieval legend dating from the thirteenth century, it is told that the saints Cosmas and Damian appeared in a dream to a faithful white man whose left leg had been totally consumed by cancer. Bearing salves and surgical instruments, the saints proceeded to replace the man's bad leg with one cut off from "a recently deceased

Unlike the Leopard Family in Gartner's painting, this couple-coloured Brazilian slave is depicted as an exotic curiosity in J. L. Da Rocha's 1786 *Portrait of Siriaco.*

Ethiopian."[21] The saints departed, the sick man "came to his senses, bounded joyfully from his bed, and told everyone about what he had seen in his dreams and how he had been healed." This apparent proof of racial equality (black and white sharing the same body) is, however, contradicted in iconographic depictions of the legend. In a sixteenth-century Spanish bas-relief illustrating the miracle,[22] the saints are seen carefully attaching the black leg to the white man lying in his bed, while on the floor, screaming in pain, lies not a corpse but a living black man clutching in horror his unattended stump. For the anonymous sixteenth-century Spanish artist, the white body favoured by the saints is far more precious than that of the mutilated Ethiopian.

A sixteenth-century Spanish woodcarving illustrating the miracle of Saints Cosmas and Damian.

In Gartner's portrait, it is the outsider who is privileged. In documentary black and white, against a blurred background of darkened gold, the leopard family acquires a regal quality at odds with the expectation created by their freakishness. They are freaks, but freaks enthroned, abnormality rendered normal, and this ambiguity unsettles (and enriches) our reading.

To ground this sense of the ambiguous, Gartner relies on an eighteenth-century convention whereby scientific (that is to say, factual) exploration is based not on the general or serial natural laws, but on the accidental, the rare, the exceptions to the rule.[23] It is through the unique that the scholars of Newton's age sought to understand the functioning of the normal, and by collecting the bizarre attempted to shed light upon the world of every day. Commenting on Gartner's *Myths and Images* exhibit, the Canadian critic Robert Enright writes: "Gartner's strategy has been to take the combination of the beautiful and the sinister, and insinuate one quality into the other.... The source of the painting's ambiguity is the artist's own."[24]

In Gartner's later work, this "private" ambiguity is even more of the essence. An extraordinary triptych called *Tightrope Clara* depicts a young girl in a starched white dress standing delicately (like the parrot girl) on a tightrope held by two skeletons. The light, joining all three panels, comes from somewhere above and behind the viewer's head, reflecting off the skeletons and Clara's dress, illuminating both the white background of Clara's act and the dark, hollow backgrounds of the skeletons, and suggesting, as in later paintings by Caravaggio, a secondary and removed point of observation that includes the viewer as well.

For Caravaggio, light is its own source. It illuminates what the painter wishes to stress and conceals what he wishes to conceal, without justifying its origin to us — nothing as obvious as candle or fire, as in the paintings of Georges de La Tour, for example. This is what one of Caravaggio's recent biographers calls "the divine hand of the artist which brings light to nature."[25] For Caravaggio, the artist is in absolute control, and so what matters is the resulting illusion, not the technical reasons for the illusion. In his *Supper at Emmaus*, nothing at the table is decorative, nothing is mere device, nothing is technical virtuosity for its own sake. Everything — the overripe fruit, the small table, the young beardless Christ and his eerie shadow — is in the service of the totality, fixed in its uniqueness, defined as itself, a stern quality that led his work to be condemned for its "vulgar naturalism."[26] As in Caravaggio's canvas, Gartner's lighting positions us in the same space as the precarious Clara, her balanced feet at the level of our eyes, so that we are physically included in the very centre of her circle of existence. She is not part of our world: we are nightmarishly part of hers.

Marianna Gartner, *Tightrope Clara.*

Here too we can reach back to a more ancient iconography, forgotten to most of us, and even perhaps unknown to the artist herself, but present nevertheless in the very weave of our society. Seven butterflies hover around the earnest Clara. The butterfly can be a mere decoration, a pun on a woman being as flighty as a butterfly, a

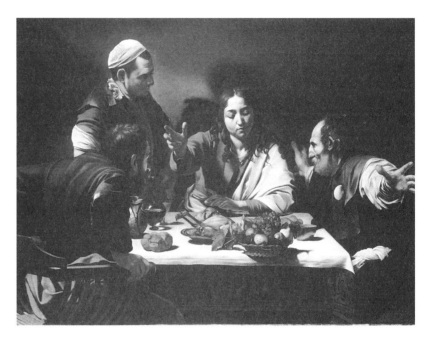

Caravaggio,
*Supper at Emmaus.*

classic image echoed in drawings by the eighteenth-century French artist Antoine Watteau, for example. But in medieval iconography,

Antoine Watteau,
*Seated Girl
with Butterfly.*

the butterfly represented the three stages of the human being: life (the caterpillar), death (the chrysalis) and resurrection (the butterfly itself, which, in many depictions of the moment of death, issues from a corpse's mouth, representative of the soul).[27] The emblem of Christ's Resurrection (and consequently, of the promise of resurrection to all those who keep the faith), the butterflies in Gartner's painting are like seven cautionary symbols, one for each of the seven deadly sins that can lead a soul to perdition.

Gartner's butterflies may not have been consciously chosen, but her inclusion of the skeletons is quite deliberate. The custodian skeletons of birth and death are quotations: from *La Belle Rosine* by the early-nineteenth-century Belgian painter Anton Wiertz, Gartner has borrowed the skeleton that stands to Clara's right, with its echoes of medieval Vanitas, philosophy and poetry allegorized as a pretty woman inspecting death; and from *The Anatomy Lesson* by the seventeenth-century Dutch painter Thomas de Keyser she has taken the skeleton

Anton Wiertz, *La Belle Rosine*.

that stands to Clara's left, with its "realistic" connotations, science and medicine investigating the mystery of our passing. These skeletons, two mementoes of what the flesh will become, according both to art and to science, are not only by Clara's side: they are by our side as well, we the living waiting our turn to take part in this mortal tightrope act that will

Thomas de Keyser, *The Anatomy Lesson*.

145

end at the time of our death. The Passion of Christ, balanced between the crosses of the good and bad thieves, exemplifies the fragile nature of our leavetaking: Christ dies well, but until our soul leaves our body, we are held in equal equilibrium between the choice to accept the Word, as the Good Thief did, and be promised Paradise, or to reject salvation, as the Bad Thief chose to do, and be hurled into Hell. This is our private sense of death, what the French historian Philippe Ariès calls *"la mort de soi"* (the death of oneself), as opposed to the shared sense of death that developed in the bourgeois European societies after the Middle Ages.[28] Here Clara stands alone, flanked solely by her own possible deaths.

*Four Men Standing* is for me one of Gartner's greatest paintings. I have no knowledge of what inspired it; I read it from my own uninformed position as a common viewer, inventing for it a vocabulary that may or may not serve to reveal it; I translate it into images whose meanings I make up from distant sources, and I can only trust my own sense of what is *juste* or *pas juste* in my reading. *Four Men Standing* takes its power exclusively from the force of the subjects' presence. Traditionally in Christian iconography, a group of four suggests a trio "intruded" upon by a fourth character — the Trinity and Mary, the four evangelists. The fourth person brings to the group an excluded or neglected aspect (the female divinity through the presence of Mary; the Messianic nature of Christ in the gospel of John, the only evangelist whose emblem is not a beast but an angel). Sometimes, the fourth character fulfills a subversive role not explicitly expressed in the official story. In Hieronymus Bosch's *Adoration of the Magi* (a painting I saw for the first time many years ago in the Prado museum in Madrid and that I now mysteriously associate with *Four Men Standing*), the three kings are offering their gifts, in the customary manner, to the infant Jesus. The trio is depicted as tradition requires: one black and two white, the black king holding an ornate censer, one of the white kings presenting a platter of either gold or spices, the other kneeling in devout prayer. But from behind the door of the stable, where a dark and unsettling crowd of men have assembled, a fourth king peers out, naked except for a golden crown and a red cloth draped hastily over his body. He carries a sword hanging from his waist behind him, and he holds a second crown in his left hand. His entire demeanour tells us that he is mad: his nakedness, the odd adornments on his body, his broken grin. His disturbing presence in this scene of joyful birth serves as a reminder that even at the moment when the promise of redemption enters the world, our understanding, our essential human capabilities,

Hieronymus
Bosch, detail from
the central panel
of *The Adoration
of the Magi.*

cannot suffice to grasp the greatest of all miracles. The German critic
Wilhelm Fraenger traced Bosch's terrifying iconography to the heretical
dogmas of the fifteenth-century Adamite sect, and noted how what
appears to us, from our modern perspective, as fantastical is in fact a lit-
eral rendering of Adamite traditions, parables and teachings.[29]

In Gartner's painting, the four men, though clearly forming a homogeneous group, are not equal. The man on our far left — the only one sporting a walrus moustache, a man somewhat frailer and older than the other three — is wearing a mask, unnecessarily hiding an identity that (like those of the other three men) the viewer would anyway fail to recognize. What is he subverting in this otherwise open-faced trio? What excluded quality does he bring to the group? Is his inclusion benign or malevolent, damning or redemptive? The presence of this masked fourth man, the remote undersized trophy of a deer's head, the fact that only three hands are visible disturbs but doesn't illuminate us. The green background, a sort of fake verdure lining the wall and floor behind them, suggests a space that is essentially artificial, as in a dream, a realm where the forces of nature are subdued, under control, kept at bay. This is a stage, a setting, but for what? Nothing happens here, nothing will happen. The threatening feeling implied by the four men is one of ongoing tension, never to be resolved. The four are self-sufficient, free of context, without past or future, in the nightmare of an absolute present. "Existence requires no reason," writes the Spanish philosopher Miguel de Unamuno.[30] Gartner's four men offer the viewer no excuse for their being. That is partly why this painting is so disquieting. Nothing is more terrifying than that which is unconditionally, absolutely there. Moses's hair went white when he was in the presence of God, because he realized that God's presence is absolute. "I am what I am," said the voice of God to Moses from within the Burning Bush. The characters of Gartner's paintings echo that divine definition. They are what they are.

How far can I take these readings? In the Middle Ages or the Renaissance, the construction of a subject through elements both familiar and allegorical allowed — and even encouraged — contemporary audiences to undertake these interpretative readings. A painting would not have contained "arbitrary" elements, any more than a text would have contained "arbitrary" words. Gartner's nightmarish portraits may not allow for any one "exact" or "correct" interpretation, but the sitters and their emblems are never arbitrary: they seem exactly "right," as Magritte argued, in the particular situations in which they were painted. But Gartner's paintings are not riddles like *The Virgin and Child before a Firescreen*, conundrums to be explained with a solution. The questions these portraits pose imply coherent and satisfactory answers, but not absolute answers such as those demanded by, for example,

*La Bella Rosina.* Since the artistic language of our time is not specific in its connotations, our interpretation remains private, one of many, a story added to the private story of the painting itself, a second or third or tenth layer of meaning that grows not from the original skin of the painting but from our own time and place. This is what I would call a "blind reading" as opposed to a "sighted reading" like the one allowed by a painting that supposes a shared and established vocabulary.

The depiction of a subject through its related parts, a sort of gestalt creation by a collection of visual metonymies, changes from a conventional iconographic vocabulary to a vocabulary in which each sign, as it becomes apparent, no longer corresponds to a common sense — unless it is a private common sense, where "common" means not shared but merely reasonable. That is to say, like the image in a kaleidoscope, a portrait made up of distinct individual details changes every time we turn the bits of coloured glass and recognize a new story in the pattern.

Bearing in mind Pope Gregory's call for the reading of pictures, I would go further. I would say that if looking at pictures is equivalent to reading, then it is a vastly creative form of reading, a reading in which we must not only put words into sounds into sense but images into sense into stories. Of course, much must escape our narratives because of a picture's chameleon quality and because of the protean nature of a symbol. Image and meaning reflect each other in a gallery of mirrors through which, as through corridors hung with pictures, we choose to wander, always knowing that there is no end to our search — even if we had a goal in mind. A line from Ecclesiastes sums up, I think, our dealings with a work of art that moves us. It acknowledges the craftsmanship, it intimates the inspiration, it tells of our helplessness to put our experience into words. It is worded like this in the King James Version: "All things are full of labour; man cannot utter it; the eye is not satisfied with seeing, nor the ear filled with hearing."[31] The experience of a work of art can no doubt be understood, because it is, after all, a human experience. But that understanding, in all its illuminating and ambiguous revelations, may be condemned, because of its very nature, to remain for us just beyond the possibilities of our labours.

Philoxenus

The
Image
as
Reflection

*If I ... ask if all be right,*
*From mirror after mirror,*
*No vanity's displayed:*
*I'm looking for the face I had*
*Before the world was made.*

W. B. Yeats,
*A Woman Young and Old*

Mosaic of the
Battle of Issus, in
the Archeological
Museum, Naples.

EVERY PORTRAIT is, in some sense, a self-portrait that reflects the viewer. Because "the eye is not satisfied with seeing," we bring to a portrait our perceptions and our experience. In the alchemy of the creative act, every portrait is a mirror.

After conquering Greece and razing to the ground the city of Thebes (only the house of the poet Pindar was spared), Alexander the Great invaded Asia with the intention of capturing the kingdom of Persia, ruled at the time by Darius III. With fewer men, fewer ships and far less wealth than that of the Persians, Alexander crossed the Troad, subdued Sardis and the cities on the coast, and after destroying Halicarnassus, the birthplace of Dionysius, he marched triumphantly through Lycia, Pamphylia and Pisidia and, in the capital of Phrygia, famously announced that he had cut the Gordian knot. Darius advanced to meet him, but Alexander, before facing him, decided to subdue the recalcitrant Cilicians. Darius attributed the delay to fear, and instead of meeting Alexander on the plains of Syria, where his own larger army might have been at an advantage, he led his men across Mount Amanus and into the narrow plain of Issus. The armies met and fought, but even while the outcome was still undecided, Darius lost faith in the superiority of his troops and fled. Alexander pursued him until nightfall, when he could no longer see his prey, and then returned with Darius's chariot, mantle and arms as his booty.[1] The story is told in generous detail by the Greek historian Flavius Arrianus in the early years of the second century A.D., almost four centuries after the events.[2]

Darius's flight provoked a general panic among the Persians. In the confusion, the Greek mercenaries were massacred by the Macedonian infantry, and the Persian horses, slow under their heavily armoured

riders, suffered greatly; the men who tried to escape on foot, struggling in disorder through the narrow mountain paths, fell, trampled under the feet of their own fleeing cavalry, or were cut down by Alexander's pursuing troops. A hundred thousand Persian infantry and ten thousand cavalry were killed in the battle of Issus; on Alexander's side, about 504 were wounded, a total of 32 infantrymen were lost and 150 cavalrymen died. "At so small a cost," says Alexander's biographer, Quintius Curtius Rufus, "was a huge victory secured."[3]

Alexander died in Babylon at the age of thirty-two, of a malignant fever, after having (in the words of the First Book of Maccabees) "advanced to the ends of the earth, plundering nation after nation; the earth grew silent before him and his ambitious heart swelled with pride."[4] His pride was justified: fame had made him immortal. Even to this day, in the Aegean Sea, a two-tailed mermaid will appear to sailors and ask, "Where is Alexander?" to which the right answer still is "He lives and reigns."[5]

The battle of Issus caught the popular imagination not only among the Macedonians but also among the people he defeated and conquered. Philoxenus of Eretria, a disciple of the famous artist Nichomachus, painted for Cassander, the son of Alexander's successor, a depiction of the battle, which became one of the most admired works of art in antiquity.[6] It was copied many times: there remains, for instance, a detail in relief on an Etruscan urn from Perugia, and another on a Roman ceramic cup from the workshop of a certain Gaius Popilius.[7] Most famously, it was reproduced in a vast mosaic in one of the finer houses of Pompeii, known today as the House of the Faun, where it adorned an exedra surrounded by columns, overlooking the central peristyle. Protected by the ashes and lava of Vesuvius that buried the city in 79 A.D., the mosaic was uncovered on October 24, 1831.[8] Goethe, a few months before his death, could not contain his enthusiasm: "Neither the present nor the future will be able to comment fittingly on such a remarkable work of art, and we shall be eternally obliged, after all our studies and explanations, to contemplate it in pure and simple wonder."[9]

The mosaic (and presumably the lost painting) depicts the moment when Alexander, riding triumphantly through a tangle of battling soldiers, is about to pursue the fleeing Darius on his two-wheeled chariot. Horses run in all directions; one falls dead between the two leaders, spewing blood; another (Alexander's) aggressively raises its front legs; a third displays its rump as a dismounted cavalryman grabs the reins to

prevent it from escaping, while Darius's black horses gallop on. The sky is a forest of slanted spears. The Florentine Paolo Uccello could not have known of this mosaic before creating his spear-crossed *Battles* in the mid-fifteenth century, nor could Velázquez when he painted the upright lances of his *Surrender of Breda* two centuries later, and yet both paintings eerily echo the vertical lines behind the battling armies. Horses, soldiers and weapons are caught in a vast turmoil; only one detail contradicts this picture of chaos, and that is the quiet portrait of a man who is dying.

The dying soldier (detail from the Battle of Issus mosaic).

He lies just below the narrative centre of the mosaic, under the large wheel of Darius's chariot. He is a Persian soldier (wearing the open hood of the Persian army, distinct from the Macedonian helmet); he has fallen among the scattered swords and lances and hooves; his last gesture is to lift his shield and see, in its mirror-like surface, his own face. This soldier wants to know who he is before dying.

Paolo Uccello's *Battle of San Romano: Bernardino della Ciarda Unhorsed,* 1435–36.

157

Diego Velázquez's
*Surrender of Breda.*

The ancient Greeks, as well as the Romans and the old Germanic tribes, believed that the mind, the conscious self, resided in the chest, and they associated thought with breath: he who no longer drew breath could no longer give birth to thoughts. The surviving soul, in the guise of a bright fire, took up residence in the head, the seat of life. For that reason, in the most famous of Anglo-Saxon poems, *Beowulf,* when the hero and his enemy are lying dead, the faithful Wiglaf makes certain that the heads of dead warriors, "friend and foe alike," are wrapped up tightly, to prevent them from haunting the living.[10] This fear of the disembodied head lent the Anglo-Saxon word for "mask" or "helmet," *grima,* the further meaning of "spectre" or "ghost,"[11] leading to the modern English word "grim." The fire in the head was known as "genius"; the soul, this "genius" embodied in a grim flame, would appear on the graves of the dead, or would cast an eerie light from within the head of those graced by the divinity, like the halo later depicted in Christian iconography. According to Cicero, the orator Servius Tullius, born of a slave mother, had such a bright and fiery soul that when he slept, "his head blazed in the sight of many people," who became so frightened that they fetched water to put it out.[12]

For the Greeks of Homer's time, the representation of a face (the visible identity of the head, the house of a person's soul) possessed something intrinsically magical. As if to allay its power, early Greek art showed a face usually in profile so that its glance would not reach the viewer. When the face was depicted in full frontal view, as in the tragic mask known as *gorgoneion,* it was deliberately meant to frighten,

reminding the viewer of the mythical Gorgon, whose sight turned those who looked upon her into stone.[13] In later times, as I mentioned earlier, masks used in the theatre were considered sacred, especially the masks representing gods and goddesses, which is why, after a performance, the mask was ceremonially dedicated to the god it was supposed to symbolize and then left in the theatre so as not to carry into the outside world the god's "otherness." Masks not only represented a god or a person: they *were* that god or that person's "other" incarnation, and were treated as such. In a fragment of a lost play by Aeschylus, one of the characters says, picking up a mask of himself, "Look and see whether this image could be more like me, this Daedalic likeness: it only lacks a voice.... It would give my mother trouble: if she could see it, she would certainly turn and shriek, thinking it me, the son she brought up."[14] Looking at one's mask was a way of knowing oneself.

However, Socrates' dictum "know thyself" does not suggest a straightforward inquisition. According to Diogenes Läertius, Socrates would offer a mirror to his disciples so that if they were handsome, they would strive to be worthy, and if they were homely, as he was, they should seek to be wise.[15] Pausanias, in what may be considered the world's first tourist guidebook to Greece, also from sometime in the second century A.D., tells of a tarnished mirror fitted to the wall of a temple in the so-called Sanctuary of the Mistress, half a mile from Akakesion, in Arcadia, in which a visitor leaving the temple would see, on the right, his face but dimly reflected, since only the goddess was capable of clearly knowing the visitor's true self.[16]

What relationship did the Greeks have with their mirrored images? In Plato's day, the Sophists' had equated such reflections to the unreality of solid flesh and bone. For the Sophists, both were illusions. Mocking this notion in a late dialogue, Plato described the Sophists' denying reality simply by closing their eyes and refusing to admit the information provided by their senses, whether of "the actual thing" or of its image.[17] But even if the reality of a living face were to be admitted, what of the reality of its representation? How "real" was a mask, or the painting of a face, or a reflection in a mirror? Did its reality depend on the moment of perception, when the public saw the actor act, or when someone looked upon the features of a loved one dead, or when someone caught his or her own likeness in a circle of polished metal? Or did the reality of these images have an ongoing existence, beyond

the eye of the beholder? Mirrored images were, for Plato, "false creations," since the reflection in a mirror has no tangible reality. "If you should choose to take a mirror and carry it everywhere," says Plato's Socrates, "you will speedily produce the sun and all the things in the sky, and speedily the earth and yourself and the other animals and implements and plants and all the objects...." "Yes," answers his companion, "the appearance of them, but not the reality and truth."[18]

And yet, some degree of "reality and truth" was conveyed by these appearances in mirrors and in masks. After the middle of the first century A.D., masks were put to uses other than those of the stage: decorations on grave monuments, for instance, on murals and on sarcophagi. A marble relief, probably copied from an early Hellenistic original, shows the poet Menander looking at the mask of a youth, while other masks sit on a table nearby: it is as if we, the viewers, are meant to read in the scene not only a likeness of the dead man and a symbol of his craft (a poet was "a dealer in masks")[19], but also of the self and its reflection, of someone who in death has learned to look upon the faces he wore on the world's stage.[20] In this portrayal, "the actual thing" and its image coincide in one place: the moment of death.

In the Villa of Mysteries, in Pompeii, a country house built sometime in the middle of the third century B.C., a famous fresco depicts a scene that archaeologists suggest formed part of a Dionysian rite.[21] On the right-hand corner of the farthest wall, the seated figure of the satyr Silenus holds up a bowl for a young man to drink from. Behind them, another young man holds up a theatrical mask so that as the young man peers into the bowl, perhaps to see his future in the mirrored features, the image reflected will not be his own face but that of the bearded mask.[22] The notion is terrifying, since it implies that we may not be the person we think we are; that the image we see cast back to us may not be our own but another — true or false we don't know, but not the face we display to the world. Centuries later, Jorge Luis Borges expresses that same fear, suggesting that

Marble relief of
Menander.

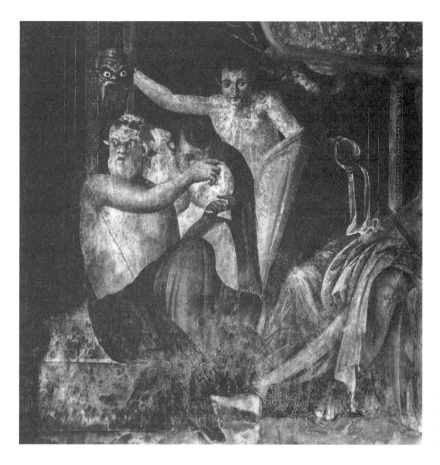

Detail of the
so-called initiation
fresco in the Villa
of Mysteries,
Pompeii.

God created the nights built of
Dreams and looking-glass shapes
For man to feel that he is merely
Vanity and reflection. That's why they frighten us.[23]

In another poem, more generously, he writes:

Sometimes in the afternoon a face
Watches us from the bottom of a mirror;
Perhaps art should be like that true mirror
That reveals to us our own face.[24]

During our lifetime, our face changes. Age, experience, emotions,
accidents and shifts of light alter the traits we believe to be ours, so that

A combination of the letters in *OMO DEI* ("Man of God") forming a human face.

a mirror can constantly surprise us. We have no present face; when we think that we have grasped our features in a reflection, they have already changed into something else, edging our selves into the future. Every one of our cells is reborn in cycles of seven years, wave upon wave; we are never who we are, we are always in the process of becoming. Death (who, as the prophets have warned us, holds up "this mirror ever in re-membrance")[25] begins another kind of alteration, but before the skull crumbles to dust there is one last face that we can call ours, which, if we are lucky, we may be shown. Dante reminds us, in the twenty-third canto of *Purgatory*, that the emaciated human face spells out the word *omo* ("man") for us to read: each eye is an *o* and the *m*, the nose and the superciliary arches.[26] It is that face that the Persian soldier sees.

The critic Roger Caillois, discussing the use of masks as a way of mimicking nature, argues that there exists a natural law whereby organisms become captured in their environment, taking on aspects of the space around them.[27] The face we show is the face by which we are seen, lending a new twist to Bishop Berkeley's pronouncement in the eighteenth century, "to be is to be perceived."[28] For the French psychiatrist Jacques Lacan, this theory can be used to explain how humans acquire an image of themselves.[29] According to Lacan, the child identifies with an outside image, a mirror image, which both allows him mastery over his body and provokes in him an essential sense of alienation. This identification with an image takes place at about eighteen months: prior to that age, "infants do not seem to know that what they are seeing in a mirror is their own reflection,"

says the American psychiatrist Daniel N. Stern. "This can be shown by surreptitiously marking infants' faces with rouge, so that they are unaware that the mark has been placed. When younger infants see their reflections, they point to the mirror and not to themselves. After the age of eighteen months or so, they touch the rouge on their own faces instead of just pointing to the mirror. They now know that they can be objectified, that is, represented in some form that exists outside of their subjectively felt selves."[30]

In order to know objectively who we are, we must see ourselves outside ourselves, in something that holds our image but is not part of us, discovering the internal in the external, as Narcissus did when he fell in love with his image in the pool[31] —

Magnus Enckell,
*Narcissus*,
1896–1897.

though Pausanias dismissed the legend by arguing earnestly that a grown boy would not have mistaken a reflection for the real thing.[32] And yet, beyond such scepticism, the mirror, the pool, is nevertheless like a mask that both reveals to us who we are and yet is at the same time something different from us. To know ourselves as God might see us, we must, like the dying Persian soldier, stand still in time, look for our face in a reflection, become our own witness. (Because sometimes mirrors can reflect the truth, in ancient China, the Ku t'ung ching or "Old Brass Mirror" would heal anyone who had gone mad at the sight of a demon by replacing that sight with the sick person's real face. In the third century A.D., the First Emperor of the Ch'in dynasty, Ch'in Shih Huang, was said to possess a mirror that reflected the inner nature of those who looked at it.[33] This "true" face is, of course, the one depicted by the picture of Dorian Gray in Oscar Wilde's classic novel.[34])

Mirror of the
T'ang Period
(618–907).

But dozens of false images of ourselves surround us, and for that reason the emblem of Knowledge (a mirror in the allegorical representations of the late Middle Ages and the Renaissance) is also the symbol of vanity. The face we see in the mirror can be that of our self, the one that must be rendered unto God since every human face is God's self-portrait; it is also a portrait of the wishful self, the double, the forbidden, the desired or imagined self searching to know its own identity.

In the Judaeo-Christian tradition, even God must find out who He is. His utterance to Moses, "I am that I am," must find its mirror in the New Testament, an instant of self-recognition before the moment of His death: if He is made flesh, His omnipresent identity must also be made flesh and must become known to Him. This second divine recognition is not in the Scriptures, but sometime in the Middle Ages scholars imagined a reference to this moment in three of the gospels, when Matthew, Mark and Luke tell of a woman who, having suffered from a

flow of blood for twelve years, was cured after touching the hem of Christ's garment.[35] According to the medieval story, this anonymous woman reappeared in Jerusalem during Christ's Calvary and offered Our Lord a cloth to wipe His weary forehead. He pressed the cloth against His face and when He returned it, a perfect and true likeness (*vera icon*) of His features could be seen on it; in a gentle play on words, the woman became known as Veronica. During the iconoclastic debate in the eighth century, this *vera icon* became the subject of great controversy. For the orthodox of Constantinople, Christ's holy likeness as imprinted on the cloth was unique unto itself and could not be reproduced without blasphemy; for their opponents, the image was a sacred paradigm and it was important that it be reproduced in as many places as possible. Both sides referred to the representation of Christ's face as "the Father's Economy." They argued that like the economy that concerns the distribution of material goods, the likeness of the face of God's Son — the essence of God — also concerned a similar distribution of goods: the distribution of His essence in the visible world.[36]

After the twelfth century, the *vera icon* acquired great significance, and at least three authenticated cloths were treasured in Laon, Genoa and Rome, the most famous kept in the Basilica of St. Peter. To explain this multiplicity, it was argued that Veronica had folded in three the cloth before handing it to her Saviour, and therefore the Holy Face had been imprinted not once but three times.[37] The Cloth of the Veronica (as it came to be known) was thought to possess miraculous healing powers. In the *Golden Legend*, Jacobus de Voragine records that Tiberius Caesar, seriously ill, asked that "the famous physician Jesus" be brought to him, unaware that his servant, Pontius Pilate, had condemned Him to death. Tiberius's delegate meets Veronica and hears from her that he can't now fulfill his master's orders, since the physician Jesus has died on the Cross. But Veronica offers the man an alternative: since Jesus Himself cannot be sent to Tiberius, just as Tiberius has sent a delegate, why not send a delegate image of His face instead? Confident in the power of the healer his officers have crucified, Tiberius has the road to Rome carpeted with silk cloths and orders that the image be brought to him. "And the moment he looked at it," De Voragine concludes, "he won back his pristine health."[38] The cloth that Veronica held in front of Christ not only offered the Lord about to die a final mirror, preserving the inconceivable face for future believers, but also acquired certain of His attributes and became faithfully imbued with divine healing powers.

Hans Memling,
*Saint Veronica.*

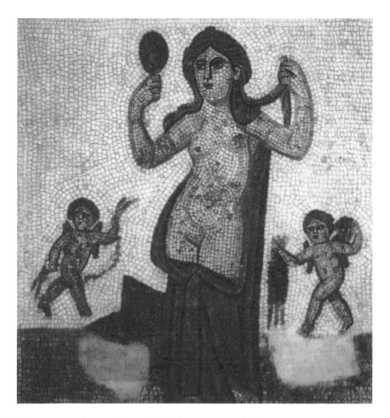

Roman mosaic showing Venus at her toilette.

God's mirror shows Him both human and divine; every human mirror is also of a double nature. It reflects both the body and the soul, the loveliness of vanity and the reality of prudence. Both qualities are offered by the mirror and we can choose to see either: whichever face we see is our own. "We make mirrors, not faces," warned the mirror-makers' guild of Renaissance Florence.[39]

As an instrument of loveliness, the mirror accompanies Venus in her toilette, as in a wonderful Roman mosaic that depicts the goddess, half disrobed, lifting her hair in front of a hand-held mirror, accompanied by two cupids, one on each side. Or, more lasciviously, it serves to draw the drinker's attention to the self-absorbed charms of a courtesan, looking at herself in a mirror, as depicted on the tondo of an early-classical Greek cup that carries the simple inscription "She is beautiful." With the strictures of Christianity, the image of the preening woman was translated into a warning against the secondary sin of vanity. Now the mirror no longer reflected beauty; instead, it showed, for those willing to see, the utter opposite of God's radiance, the Devil's rear.

*Vanitas*, woodcut attributed to Albrecht Dürer, in which the Devil's rear can be seen in the woman's mirror.

"The mirror is the Devil's ass" was a sixteenth-century Spanish saying.[40] More commonly, the mirror of vanity displays the face of Death, mimicking the gestures of a preening young woman.

Jan van der Straet, *Modesty and Death*.

Mirrors cast back the brittle adornments with which we clothe our body, but also the light of truth that offers illumination through contemplative life. Mirrors have the qualities both of Martha, who sees the solid realities of the world and the flesh, and of Mary Magdalen (assimilated to Martha's sister), who sees the inner world of the soul. In fact, both aspects co-exist in Mary Magdalen herself, who, as the repentant whore, displays in the mirror, like Venus, her finery and sensuous body,

Artemesia
Gentileschi,
*The Conversion of
Mary Magdalen.*

and as the bride of Christ, searches in the mirror for her true sacred
self. In 1620, the gifted Artemisia Gentileschi painted in Naples *The
Conversion of Mary Magdalen*: we see her sitting at her table in a rich
damask dress, one hand on her heart, the other on the mirror that
reflects her physical beauty and on whose frame are inscribed the
words from Luke 10:42, "But one thing is needful: and Mary hath
chosen that good part" — *optimam partem elegit* — which Hamlet

translated for the benefit of his mother as "throw away the worser part of it, / And live the purer with the other half."

During the Victorian Age, the theme of the "mirror of Venus" became emblematic of female identity (and remains the symbol for woman — ♀). As the American historian Bram Dijkstra makes clear in his lengthy study of the female image in the nineteenth century, *Idols of Perversity*, fin-de-siècle woman existed mainly in her reflection: either as a mirror for the world of man, civilized and tame, or as the mirror of nature, bestial and unleashed. "To prevent loss of self," Dijkstra remarks, "she had to reassure herself continually of her existence by looking in that natural mirror — the source of her being, as it were, the water from which, like Venus, she had come and to which, like Ophelia, she was destined to return."[41] Woman's death by water was a common Victorian theme: giving herself up for love, she lost her identity, symbolized by her reflection, either sinking into it or breaking it. Tennyson's Lady of Shallot does both: her mirror cracks "from side to side," and she loses herself in the water that carries her funereal boat down to Camelot.[42]

The mirror as a physical instrument for self-reflection was a common presence in the Renaissance scholar's studio.[43] In the early Middle Ages, mirrors had acquired the connotation of encyclopedias: since they could (and did) reflect everything, they became an apt metaphor for a collection of knowledge that aspired to being universal. The true and ultimate mirror, according to St. Augustine, was the Holy Book, which reflected both God's glory and man's miserable condition. "See if you are he whom He speaks of," Augustine wrote in a commentary on the Psalms. "If you are not yet him, then pray that you become him. God will show you his features ... and his radiance will show you who you truly are. If you see yourself with blemishes, you will displease yourself and will already be on the path of beauty. Pointing out your own faults, you will learn to become beautiful."[44]

Following the notion of a book as universal mirror, numerous "mirrors" were written from the sixth to the sixteenth century, collecting and providing information on education, amorous conventions, morals, instructions for the faithful, natural history, witchcraft and all manner of subjects. According to Joseph de Chesnes in his *Miroir du Monde* of 1587, God offered man a text to read in the mirror of the world, a text of which man himself is part. "If man wishes to see himself/ If he wishes to gaze upon the greatness of his soul/ He must cast his eye upon this mirror of the world."[45]

In many Renaissance portraits of writers and scientists, the presence of a mirror lent the sitter a learned quality, since mirrors were known to have numerous uses for the scholar. A mirror could be treated as a magnifying glass (even though it reflected script in reverse) to study the small script of studious tomes. It could be angled so as to concentrate the light, and as the calligrapher Gianbattista Palatino noted, it helped "preserve the sight and comforted it during constant writing."[46] But above all, it reminded the owner of his own self. In the midst of scholary pursuits, studying nature or recording the events of history, speculating about philosophy or criticizing the manners of society, the scholar might forget that the object of his curiosity is defined through that first person singular whose senses reveal or conjure up the world. Whether the observer is central to the system, like Ptolemy's earth, or shifted to a distant point, like the earth of Copernicus, his studies are defined by the conscious existence of him whose face the mirror reflects, *memento mori* and *memento vitae* all in one. For the German mystic Meister Eckhart, writing in the late thirteenth century, God Himself was this self-conscious mirror, but while a man's semblance disappears when the viewer moves away from the glass, God's image is ever-present, reflection and existence all in one. "The eye with which I see God," he writes, "is the same eye with which God sees me."[47]

Man's reflection, however, remains divided. Among the many elements that furnish the allegorical geography of Jean de Meun and Guillaume de Lorris's *Roman de la Rose* in the mid-thirteenth century are two fountains. The first is described in the main part of the book, written by Jean de Meun. Flowing from a triple source in the Beau Park, this pure fountain nourishes the olive tree's fruit of salvation. At its bottom lies a three-faceted carbuncle or ruby whose perfect reflection of eternal light makes the day last forever, and in whose crimson radiance any man can see his true face reflected, as well as the whole of the garden. This is the Mirror of Nature that reveals to man his soul, in perfect truth. The other fountain is imagined by Guillaume de Lorris, in the deceitful Garden of Deduit (or Pleasure) where nothing is stable. This dubious fountain, which he calls "a perilous mirror," is murky and unclear. No man can recognize his face in its dark waters, and the two clouded crystals that lie at the bottom merely reflect a small part of the garden and only on days when the sun shines very brightly. This is the fountain that killed Narcissus: when someone looks into it, he sees not his soul but simply his body, a transitory image that he takes to be his true self. Lorris's

fountain is also the mirror described by W. B. Yeats in "The Two Trees,"
when he warns his beloved to "gaze in thine own heart" and not

> . . . in the bitter glass
> The demons, with their subtle guile,
> Lift up before us when we pass . . .
> For all things turn to barrenness
> In the dim glass the demons hold.
> The glass of outer weariness
> Made when God slept in times of old.[48]

Because Narcissus' mirror (the "bitter glass") is a false one, Dante
places it in the Hell of the counterfeiters who would (it is suggested)
lap it up as if its reflections were real.[49] Comparing the two fountains,

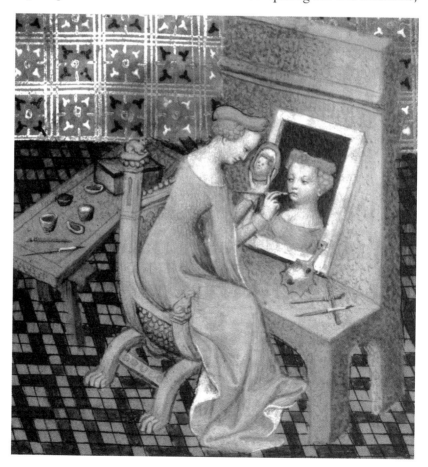

Portrait of Marcia
in a fourteenth-
century French
manuscript of
Boccaccio's *De
claris mulieribus*.

Genius, the garden's keeper, warns that the Fountain of Deduit makes living men "drunk with death," while the one of Beau Park "makes the dead live once more."[50] One reflects the corruptible flesh, the other the promise of the resurrection.

I suggested earlier that every portrait is a mirror; contrariwise, mirrors, whether instruments of vanity or of soulful reflection, are portraits. In a fourteenth-century illuminated manuscript of Boccaccio's *De claris mulieribus*,[51] the illuminator depicted the painter Marcia (a pagan virgin artist described in Boccaccio's treatise on female virtues) painting her self-portrait from a hand-held mirror: in the small framed illumination she appears three times, as herself, as her reflection and as her own painted creation. The artist looks into the mirror to see her own

Rembrandt van Ryn, *The Artist Open-Mouthed*, a 1630 etching.

features, and then conveys on wood or paper the mirror of a mirror, the self twice removed. Would Marcia (or her illuminator) have seen self-portraiture as an act of introspection or as the depiction of a mask, a face outside the self?

As the critic Ernst van de Wetering explains in his introduction to the catalogue of the 1999 exhibition *Rembrandt by Himself*, the term "self-portrait" did not come into existence until the nineteenth century. Instead, if one wished to speak of a self-portrait in the previous centuries, one would call it "Rembrandt's likeness done by himself" or "the portrait of Rembrandt painted by himself."[52] The *Oxford English Dictionary* does not trace an appearance of the word further back than 1840, to Isaac D'Israeli's *Miscellanies of Literature*. It is as if, in the eye of society, the painter and the subject, even when that subject was the painter himself, were seen as two separate entities, observer and observed. In a way, that early thinking was right: there is no such thing as a self-portrait, since that which the painter sees and puts on canvas is outside himself, "another." Rembrandt's self-portraits, of which he painted or sketched close to a hundred throughout his life, appear

when viewed in sequence as a series of "others": less an evolutionary portrait of one man than a catalogue of possibilities for the man or woman who sees them. While some of the self-portraits were no doubt meant to be recognizable likenesses of the artist, others were depictions of another man's emotions or attitudes for which Rembrandt merely posed. He himself saw these self-portraits as artificial creations, as attitudes contrived by the artist much as if he were arranging the gestures of a model on the stand. Rembrandt's pupil, Samuel van Hoogstraten, advised his own pupils to look into a mirror and "reshape oneself entirely into an actor . . . being both exhibitor and beholder."[53]

In 1997, the Museum of Mankind in London held an exhibition on the people of Patagonia. The last image in the show was a photograph taken in 1939 by a German ethnographic expedition, showing a Native man of Tierra del Fuego whose head is being forcibly held up to the camera.[54] The man's face stares at the lens (and now at us, the new intruders) with watery eyes and a mixture of emotions that it would be impertinent to interpret. The image has the brutal, horrific quality of violence being done to someone, in a place that is meant to remain utterly private. By means of the camera, the man's face is snatched from him and offered to alien eyes, not as a mirror or a portrait, but as something akin to the spoils of a rape. Such an image effectively destroys what it sets out to portray.

The soldier whom Philoxenus painted in a now-vanished mural, who sees his dying face in the mirror of a shield, later reproduced in a mosaic by a Roman artist and later still brought back to light in the excavations of a vanished city, is the anonymous individual incapable of knowing that someone would imagine his face and its image at the moment of his death; he is also the artist's reflection on the act of dying, and on the ancient imperatives of knowing who we are before we are no more. He is the Roman version of the question as conceived by the contemporaries of Seneca; he is the same question rephrased by Christianity in an effort to reassess the self, an act symbolized by the *confessio in extremis*; he is the paradoxical nature of the mirror that feeds vanity and mourns sin; he is the mirror of Everyman held up to our common human nature; he is not an instance of destructive violence, as shown in the photograph of the Patagonian Native; he is the emblem of the creative act itself, the reproduction of a reproduction of a reproduction of God's own image, clay returned to coloured clay.

A 1939 photo of a
Native man from
Tierra del Fuego.

If every portrait is a mirror, an open mirror, then we, the viewers, are, in turn, a mirror for the portrait, lending it sensibility and sense. The soldier sees his dying face in the shield, but his own face, in its humanity, reflects the birth and growth and passing of the world. This apparent confusion of roles, this mingling of identities that joins and then separates creator and creation, portrait and viewer, produces in the presence of a reflected image (but perhaps this is true of any work of art) a tension in which we, the audience, appear to be on both sides of the canvas at the same time, watching ourselves being watched. Jackson Pollock liked to place his canvas on the floor to apply his

paint. By doing this, he said, "I feel nearer, more a part of the painting, since this way I can walk around it, work from the four sides and literally be in the painting. This is akin to the method of the Indian sand painters of the West."[55] In this intimate relationship a new identity is formed in which sitter, artist and observer become all at once one and the same.

Pablo Picasso

The
Image
as
Violence

*These are animals, massacred animals.*

*That's all, so far as I'm concerned.*

*It's up to the public to see what it wants to see.*

Picasso on *Guernica*

IF A PORTRAIT IS AN OPEN MIRROR, is it possible to read it in any coherent way? If a single portrait can become, as in the case of Pablo Picasso (perhaps the most versatile portrait painter of the twentieth century), a multiplicity of portraits, faces and bodies displayed in his myriad styles, how might we read it according to our own experience or vocabulary?

Picasso's evolution wasn't linear, it was geometrical. Each new style that he encountered and then incorporated into his work fed on his previous styles and enriched them retrospectively, leading to other forms and minglings of those styles. Throughout his life, Picasso kept odds and ends like a miser: pencil stubs, boxes, bits of metal and wood.[1] Like a miser, too, he preserved the successive styles he attempted, so that late in the years before his death, long after the jagged horrors of Avignon and the bucolic roundnesses of Juan-les-Pins, he could resort to the black lines and faded colours of his Spanish and early Paris days when he already seemed to know everything. He was a paradox: a clearly evolving artist for whom time stood still. Picasso advanced in one same, fixed place.

His portraits too — especially his portraits of women — are caught in this paradox. Jacqueline, Marie-Thérèse, Olga, Dora have lost their personal identity together with their surnames; they've acquired instead the identities Picasso painted for them when they entered his fixed and fluid universe as *Woman Sitting*, *Woman Reading*, *Woman with Beach-Ball*, or sometimes *Portrait of Jacqueline*, *Portrait of Marie-Thérèse*, names that seem fictional, made up for the occasion. Quite unlike, for instance, Edward Weston's photographs of Tina Modotti or Marianna Gartner's subjects, Picasso's women are present — soft or broken into angry pieces, lightly sketched or cut in acid — not

through gestures of their own choice. They are there as reflections of Picasso, the self-appointed master.

What perhaps never changed throughout his many styles was his attitude toward his sitters. Perhaps, as his friends and lovers declared, Picasso was incapable of feeling deeply for another person, and this made it impossible for him to portray others except as himself. "Nobody has any real importance for me. As far as I'm concerned, other people are like those little grains of dust floating in the sunlight," he once told Françoise Gilot.[2] Instead of feeling in his own mind and body, Picasso seemed to feel on canvas, making graphic sense out of the "little grains of dust." The critic John Berger noted that Picasso's "portraits of women are often self-portraits of himself found in them." Picasso, Berger wrote, "can only fully see himself when he is reflected in a woman."[3] It may be that in an almost physical sense, all his sitters were, in fact, used as canvases — canvases prepared through cajolery, through fear, through lovemaking, through money or friendship, causing the emotions he wished to experience himself to well up in the sitters. The procedure is the reverse of the neoclassicist norm of eighteenth-century academic painters such as Jacques-Louis David (whom, according to Malraux, Picasso derided),[4] for whom the canvas had to portray not the painter's emotion but the sitter enacting the conventional gestures of an emotion. If so, what part does Picasso allow the viewer to play? Are we to be the accomplices or merely the observers of Picasso's representation?

One of the most memorable of Picasso's "portraits" is no doubt his *Weeping Woman* of October 1937, which the critic Ronald Penrose acquired from Picasso that same year (and later sold to the Tate Gallery in London, where it now hangs).[5] Small, the size of a human face, it burns in complementary colours that pull the eye in opposite directions: green and red, violet and yellow, orange and blue. The white handkerchief crumpled into sharp corners takes on the traits of the wiping fingers and the gnashing teeth. Against the background of golden browns and yellows (part iconic gold leaf appropriate to sacred subjects, part Paris bistro wall with its common profane passions), the red hat and its deep cornflower touches me more than any other detail in the picture. The woman has made herself beautiful, put on a cheerful hat, combed and adorned herself in expectation of happiness, and now here she is, displayed for all to see, deformed by grief, her hat mocking her distress, happy and stylish and overwhelmingly uncaring. How can

we bear to watch this very private sorrow? What is *absent* in this picture that allows us, as outsiders, to enter its space so easily, to pity it and to admire it, all at the same time? What can we learn from this portrait's story that will inform a guided reading, half a century removed, of this emotion-torn and blazing face?

The relation between the life of an artist and the work that artist produces is amply studied by sociologists, psychologists, theologians and writers of fantastic literature. For most of us — the common viewers — an artist's work belongs not only to the artist's life but also to our own lives (lives that include no doubt certain ideas of what that artist's life might have been). Maybe the only usefulness in this kind of information is that it provides sometimes a starting point for observation, a lead (however false), a conjuring-up of images (however bewildering), around which the viewer's reflections on the work can cluster. One of these starting points is Paris, 1935.

That year, one autumn evening, the fifty-four-year-old Pablo Picasso saw a woman sitting across from him at a table in Les Deux Magots. She had pale blue eyes, thick dark eyebrows and very black hair and was wearing black gloves embroidered with roses. She had spread her left hand flat on the wooden tabletop and with her right hand she was trying to drop a small penknife into the wood between her fingers, as close as possible to her hand without actually cutting into the flesh. Sometimes she missed, and after a while the black gloves became increasingly stained with blood. Picasso watched her for a long time and eventually remarked (in Spanish) to a friend with whom he was sitting that he thought the young woman was extraordinarily beautiful. Apparently she understood him, because she lifted her head and smiled. A few days later, the poet Paul Éluard introduced him to her. Her name was Dora Maar and she was a photographer. Later, Picasso asked her for the blood-stained gloves and kept them at home in a showcase with other mementoes.[6]

Dora Maar became his lover, holding herself ready for him whenever he wanted her. She rarely visited his studio on rue des Grands-Augustins (which she had found for him) except when he told her to come over. Every day Maar would wait in her flat in case Picasso might call to invite her out. The painter André Beaudin asked her to dinner one night, but Maar told him she couldn't give him an answer until later that evening because if Picasso called and found she had made other arrangements, he would be furious. She was, she said, his "private muse."[7]

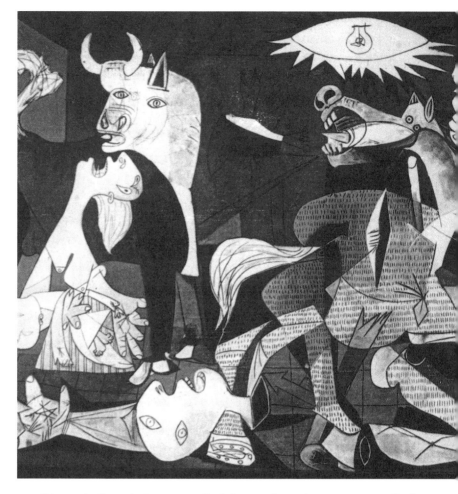

Picasso's friends later recalled how often the two quarrelled. Accusing her of imaginary infidelities, taunting her, mocking her for real or trumped-up mistakes, Picasso would provoke her until she'd break into tears. Then he would pull out his notepad and pencil and sketch the weeping woman. "I could never see her, never imagine her, except crying," he once remarked.[8] Eventually, these sketches, of which there are dozens, developed into paintings. At the time, Picasso was still married to the Russian dancer Olga Koklova and in the midst of a long affair with Marie-Thérèse Walter. Most of Picasso's portraits of both these women are done in full, soft curves. Most of the portraits of Dora Maar, however, show a ravaged, hurt, distorted face painted in harsh colours, shattered by sorrow. "They're all Picassos, not one is Dora Maar"[9] was later Dora Maar's comment.[10]

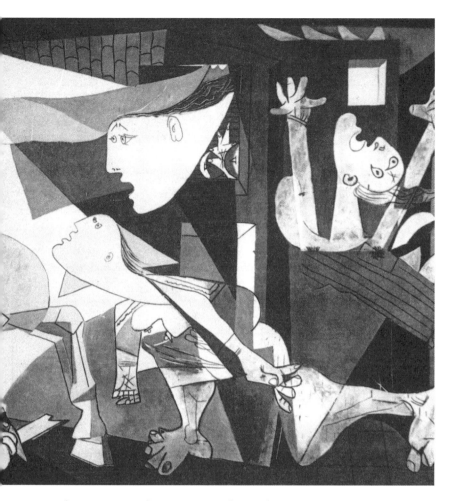

Pablo Picasso,
*Guernica.*

Almost a year after Picasso and Maar's meeting, on July 13, 1936, the Spanish monarchist José Calvo Sotelo was murdered, and civil war broke out in Spain. From the start, Picasso's sympathies were strongly in favour of the legal Republican government and against the monarchist forces. In January of 1937, the Republican government asked Picasso to create a vast mural for the Spanish Pavilion in the International Fair due to open in Paris in the spring, and left him the choice of the theme. Picasso accepted the commission, even though he couldn't think of a subject. By early April, he had not yet begun his painting.

On the morning of April 28, Nazi planes attacked the small Basque town of Guernica, killing two thousand civilians and wounding many more. Picasso had found his subject — or rather, the subject had found him. In May, the first sketch of a colossal painting, 7.62 by 3.35

metres, was completed. He decided not to use colour: the terrified animals,[11] the screaming women tower over the viewer in blue-black and dirty white. To the left, the focus of the painting is a woman holding her dead child, her face convulsed in pain. The face of the tearless weeping woman is that of Dora Maar.

Over sixty years after it was painted (after World War II, after Korea, after Vietnam, after the Falklands War, after Afghanistan, after Kosovo), *Guernica* has become the foremost (dare one say hackneyed?) anti-war image and the weeping woman clutching her child its most memorable, perhaps essential, detail. The French poet Michel Leiris, writing in 1937, saw in *Guernica* our society's death notice, telling how "everything we love is going to die, and that is why right now it is important to die, and that is why right now it is important that everything we love be summed up into something unforgettably beautiful, like the shedding of so many tears of farewell."[12] Thirty years later, John Berger was more precise: *Guernica*, he writes, "is a painting about how Picasso imagines suffering":[13] that is, it is the representation of the idea of suffering, not the expression of an emotion.

The conjunction of Dora Maar and *Guernica* puts forward a new paradox, suggesting that an act of deliberate private cruelty can be transformed into a public image that *condemns* cruelty. How is it possible that within a work of art, an act of hatred (or an act of love) is transformed into a symbol that denotes its contrary? And through what history does the new image become part of the iconographic vocabulary of our time?

In Western culture, the insensitivity of the brutal lover became, as in a distorting mirror, an attribute of masculinity. Theseus, son of a mortal woman and the god of the sea, uses his male strength to accomplish a number of seemingly impossible tasks, but he requires Ariadne's female intelligence to find his way through the labyrinth and kill the Minotaur. Having used her, he famously abandons her; later he is crowned king of Athens and honoured as the city's greatest hero. Closer to our time, the French novelist André Gide saw him as the glorified male, able to free himself from the all-possessing grip of the cunning Ariadne-woman.[14] For Gide, Theseus's treatment of Ariadne becomes justified because it serves a larger social purpose: the killer of the Minotaur must use and then abandon Ariadne before he can dedicate himself to the protection of the state (or, in the case of Picasso, to the service of art).

As in the Theseus legend, both notions burn simultaneously in Picasso's paintings: in the *Weeping Woman* with her private agony, in *Guernica* with its public pain. Although Picasso painted *Weeping Woman* in October 1937, he had sketched the distraught face of Maar for over a year before that. *Guernica* was completed in May 1937, but Picasso continued to sketch the figures of the bull and horse, the bird and the slaughtered people beyond a year *after* the canvas was finished. Depending on what chronology we choose, our vision of these masterpieces changes. If we consider the creation of *Weeping Woman* being sketched before *Guernica* (as was the case), we are faced with an image that has

*Weeping Woman,*
one of the drawings
from the *Guernica*
series.

Pablo Picasso,
*Rape.*

been constructed out of personal and deliberate suffering being used to criticize a cruel new act of war — the deliberate killing of civilians from the air. If *Guernica* comes first in our imagination, then an image used in the service of the huge theme of social violence was captured in order to experiment, with clinical unfeeling, on a woman in love.[15] In either sequence, one end of the equation consists of the unforgettable depiction of pain, vast in its imaginative repercussions, exemplary in its appeal for pity and revolt; the other entails the calculated infliction of pain. Both are part of the portrait's reality.

How can pain be represented?

In the same year Picasso painted *Guernica*, he drew a small pencil sketch of a man raping a woman. The sketch is carefully dated ("22 Janvier 37") and shows a man standing over a supine woman, his teeth and tongue protruding as in the massacred horse of *Guernica*, his trunk-like penis impaling her, his large hands around her neck, strangling her while she opens her mouth in an *O* of horror. Hands and penis are the largest, most notable features of the rapist, uncannily reminiscent of the medical model of the human body represented not to scale but according to our subjective perception of its dimensions: huge sexual organs, large hands, tiny torso and so on. These features appear again in Picasso's later sketches of couples making love, and in his famous drawings of the Minotaur pursuing

A model of the human body according to the proportional representation of its parts in our brain, drawn by the Canadian neurosurgeon W. G. Penfield.

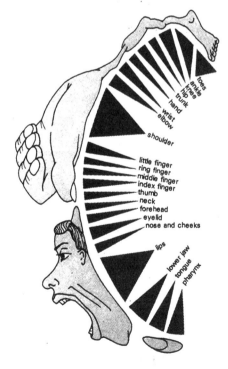

and raping women, or making them weep. Commenting on Picasso's womanizing, Cocteau shrewdly observed, "This womanizer reveals himself as a misogynist in his works. There he takes his revenge for the hold women exert on him and for the time they consume, and there he savagely attacks their faces and their outfits. On the other hand, he flatters the male and, since he has nothing to reproach him, he pays homage to him in pen and pencil."[16]

Throughout Western art, we have learned to look aesthetically at the image of a woman weeping. The classical image of female grief, common in Hellenistic sculpture, is that of Niobe, who wept for nine days and nights over her dead children (twelve according to Homer, fourteen according to Ovid) slaughtered by Apollo and Artemis to avenge their mother, Leto, whom Niobe had mocked for having only one son and one daughter. Niobe's image is trans-

Niobe, a copy after an original of the fourth or third century B.C.

ported to other settings: the grieving mothers in depictions of the Slaughter of the Innocents, grieving daughters in historical scenes such as *The Lictors Bringing to Brutus the Bodies of His Sons* by David, grieving women at the foot of the Cross, Rachel (the personification of Israel) weeping for her children in the prophecies of Jeremiah.[17] In the eighteenth century, female tears, once a sign of weakness, were elevated to the status of a praiseworthy sign of sensibility, and for a time it was permissible for men to join in the weeping.[18]

Weeping figures painted on the side of a third-century B.C. tomb from the necropolis of Laghetto, Italy.

Detail of Jacques-Louis David, *The Lictors Bringing to Brutus the Bodies of His Sons.*

In private grief, the mere evocation of a painful image was enough to justify the manly shedding of tears. When Rousseau, in his *Confessions*, recalls his own father saying, "'Jean-Jacques, let us speak of your mother,' I would say to him, 'Ah well! In that case, my father, we are going to cry' and these words alone already drew tears from him."[19] These tears bonded the two men, and spiritual camaraderie was signalled through tears not only between father and son but between male friends. Writing to his fellow philosopher Denis Diderot at the time of one of their quarrels, Rousseau makes clear the difference between friendship in tears and enmity without them: "I have never written to you without emotion and my last letter was bathed with my tears; but at last the dryness of yours has reached me. My eyes are dry, and my heart is closed as I write to you."[20] In this context, men's tears appear honourable, even desirable, and their absence is an indication of anger, or worse — indifference.

However, most men in Western art suffer stoically. Laocöon, the Trojan priest strangled with his two sons by the serpents of the goddess Athena, is represented in a celebrated group of marble statues from about 25 B.C. in "restrained agony."[21] Male saints and sinners have a certain claim to tears. Masaccio's weeping Adam as he is expelled from Paradise,[22] and weeping John, the Lord's beloved, at the side of the Cross;[23] the young Castilian nobleman El Cid falsely accused of embezzlement, exiled in tears from the presence of his beloved king, asking "Why do you lift the drapes of my heart?"[24] and Dante moved to tears by the eternal punishment of his fellow Florentines;[25] John Bunyan's Christian, weeping and trembling as he wails "What shall I do?"[26] and Ulysses weeping for his comrades devoured by the Cyclops[27] exemplify the

permissible shapes of male grief: for one's own faults (real or imagined) and for another man's sufferings (even though that man be also a god). But mostly, weeping in men was deemed unseemly, and "restrained agony" was conventionally the proper male emotion to be depicted. "Let not women's weapons, water drops, / Stain my man's cheeks,"[28] begs

Masaccio, *Expulsion from Paradise*, a fresco in the Brancacci Chapel, Florence.

A 1793 engraving
after a drawing by
John Flaxman,
*Achilles Lamenting
the Death of
Patroclus.*

Lear to the unyielding gods. Even in the grief-loving nineteenth century, Van Gogh's drawing *Old Man Weeping* (which I discovered in my aunt's book, the first image of male grief I had ever encountered) shows the subject with his face buried in his fists, so that the eyes are hidden.[29] In *Guernica* there are no weeping men.

The story of Dora Maar's tears does not end with either *Guernica* or *Weeping Woman*. Like Tina Modotti, her contemporary, Maar was a tal-

ented photographer. Though Picasso used her talents to document his own work and had her photograph, for instance, the creation process of *Guernica* in over a hundred shots, photography was for him an "unrealized" craft. For Picasso, who nevertheless counted the avant-garde photographer Man Ray among his friends, the photographer was merely an artisan who aspired in vain to the art of the painter; he compared photographers to dentists, who, he said, always wanted to be doctors.[30] Even though there are photographic portraits by

Vincent van Gogh,
*Old Man Weeping.*

Picasso himself (*of* himself, for example) he apparently believed that photography would not allow him, as an artist, the usurpation of the model to the degree allowed him by painting or sculpture. In one particular sense he was right. Looking at an early photograph of a Newhaven washerwoman, the cultural theorist Walter Benjamin observed in 1931 that here was "something that does not testify merely to the art of the photographer . . . , something that is not to be silenced, something demanding the name of the person who had lived then, who even now is still real and will never entirely perish into *art*."[31] For Picasso, this perishing was of the essence: the body had to die before being cut up and brought back, Frankenstein-fashion, to life. For Picasso, photography clung too fondly to the living flesh.

In 1943, Picasso had taken the young Françoise Gilot as his new mistress and tried several times to force her to strike up a friendship with Maar. Their confrontation was uneasy — though not as violent as that between Maar and Marie-Thérèse, which ended in a fight on Picasso's studio floor, much to the master's amusement. Sometime later, shortly after the liberation of Paris, Picasso asked Gilot to come and see him, and sitting by her side on the bed, he confessed to her that he was deeply concerned about Maar. He had gone to her apartment to take her out to dinner and found that she wasn't at home; when she arrived, her clothes were torn and her hair dishevelled, and she told him that she had been attacked by a man who had also stolen her dog, a gift from Picasso. Two nights afterwards, she was found by a gendarme near the Pont Neuf, in the same unsettled condition, saying that another man had attacked her and that he had stolen her bicycle. The bicycle was later found untouched, at the spot where she said the attack had taken place. Then, a few days later, she began having religious visions, what she called "the revelation of the inner voice." One afternoon, filled with mystical fervour, she urged Picasso and Éluard (atheists both) to repent of their sins and to kneel before her. When Picasso refused, she screamed at him, "As an artist, you're extraordinary, but morally you're worthless!"[32] After that, what Picasso called her "scenes" became louder and more frequent.

Picasso and Éluard arranged to have Maar seen by their friend the psychiatrist Jacques Lacan, who was gaining eminence as "the man able to answer the questions Freud left unsolved." Lacan kept Maar at his clinic for three weeks and then convinced her to undergo analysis with him. Meanwhile, the two men blamed each other for Maar's condition.

*Dora Maar in 1941,*
*by Rogi André.*

Éluard accused Picasso of destroying her by making her so unhappy, while Picasso in turn accused Éluard of filling Maar's head with Surrealist nonsense. To Françoise Gilot, Picasso said he felt "disgusted by Dora's misbehaving." Curiously, for someone who so forcefully depicted suffering, Picasso lacked all understanding of what a sufferer requires: the presence of another human being capable of recognizing the pain and of lending an ear and a shoulder, not merely a talented eye.

In Lacan's view, Dora Maar's case illustrated the psychoanalytic theories of identity that he had developed a few years earlier. According to Lacan, our identity stems from the mirror images that exist outside ourselves: this "alienating identification" is how we learn to see ourselves. Trapped in an image that is fundamentally alien to us — an image made of myriad haphazard and fractured images, as in a Cubist collage — our ego is, in Lacan's words, "an inauthentic agency," functioning to conceal its essential lack of unity.[33]

Some of this must have become apparent to Maar, seeing herself portrayed again and again in Picasso's fractured, haphazard canvases. But she also perceived something that had perhaps escaped Lacan's analysis. If who she was had been broken up and reassembled to construct her lover's fantasy of herself, then who in fact was she? Unrequited as a lover, unfulfilled as an artist, unacknowledged except as a battered muse, Maar sought to extend as far as possible these incomplete traits of identity, the only ones acceptable to the man who was rebuilding her. And since her image of herself had been shattered, she felt lost and unprotected, but also freed of any limits. She would be not only Picasso's object of violence, but the object of violence of any man, all men, a ready-made victim lending herself to assault and theft on the street. She would be not only Picasso's conduit to making art, his temporary muse, but also his guide to the godhead itself, to the voice of divine revelation. Bereft of a self-constructed identity, she would allow the vaster, alien identities of the masculine and the divine to possess her, make use of her, as her lover had possessed and made use of her.

Except that, if she was to be lost, she would do so actively, as her last self-willed action. In her own mind, she would withdraw from every portrait, from every sketch, from every image of her pain and her sorrow caused and used so deftly by Picasso. She would become an absence. She would (if this were possible) call back her soul from the canvas and leave nothing but the magnificent casing, the brilliantly crafted cocoon. And she would not vanish softly. As loudly as possible, *she* would lose *herself*. It was an act of violence, but the opposite of suicide. As we stare, from Picasso's side of the canvas, at the woman we are told is Dora, it is possible to believe that, beyond the vicarious and circumstantial fame imposed upon her by exhibitions and museums open to voyeurs such as we are, she succeeded.

Dora Maar died in Paris in July of 1997, aged eighty-nine.

Aleijadinho

The
Image
as
Subversion

*We are only moved by that which is invisible.*

Théodore Jouffroy, *Cours d'esthétique*

Aleijadinho,
*St. Peter.*

I WALK THROUGH A MUSEUM, I see paintings, photographs, sculptures, installations and video screens. I try to understand what I see and read the images accordingly, but the narrative threads that lead to them keep criss-crossing: the story suggested by the work's title, the story of how the work came into being, the story of its maker, and my own. And I wonder up to what point I can associate or dissociate the images from their source (if such a thing as irrefutably identifying a source were possible) or from the circumstances of their creation. Can I read an image of hatred, for instance, as a revulsion toward hatred if I know that it was bred in hatred? And since that which informs an image (the chattel of knowledge that accompanies it) can utterly transform, enhance or subvert it, can I read in an image an unspoken or invisible meaning that in effect contradicts what I know of its creation?

With the peculiar reading that the rich give to Deuteronomy 8:3, "that man doth not live by bread alone," the very wealthy King João V of Portugal decided, in 1717, to build a royal library at the University of Coimbra, thereby adding the word of God to his subjects' daily bread. Dissatisfied with this (in his eyes) paltry act of generosity, the king then ordered from Rome marble statues, silver chalices and great carved coaches to supplement the treasures of learning, and in doing so lent the already exuberant Portuguese baroque dear to his people a taste for further whorls and curlicues. To the grapes, acanthus leaves, birds and chubby boys that clung to the church interiors covered in gilt woodwork (the *igrejas todas de ouro*, the "all-gold churches" in the so-called National Style), the king's architects, under the Roman influence, now added grooved Solomonic columns wreathed with flowers and crowned with allegorical figures and flying angels in dramatic postures. In the colonies, the new style prospered under the name of the

distant monarch and, with insouciant generosity, it freely incorporated the voluptuous ornamentation of rococo motifs from other faraway realms such as Bavaria and France.[1]

Not only did the new architectural style enrich itself in the New World with further fashions but in a landscape vastly different from that of the mother country, the buildings that rose to the glory of God in Brazil in the eighteenth century acquired features that seemed literally to grow out of the new soil. In the region of Minas Gerais in particular, the baroque style took on distinctly original aspects,[2] first, without official models or qualified craftsmen, during the chaotic arrival of gold-rush settlers in the early eighteenth century, and then, a few years later, with the birth of local architects and artists, who, being familiar with the land, were able to select and adapt the elements best suited to a place that was not Europe.[3] The architects of Portugal had found their ideal material in gilt wood, as the French had found it in stone and the Italians in marble. But in the hills of Minas Gerais, the artists' materials diversified: there was the gold that ancient European legends had promised the explorers in the New World; there was wood, not the hard *pau brasil*, red as the devil's skin, that had given the country its name, but Brazilian cedar whose suppleness lent itself to intricate carving; and there was that peculiar compact aggregate of talc, the softest of all stones, known as soapstone, once used in ancient China and in Mesopotamia.

Brazilian gold was to be found in the "wildest solitude of the vast mysterious interior," as the much-travelled Captain Richard Burton called it,[4] where stood, everyone knew, the fabled city of El Dorado whose very streets were paved in gold. With a vague belief that in the process they might be serving God as well as their king, hosts of adventurers, hunting the Native people to sell them into slavery, raided the Brazilian hinterland looking for the precious metal. These men "were indefatigable in the search," wrote the English poet and historian Robert Southey in 1822, "with them mine-hunting and slave-hunting went together; the party that was strong enough for security was strong enough for offence; and a herd of Indians repaid them for a bootless expedition in quest of gold."[5]

In 1693, gold had been discovered in Minas Gerais, and during the next few years thousands of prospectors travelled to the promising region. By 1710, there were more than thirty thousand settlers in the territory, spreading out and establishing dozens of small towns and

villages. But another twelve years were to pass before any substantial discovery was made in the area. In July 1722, Bartolomeu Bueno da Silva, at the head of 152 men, set out from São Paulo with the intention of reaching the Serra dos Martirios out west, where, according to tradition, a miracle had sculpted in the rock the nails, spear and thorny crown of Jesus Christ. After three years of roaming in the wilderness, the expedition uncovered not the symbols of the Passion but a rich vein of gold, less than twenty kilometres from the present city of Goias.[6] By 1763, when Rio de Janeiro had become the capital of Brazil and the main port of trade for Minas Gerais, the gold-mining area had spread over more than two million square kilometres.[7]

An early nineteenth-century watercolour by Richard Skerret Hickson, *Scene at the Washing House of Gongo Soco Gold Mine in Brazil.*

Following the admonition to give to Caesar what is Caesar's and to God what is God's, the government decided that since God would have no interest in base material riches, the entire area should be a precinct of earthly pursuits and that all religious orders should be banned from entering it. The settlers organized themselves into secular associations: brotherhoods (*irmandades*) and Third Orders, that is to say, groups of laymen and laywomen who lived under minor vows.[8] The *irmandades* were largely associations of blacks, slaves or freedmen, sometimes elevated by official decree to the category of Third Order.[9] Most of the Third Orders, however, were in the beginning strictly white: the applicants had to prove, among other things, that they, their parents and their grandparents were "pure of blood without any trace of Jewish, Moorish, or mulatto ancestry or of any other infected people."[10] In the

Anonymous watercolour depicting the religious procession *Festa do Divino* in *Minas Gerais*.

region of Minas, both associations worked side by side (in spite of occasional disputes) and offered their members loans, financial aid for medical care and funerals, as well as the sworn guarantee that holy masses would be said for their souls after they were no more. They were also responsible for organizing religious ceremonies in honour of patron saints, and for paying artists and craftsmen to build and decorate the local churches, founded sometimes as meeting places for the congregation and sometimes as fulfilled promises for graces received from Heaven.

Sometime in the first decades of the eighteenth century, a certain Feliciano Mendes, native of the city of Guimarães in northern Portugal, arrived among the hordes of gold seekers in Minas Gerais and made his fortune in the mines. The harsh life, the insalubrious climate, the tropical insects, the back-breaking work left Mendes with a mysterious disease that threatened his life, and being a religious man, he promised his Lord that if he were spared, he would place the rest of his days in the service of a holy image. God agreed to the bargain: Mendes was cured, and true to his word, he began to pay his debt by planting a modest cross on the heights of Monte Maranhão, in the name of the Senhor Bom Jesus de Matosinhos whom, as a young and eager man, Mendes had worshipped in the land of his fathers. To the

wooden cross, the faithful miner added his entire savings, stating in the bequeathing document that this money was to be used for the building of a sanctuary. Under the imposing name of Santuário do Senhor Bom Jesus de Matosinhos do Arraial das Congonhas do Campo, the sanctuary was granted ecclesiastical approval on June 21, 1757, by the Bishop of Mariana, and a chapel was erected, with Mendes's donation, to house the first lay clerics until further funds had been collected for the construction of a grander church. Feliciano Mendes met his grateful Maker in 1765; that same year the builders finished the church's walls and roof. All that was now missing was the decoration, the exuberance so dear to the now much lamented King João. Several of the best artists of the time were summoned by the sanctuary's administrators to work on the interior and exterior: João Nepomuceno Correia e Castro, Bernardo Pires da Silva, Jerônimo Felix Teixeira, Francisco Vieira Servas, Manoel da Costa Athaide.[11] Then, in 1796, the sanctuary's fifth administrator, Vicente Freire de Andrada, called upon the sculptor Antônio Francisco Lisboa, better known as Aleijadinho or "Little Cripple."

Aleijadinho's date of birth has not been established. His certificate of baptism gives that date as August 29, 1730; his death certificate, issued on November 18, 1814, makes him eight years younger.[12] What-ever the year, he was born a slave, the bastard son of an African slave woman and a Portuguese architect, Manoel Francisco Lisboa, who later recognized the boy as his natural son.

As late as 1758, Father Manoel Ribeiro Rocha, imbued with the teachings of the French Enlightenment and steeped in the philosophy of Rousseau and Montesquieu, still found it necessary to point out that slaves were (literally as well as figuratively) sons and brothers of their masters: "They too have a soul, like white men, and Our Lord Jesus Christ also suffered and died for them, and in the churches, masters and slaves all commune at the same table."[13] Only a century later, Brazil's racial diversity, its many combinations of colour, would lead to the legend of a "rainbow country" and spark furious debates on the question of national identity. Who was Brazilian? What race should a Brazilian expect to see when looking into the mirror? What colour was the Brazilian soul?

On the one hand, there developed a theory of "spiritual blending," the notion that the different peoples who had taken up residence in this vast country contributed equally to a common imagination — a

Modesto Broccos,
*Family Portrait.*

theory that caused the literary critic Silvio Romero to declare, in 1888, "We are all *mestizos* if not in our blood at least in our soul." On the other hand, Brazil was supposed to embrace the European racial ideal, to encourage the "whitening" of the country that (according to the defenders of this theory) would bring it forward into the civilization of the twentieth century. This "whitening" was supposed to occur naturally, the mingling of European and African bloods gradually becoming lighter and lighter, "bleaching out the hues of the Dark Continent." When João Batista Lacerda, director of the Rio de Janeiro National Museum, was asked to represent his "typical inbred" country at the First Universal Races Congress in 1911, he concluded, "The hope for Brazil within this century looks to the whitening of the mestizo as its escape and its solution." The slaves who crafted for themselves a better, independent life were seen to "whiten" themselves spiritually, "becoming" the other, as honorary members of their overlords' society. This curious pseudo-scientific theory became known as the myth of racial whitening or *branqueamento*.[14]

Brazilian slaves were of three kinds: those who worked on plantations under the supervision of taskmasters; those who worked in the city as servants in white households; and the *mineradores*, those who were "set free" in order to search and dig for gold in the scorching hinterland — a task that could not be performed in shackles. By the end of the eighteenth century, more than half a million slaves had been shipped to the gold-mining region of Minas Gerais, but the rate of mortality was high, and slaves rarely survived more than seven years in the mines. There were those, however, who found ways of escaping the miner's life and working instead in one of the dozens of professions needed in these remote areas where the proportion of blacks and mulattoes to whites was approximately six to one. Of these, a fair number became craftsmen and artisans of great distinction.

The beginnings of Aleijadinho's career were fairly auspicious. First his father, and later the painter João Gomes Batista, trained him in the arts of architecture and ornamental draughtsmanship. The names of his sculpture masters remain uncertain: the French critic Germain Bazin suggested the Portuguese artist José Coelho Noronha, among others. The young man excelled in all three crafts, and once his reputation was established, he set himself up as a gentleman's son with slaves and servants of his own — one step along the road to *branqueamento*. According to the account left by Rodrigo José Ferreira Brêtas, who in 1858 wrote Aleijadinho's biography based on the testimony of those who had known him and were still alive,[15] he was "dark skinned, had a fiery voice and a short temper; his height was small, his body fat and ill-shaped, his face and head were round and the latter was voluminous, his hair was curly and black, his beard tightly-knit, his forehead wide, his nose regular and somewhat pointed, his lips thick, his ears large and his neck short. He could read and write, but there is no proof that he attended class beyond elementary school; there are those, however, who think it probable that he took lessons in Latin.... He spent his life in the pursuit of his art, always eager to keep an excellent table and perfect health, and he was often seen taking part in the lewdest of dances. Then, in 1777, he began to suffer severely from certain symptoms probably caused by venereal excesses."

Ferreira Brêtas suggested the disease might have been a virulent form of scurvy, or the *zamparina*, an influenza-like sickness that leaves the victim with paralyzed and deformed limbs. However, the exhumation of Aleijadinho's remains, conducted in March of 1998 by Dr. Geraldo Barroso de Carvalho,[16] concluded that as well as having contracted Hansen's disease or leprosy, Aleijadinho suffered from porphyria, an inherited disorder that involves the excess production of certain chemical substances known as porphyrins, reponsible for a wide series of abnormalities that range from sensitivity of the skin to sunlight and spotty pigmentation to severe abdominal pains and mental confusion. As a result of these afflictions, Aleijadinho became blind in one eye and all his teeth fell out, giving his mouth a hideously fierce expression. According to Ferreira Brêtas, the intolerable pain in his fingers and toes led him to cut them off, using his sculptor's chisel.

Unable to work on his own, Aleijadinho sought the assistance of an African slave, a carver by the name of Maurício, who would attach chisel and mallet to the artist's crippled hands, as well as endure with

respectful meekness his master's fits of rage. Slaves newly arrived from Africa were highly valued, since they were supposed not to have learned the wiles of those with a long experience of the new country, and the name given to these newcomers, *boçal*, came to mean "stupid" or "green" in the local jargon. Contrary to expectations, Maurício proved to be a gifted and invaluable assistant.

To protect himself from impertinent eyes, Aleijadinho would leave his house before dawn and return after dusk, and travel with a makeshift tent that he would erect around himself when he worked. Like Lavinia Fontana's wolf girl, Aleijadinho the Cripple became the monster other people saw; unlike her, a grown-up man and the master of his own career, he was able to imbue that monster with qualities of his own design. Instead of accepting without question the latent notion that white was "better," Aleijadinho began to exaggerate the worst qualities of his social whiteness, exacerbating the prerogatives of his position both as an artist and as a gentleman's son, the owner of slaves and master of apprentices. He became irascible, tyrannical, intolerant, demanding. Though among friends he usually appeared in fine humour, in public he started throwing violent and furious fits, usually triggered by the prurient curiosity of strangers. One day a certain general demanded to be allowed to slip under the cover in order to observe the master's craft, but he was forced to leave after only a few minutes because of the shower of dust and splinters that Aleijadinho deliberately let fall on the impertinent intruder.[17]

The first commission of which we have documented proof is the decoration of the Church of São Francisco de Assis in Ouro Preto in 1766, when he was thirty-six years old (or, if we believe his death certificate, twenty-eight). Aleijadinho completed the facade, delicately curving the soapstone pediment above the main door and playing with a combination of two colours — grey for the sculpted elements in stone, ochre for the structural outlines. He also worked on the interior, where he carved the magnificent chapel of the high altar (*capela-mor*), all the statues and both the pulpits and painted the ceiling of the nave with an Assumption of the Virgin and the mock tiles around the altar with scenes from the life of Abraham. By the time he reached Congonhas, three decades and many commissions later, to complete the promise of the grateful Portuguese miner, Aleijadinho was one of the most celebrated and sought-after artists of Minas Gerais.

Full view of the sanctuary of Congonhas.

The sanctuary of Congonhas rises above a winding path of yellow stones and straggling palm trees. Inspired by the example of the Church of Bom Jesus in Braga, Portugal, the twin-towered building sits on a terrace reached by two staircases, one on each side, bent like the arms of a stone giant holding the entrance gates between his hands. For Congonhas, Aleijadinho realized two masterpieces: a series of six life-size scenes illustrating Christ's Passion, carved in wood and housed in little chapels along the road that leads to the sanctuary itself, and a collection of twelve large free-standing soapstone statues representing almost all the Old Testament prophets, rising like turrets from the

Aleijadinho, Chapel of the Last Supper.

Aleijadinho, Chapel of the Carrying of the Cross.

balustrade of the terrace and stairs of the sanctuary. In all, during the nine years he spent in Congonhas, Aleijadinho produced seventy-six sculptures that must be reckoned among the most powerful and dramatic of his time.

The Passion scenes housed in the "road chapels" (*capelas do passos*) along the zigzag path demand that the visitor enter and look upon them in a restricted, intimate setting, as a hushed story told privately to the viewer. The *capelas do passos* are set along this narrative line, from the Last Supper to the Crucifixion; they unfold in time as well as in space, both in the time of Christ's story and in the time it takes the viewer to progress from the first scene to the last, as if witnessing a magnificent procession. The people of Minas Gerais would have been accustomed to the grand and colourful processions organized by the Third Orders and the *irmandades* to celebrate religious holidays and the anniversaries of patron saints. These processions (sometimes the source of lively squabbles due to conflicts of scheduling, protocol, precedence or route) were, however, an essential part of the life of the region. To these were added, during Easter and Christmas, sacred dramas enacting scenes from the Bible that included appearances of the prophets who would admonish in the New World the people of Israel. These appearances may have inspired Aleijadinho's own dramatic work.

The procession that Aleijadinho proposed to the faithful was the reverse of those moving pageants: instead of the scenes succeeding

each other in front of the attentive audience, here in the sanctuary of Congonhas it was the public who progressed from scene to scene, timing their own reading of the story. The public processions obliged the audience to follow the display in the limited time chosen for their passing; the sequence of scenes and the course of the action were, of course, not dictated by the viewers but by the performers themselves. But in Aleijadinho's display, the scenes are read as if in a book, written in the Greek style known as *boustrophedon* or "as the ox plows" — that is to say, from left to right and from right to left and also, in this case, from the bottom to the top of the page. The viewer passes from one chapel to the next along the meandering path, as if from chapter to suspenseful chapter and, within each chapel, from character to sculpted character as if from paragraph to animated paragraph.

The story told in the chapels is divided into the traditional chapters: the Last Supper, the Agony in the Garden, the Taking of Christ, the Scourging and the Crowning with Thorns, the Transport of the Cross and the Crucifixion. To take one example: at the foot of the sanctuary path, the visitor comes upon the first whitewashed chapel, inside which is displayed the meal of the night before Christ's death. Seated around a wooden table, the apostles look toward their Master, who is offering them the bread that is also His flesh. The colouring of their attire and even their glass eyes were added long after the actual sculpting of the wood was finished, and not by Aleijadinho or his assistants; what seems to have mattered to Aleijadinho was not the colour pattern or the extraneous details but the gestures and movements that he could conjure out of the wood. As we see them today, coloured, gilded and adorned, the figures of the *capelas do passos* are the remote ancestors of the hyperrealist three-dimensional figures of twentieth-century Pop art, such as the fibreglass sculptures of the American Duane Hanson, less interested in the form than in their anecdotal presence. Beneath the paint, however, is another preoccupation, deeper and more subtle, and less immediately obvious. It concerns the invisible human shape, beyond all social categories or hierarchies, locked away in the wood.

Regarding the long-vanished colouring of Greek marble statues, John Ruskin wondered whether this had been less an artistic choice and more a concession to the public's gaudy taste, and whether Praxiteles may have believed that his work was finished when his coaxing of the marble came to an end.[18] Such a conceit may reflect Ruskin's nineteenth-century aesthetics rather than those of ancient Greece, but

Detail of the
Last Supper.

it is possible that in this particular case, he may have been right. Alei-
jadinho's motives perhaps coincided with those suggested by Ruskin.[19]
For Aleijadinho, in a very private way, the work may have come to a
close *before* the paint, existing in a perfect state that preceded the offi-
cial dress and makeup, in which the creation was purely what the artist
had summoned up from the wood. But this is merely a suspicion, with
no documentary evidence to support it.

What is evident, however, is that the convoluted forms of the
baroque acquired solid roots in the New World, making it seem
almost endemic. The imported luxuries with which King João V
enriched his Portuguese style were, for his metropolitan subjects, an
evolution or a corruption of an art that they and their forefathers had
seen change since the beginning of time. But for the Brazilians, even
for those who had come from Portugal to the colonies and were now
more of this land than of the one they had left behind, the "new
baroque" was not new, because there were no older styles to which it
could be compared or, at least, none so different from the massive
scrolls and gold trimmings that seemed to the Europeans like answers

Duane Hanson,
*Tourists,* 1970.

to questions asked long, long ago, when the first Christian images were being daubed on the walls of the Roman catacombs. For the viewer of a Bernini marble sculpture, for instance, the contorted ecstasy of Saint Teresa transformed into fiery movement the conventional stillness of Byzantine beauty, keen on not straying far from the first Virgin and Child said to have been painted by St. Luke in the days before the Cross and the Nails. For Bernini, for Bernini's contemporaries, the calm, fixed look of a Byzantine saint now acquired

(through the subtle shifts of Giotto, of Masaccio, of Simone Martini, of Michelangelo) an expression of evident emotion that the older artists must have judged implicit. In this sense, King João's baroque was a speaking-out, an opening-up, a *mise en évidence* of that which earlier styles had preferred to keep secret.

But translated to the colonies, the baroque took root almost without history: it acquired its own proportions, shot out in all directions, reflected colours and adopted textures that the European craftsmen could not have foreseen. Brazilian wood, Brazilian gold and Brazilian soapstone dictated their own terms, and the local craftsmen who thought they were learning techniques from a land so remote that their own king seemed mythical were in fact refining those techniques according to the age-old crafts of the land where they worked. The Native people had perfected, over centuries, the carving of that particular wood and the cutting of that particular stone, and African slaves (such as Aleijadinho's Maurício) who in their own distant countries (Nigeria, Angola, Mozambique, Guinea) had been sculptors and mask-makers and goldsmiths and architects had carried their skills and talent across the sea to Brazil.

Aleijadinho never travelled to Europe, never saw the churches and palaces and galleries that exhibited the roots of the art in which he excelled. He came to that art vicariously, through the work of other master craftsmen, several of whom had indeed seen the shapes and colours of the changing Western imagination and knew the place of these images in the pageant of European art, and may have spoken of these things to their talented apprentice; he also appears to have been familiar with the religious images in textbooks printed in Lisbon, Madrid and Florence,[20] and with the coloured broadsheets from Nuremberg and Strasbourg, so popular in the colonies. The faces of the apostles, of Christ, of the angels and onlookers in the *capelas* and above the sanctuary balustrade are less everyday faces from the streets of Ouro Preto or Congonhas than those same faces stylized and revised by comparison to the traditional printed images that reached him from across the sea. He did not attempt to set ordinary men and women on a mystical stage, as Caravaggio had done almost two centuries earlier, or to represent, like Guido Mazzoni in the late fifteenth century, the extreme emotions of his shrieking *Pietà* in the Church of Sant'Anna in Naples. On the contrary: the real men and women, whose gestures and postures, grimaces and looks may have inspired

Guido Mazzoni,
*Pietà*, in the
Church of
Sant'Anna dei
Lombardi, Naples
(detail).

his sorrowful John or his impatient St. Andrew in the Last Supper, lose their native traits under his chisel. They are no longer bricklayers or lawyers but have acquired instead the long, delicate features and large almond-shaped eyes of a fantastical human beauty dreamed up by the gifted artist.[21] His saints and sinners (even taking into account the variations due to the various hands of his assistants) all seem to belong to the same ideal family, less differentiated in their particularities than united in their common archetypal humanity. Aleijadinho, deformed by the illnesses from which he suffered, losing fingers and sight, seeing himself so ugly that he felt forced to work under the cover of a tent, and raging against the ugliness that the eyes of others imposed on him, sought to show the story of a God who chose to be human, in human shapes as far removed from his own as he could possibly imagine. And in those elegant faces and limbs that his dreams had created, perhaps his wishfulness saw himself reflected, a species of artistic *branqueamento*.

In the interior of the Church of São Francisco de Assis in Ouro Preto, the young Aleijadinho had deliberately confused the viewer: *trompe l'oeil* and three-dimensional reliefs, painting and carving alternate in an explicit attempt to bewilder the eye, to force us to lose confidence in both the tangible world of the senses and the intangible world of intuitions. Here the religious imagery, though Christian, was also meant to be read according to the African tradition by the black

African cowries
sculpted by
Aleijadinho in a
wooden
decoration from
the Church of
St. Francis.

population that flocked to the church: our Lady of the Rosary is also Iemanjá, the African goddess of the sea; the cowries carved out among the scrolls and leaves are African symbols of fertility; turtle shells depicted on the bas-reliefs carry specific meanings in slave initiation rites.[22] In São Francisco, the imagery may be European, but the articulation, the undercurrents of meaning definitely belong to the black traditions of Africa, the reverse of *branqueamento*.

But in Congonhas, the older Aleijadinho laboured to create a very different ideal.

The towering prophets of the sanctuary proper were sculpted in the early 1800s, when Aleijadinho's health was at its lowest, his limbs decaying and his entire body racked by pain. Displayed over the full length of the artificial horizon of the balustrade, loudly demanding repentance of our sins and heralding the world to come, the prophets seem to be addressing not a single individual but the whole of mankind. The effect is achieved partly because of the greyness of the stone that contrasts with the gaudiness of the *capelas do passos* below, and partly because these figures are not enacting a story but stand themselves as storytellers, engaging us in the dramatic dialogue. The scenes in the *capelas do passos* are the performed text of the Scriptures; the stern prophets above are the gloss, the sermon.

Layout of
Congonhas.

SANCTUARY  TERRACE  CARRYING THE CROSS  CHRIST IN PRISON  LAST SUPPER

CRUCIFIXION  FLAGELLATION & CROWN OF THORNS  GARDEN OF GETHSEMANE

JONAH    DANIEL    HOSEA    JOEL

AMOS    BARUCH    EZEKIEL    NAHUM

ISAIAH    JEREMIAH

OBADIAH    HABAKKUK

Obadiah, the prophet farthest to the left of the viewer, might be considered the leader of the group, his right arm stretched out and his index finger marking a beginning, while Habakkuk on the far right, his left hand raised in a menacing fist, seems to be concluding the circle.[23] Within this arc, the other figures suggest, like the alternative and geometrically progressive structures of baroque music, a sequence of complex relationships: the prophet Ezekiel's right arm, for example, lifted up to his left shoulder, acquires movement and force through its link with Habakkuk's raised fist, which, to our eye, follows directly from Ezekiel's shoulder. Curiously, some have seen in the distorted proportions of the prophets (the long torso, the short legs) the hand of one of Aleijadinho's less skilled assistants or even a sign of the master's declining powers;[24] but if you approach the balustrade from the path of the *capelas*, you realize immediately that such proportions are necessary in order for the eye to compensate the foreshortening of a low point of view. If anything, Aleijadinho proves here a greater, not a lesser, talent for combining the arts of sculpture, architecture and stagecraft than he ever showed before.

Placement of Aleijadinho's twelve prophets on the terrace and stairs of the sanctuary.

Obadiah, Habakkuk

Jeremiah, Isaiah

Baruch, Ezekiel

Daniel, Hosea

Joel, Amos

Jonah, Nahum

The twelve prophets of Congonhas can be read as one all-encompassing text. They are the *iluminados* who prepare the coming of the Messiah in the Old Testament.[25] Within the open space of a single thundering collective statement that announces the Day of Wrath, each prophet appears in painful conflict with himself: having seen the godhead, he must find the words to frame the ineffable experience, enfolding in his warning to humanity his own secret interior struggle. What comes through in this ensemble of restrained violence is the Renaissance concept of *terribilità*, "terribleness," the condition the Renaissance biographer Giorgio Vasari attributed to Michelangelo:[26] not something that provokes fear and thereby precludes admiration but its contrary, something invisible that because it has been taken to the utmost attracts us, the viewers, by the sheer force of its own extreme condition. In Aleijadinho's prophets, this extreme is contained or implied, but its *terribilità* is clearly present.

One of the suggested etymologies for *baroque* is that of a rough pearl, something created through layers excreted by an oyster around an intimate, invisible grain of sand. Like that pearl, the baroque offered artists the magical possibility of revealing through concealment, of taking a concept or a form and surrounding it with other forms or concepts, so that through the many layers of gloss, movement, imagery and contortion we might intuit, but never quite seize, the central idea in all its complexity. That baroque found in Aleijadinho its perfect craftsman.

The bastard son of a European and a slave, crippled by diseases that he was told were the wages of sin, excelling in the art of his father, of the white Portuguese overlords, Aleijadinho perhaps discovered in the scrolls and volutes and fables and parables of his father's distant kingdom a method of survival. His mother's people had read into the story of a God nailed to a tree, and the virgin woman chosen to bear Him, disguises for their own ancestral gods, whom they could then adore without fear of persecution. Perhaps Aleijadinho found in the art that depicted this God, His birth and His Passion, both a way of celebrating the body he did not have and of raging against the gods that made him the way he was — the gods of his father and those of his mother, gods who told him that he had been made in a divine image and who mocked that same image in his decaying and deformed body. If the underlying vocation of those in power was to foster the myth of *branqueamento*, to "civilize" the many-coloured people of Brazil through a process of

spiritual "whitening," then perhaps it was possible to undermine that very myth through its exposure, by assuming the "white" religion and history, the stories brought over from Portugal by priests and politicians, and then carving them in his own terms, exaggerating their mythical qualities, as he had exaggerated their perversions in his own crippled self. Perhaps it was possible to transform even his own abused body into a mirror or a metaphor for an abused race and an abused continent that his social self, a "gentleman's son," so furiously denied. Perhaps at the core of his extraordinary sculptures were not the tenets of theological or sumptuary dogma, but simply the proof he had found of his forsaken divinity, or of what the outside world saw as forsaken: the ability to turn stone and wood and gold into something like flesh and blood, to create life out of lifelessness, in joyful contradiction of the Second Commandment of the jealous God of his father.

Claude-Nicolas
Ledoux

The
Image
as
Philosophy

*Architecture is a turn of mind.*

Le Corbusier, in a letter of September 23, 1936

Arc-et-Senans.

IN EASTERN FRANCE, somewhere in the Franche-Comté, lies an imaginary place. I had spent the night in Besançon, a city whose stones were already old when Julius Caesar conquered it in 58 B.C. Trying to disentangle myself from a maze of one-way streets, I remarked once again, as every traveller must, that the world is an untidy place. Castles spring up next to modern housing complexes, tiny medieval alleys wind their way past designer boutiques, and romantic mountains are elbowed in the foothills by grim industrial complexes. The ideal and ordered city, one mind's unified vision of what our living space should be, exists (I thought) only on paper, in Thomas More's *Utopia* or in the elusive accounts of Atlantis.

Most landscapes have something comforting about them, because their very shapelessness has made them unsurprising. You know that the next little town you come to will have its square and its church, its medley of shops, its bevy of pre- and post-war houses — different, but all different in the same way. As I drove south from Besançon, in fact, the fields seemed to have what I had thought was the unique blue light of southern Ontario on an early autumn morning. Then, literally out of the blue, there rose in front of me the eighteenth-century Saltworks of Arc-et-Senans.

The picture Arc-et-Senans offers to the visitor is that of a walled-in house assembled by a meticulous child out of butter-coloured building blocks. And yet, the house is not a house. It is a visionary rendition of a house, the stone realization of someone's idea of a house as a lesson in architectural harmony, a philosopher's notion of a house. Of course, we all know what a house is: this knowledge colours our viewing of buildings of stone and mortar (an anonymous fifties suburban bungalow in Mississauga or Antonio Gaudí's extravagant Sagrada Familia cathedral in

Barcelona), but it also allows us to grasp certain literary images of build-ings, as when a twelfth-century Anglo-Saxon poet calls the grave "a win-dowless house,"[1] or when the scholarly Apollodorus (of whom we know nothing except his name) describes, in the second century B.C., the labyrinth of Crete as "a house without doors."[2] Behind the aesthetic judg-ment of the first two examples and the *frisson* of horror provoked by the second two stands a primordial and domestic model of "house."

Though architectural models existed in the ancient world — in Egypt, Greece and Rome — they do not seem to have been used for building full-size edifices but rather as later reproductions of the fin-ished work. We have building models and architectural plans from the early Middle Ages, but it was not until the fourteenth century that it became customary to assemble small-scale representations of the structure to be erected. Brunelleschi, Bramante, Alberti, Michelangelo — the great architects of the Renaissance — all relied on models, even though some of these (Brunelleschi's models, for instance) were left purposefully incomplete so as not to give away the architect's secrets. Michelangelo's models, on the other hand, served strictly as guides for the workers and were careful renditions of what was to become the final building.

Leon Battista Alberti, author of the fundamental architectural trea-tise *De re aedificatoria*, recommended in 1452 the use of models to explore "the relationship between the site and the surrounding district [as well as] the parts of the building itself" but, above all, as a thinking pad, as a working space for the *disegno* to evolve, as an experimental construction that allowed the architect to test an idea only imperfectly

Filippo
Brunelleschi's
wooden model
of the dome and
apse sections
of Florence
Cathedral.

formed in his mind. "As far as I'm concerned, I must say that very fre-quently I conceived a project which, at first, seemed to me full of merit, but which once sketched proved to contain errors, serious errors, in the very sec-tions that I liked best; rethinking what I had conceived, and measuring again the proportions, I would now rec-ognize and deplore my carelessness; finally, after building a model, I would often find, upon examining the differ-ent elements, that I had even made a

mistake in their number."[3] A generation later, the illustrious Andrea Palladio based his model for the church of San Francesco della Vigna in Venice on the theory of Pythagorean harmony outlined in Plato's *Timaeus*, in order to visualize the metaphysical concepts put forth in that dialogue.[4]

The notion that architecture is the realization of an idea, that it evolves and changes from conception to conclusion through the equivalent of a rhetorical device (if we consider a

Plan for a church based on the celestial square, by the thirteenth-century French architect Villard de Honnecourt.

cathedral, for instance, as a metaphor for a philosophical theory), may explain in part our relationship to buildings that we both look upon and inhabit. They exemplify our concept of space, as well as our ideas about society and the individual. There exists a tradition by which our earthly dwellings are imperfect models of divine architecture, beginning with the description of the celestial Jerusalem in the Apocalypse, which descends from the heavens at the end of time. Carefully measured by an angel of God, this *Civitas Dei* is a perfect cube ("the length and the breadth and the height of it are equal") made of jasper and gold and "all manner of precious stones"; it requires no temple, because in this perfect city "the Lord Almighty and the Lamb are the temple of it."[5] Our humble and impossible task (following this tradition) is to build that Jerusalem on earth, and many of the medieval cities — Sainte-Foy, Montpazier — are built on this square model.[6] Hegel, in his *Introductory Lectures on Aesthetics*, saw the architect's mission as that of "purifying the external world," "endowing it with symmetrical order and with affinity to mind," so that the divinity (the god of the community) can then enter the newly created building through "the lightening-flash of individuality, which strikes and permeates the inert mass."[7] The architect constructs a copy of the divine original based on our archetypal idea of dwelling, which (if successful)

becomes in turn the realm of the numinous, a man-made structure that is both house and home.

Accordingly, every building puts forward an argument that involves us as viewers and that we are involved in as dwellers. The success of a building can be measured from both these positions, and our reading of a building requires at least these two perceptions or experiences. When a client complained to Le Corbusier that the roof he had built was leaking, the architect answered, "Of course it leaks; that's how you know it's a roof." The disrespectful answer was wrong: that is not how you know it's a roof, that is how you know it's a failure. The roof as image and the roof as instrument are both part of the definition of *roof*, a construction that must be pleasing and that, above all, must not leak. The architects of the Parthenon of Athens sculpted in some instances even the backs of the figures that adorned the pediments, in spite of the fact that only the front of these figures would be seen, and then at a distance of ten metres above the viewer. This attention to minutiae merely reinforces the importance these Greek architects gave to every part of the building, in all its aspects, however invisible except to Hegel's God.

Such details affect the way we read a building. The gloomy, seemingly uninhabitable towers of La Défense in Paris, the monstrous blocks of Soviet urbanism, the bunker-like structures of London's South Bank, the arrogant bulks blocking Toronto's waterfront, the bleak, characterless mazes of so many North American universities tell of architects who

Luciano da Laurana's Ideal City in the Palazzo Ducale, Urbino.

refuse dialogue with those of us who live, work or have to look upon these places: they advance a concept or a question and, like Pilate, will not stay to hear the answer. What these architects forget is that a building gives corporeal reality to

The highway and railway lines that run along the edge of Lake Ontario brutally separate the city from the water.

an idea that is put to the test by the argument of use: either renewed through the millennia, like the white houses of Jericho or the mud skyscrapers of Yemen, or toppled through the architect's inability to articulate his ideas coherently, as in so many twentieth-century examples.

Sometimes a building is only story, erected in words or image, in paper and paint. The fallen House of Usher, the nostalgic Green Gables, Toad Hall and Dracula's Castle, the ashes of Manderley and the dream house of Le Grand Meaulnes require no bricks and mortar. Luciano da Laurana's fifteenth-century Ideal City in the very real Palazzo Ducale of Urbino, Giorgio de Chirico's melancholy twentieth-century arches and sunlit courtyards, the nightmare dungeons of Piranesi in the eighteenth century and Pieter Brueghel's spiralling Towers of Babel two centuries

earlier occupy no vast sites except in the imagination. All propose, however, a theory, imply a philosophy of what our habitations might signify, and suggest to the reader or viewer fables for dying and living under a certain notion of roof. And perhaps one of the clearest examples of architecture as philosophy, in actual solid stone, can be seen in the site of Arc-et-Senans, the masterpiece of the visionary genius Claude-Nicolas Ledoux.

Today, the first sighting of Arc-et-Senans tells you nothing, except that whoever dreamed it up had a marvellously well balanced mind. There, in the fields not far from Besançon, as fitting as a row of cypresses, stands a huge portico held high by eight Doric columns, and built out of rocks piled up to resemble a grotto. On each side of the entrance gate, embedded in the rocks, is an overturned urn spilling sculpted brine. This is the only decoration, repeated many times throughout the site.

Unless you are a bird, you must cross the portico to realize that you are standing at the central point of a semicircle, the tip, as it were, of an open fan. To your left and to your right are low white buildings with tiled roofs; in front of you, serving as the open fan's straight base, is a tall house with impressive columns, flanked by lower constructions. The place has a pristine symmetry.

(left)
A wall of decorative upturned urns.

(right)
A bird's-eye view of Arc-et-Senans.

Officially, and unsurprisingly, the Saltworks of Arc-et-Senans were built for the purpose of producing salt. Since the thirteenth century, salt was taxed in France and was one of the Royal Treasury's main resources; in 1681, Jean Baptiste Colbert, one of Louis XIV's chief advisers, introduced a system of tax collectors — the infamous *fermiers généraux* — who, in exchange for a substantial payment to the Crown, collected the salt tax directly, thereby creating a class of administrative scapegoats on whom the people could vent their anger and still profess love for their king. Through taxes and through foreign sales — mainly to Switzerland — salt was for many centuries as valuable as gold to the Royal Family.[8] So when in the mid-eighteenth century the output of the several saltworks of the Franche-Comté began to decline, Louis XV *le Bien-Aimé* (who at the age of five had succeeded his great-grandfather in 1715) decided to build a larger, more efficient factory that would ensure a continuous and increased production.[9] The site was to be at Arc-et-Senans, near the Forest of Chaux, where firewood for the brine cauldrons was plentiful. The architect he chose was Claude-Nicolas Ledoux.

Ledoux had successfully crossed the social barriers of prerevolutionary France. He was born in what would later be called the Department of the Marne, on March 21, 1736. His parents were not rich, and in spite of a parish grant, Ledoux was forced to leave school and become an engraver's apprentice in Paris, learning design from reproductions of great works and sketching trees and animals at the Jardin des Plantes. He specialized in battle scenes, which supplied him with pocket money and gave him the draughtsman's training he required to become an architect. Aided by aristocratic patrons who had recognized the young man's skills, he at the age of twenty-four entered Jacques-François Blondel's École des Arts, the first art school in France that taught architecture to its students.[10]

A replacement job at the Superintendence of Waterways and Forests of Sens introduced Ledoux to the world of the rich *fermiers généraux*, who in turn led him to Mme Du Barry, the king's favourite. Du Barry, a shop assistant who became, after the death of Mme de Pompadour, the king's *maîtresse en titre*, reigned at the court until the ascension of Louis XVI in 1774, when she was banished to a nunnery. During her days of glory, the old king gave her a vast wooded property at Louveciennes, and there Du Barry decided to build a pavilion where she could receive her royal guest and house her magnificent art collection.[11]

The last exuberances of the baroque that had so delighted King João V and most other European monarchs had burst, gaudy and gilded, over every inch of French masonry and furniture, including the Sun King's Versailles, and had become, in the eyes of the *parvenue* shop assistant, *vulgaire*. The new Italianate manner, with its elegant sobriety, appealed to Du Barry. It provided a sophisticated framework; it didn't overburden. Victor Hugo was later to pour scorn on its restrictions. "After the dazzling orgies of form and colour of the eighteenth century, art was put on a diet and was allowed nothing except straight lines," he wrote. "Nobility had been exalted to the point of insipidness, and purity to the point of boredom. There is such a thing as prudery in architecture."[12] But Ledoux was not a prude; he possessed an innate talent for the neoclassical style, and though he had never been to Italy, it was said that his soul and that of the great Palladio were brethren. In December of 1770, Du Barry appointed him her architect. One year later, on September 2, 1771, the Pavilion at Louveciennes opened its doors to receive the King of France for dinner.

The Pavilion at Louveciennes, with its honeycomb coffering, delighted the king, and Ledoux was offered the design of the new Saltworks at Arc-et-Senans. The first plans, presented in April of 1774, a few days before the king's death, were not to the royal liking, and it was His Majesty's son, Louis XVI, who accepted the revised plans in the last weeks of that same year. By 1779, the project was completed.[13]

Ledoux's Saltworks had to fulfill a number of requisites. They had to allow for expansion so as to prevent congestion, as had happened at the saltworks of Salins, trapped between the town and the river Furieuse; they had to permit easy access both to the brine from which the salt would be extracted and to the wood necessary for furnaces where the water would be evaporated; they had to be secure against fire and petty thieving of the precious salt; but above all, they had to represent an idea that was creeping into the European consciousness and was to find its literal enthronement during the coming French Revolution: they had to be an embodiment of Reason. "The builders in those days," commented Victor Hugo with a touch of irony, "mistook symmetry for beauty."[14]

Society itself, said the revolutionaries, must be the product of Reason. "Man's reason," pronounced the utterly unreasonable Robespierre during the Terror, "still resembles the globe man himself inhabits — half plunged in darkness, half full of light."[15] And Architecture, according to

Ledoux, writing five years after the Revolution's mottoes had been erased by Napoleon, was one of Reason's most efficacious instruments. "Isn't the power of Architecture a colossal power?" he asked passionately. "It can, within the very nature it emulates, construct another nature; it isn't limited to a piece of ground too narrow for the greatness of its thoughts; the extension of the heavens and the Earth are its domain; ... it can yoke the entire world from the longings of the newborn to the sublime hazards of the imagination."[16]

But even the sublime hazards of the imagination require a starting place. Ledoux found it in the commissioned Royal Saltworks. He would produce the most efficient, most eye-pleasing factory the world had ever known (the only factory to appear, two centuries later, on Unesco's World Heritage list).[17] But it would not only be a factory where the workers would live with their families and toil over the cauldrons of brine, overseen by the Saltworks' director: for Ledoux, it would also be a model of social justice and popular happiness.

The Director's House at Arc-et-Senans, the tall building facing the portico at the very eye of the fan, exemplifies Ledoux's intentions. As you approach it, it becomes obvious that this house is the centre in every sense: power emanates from there, and wherever you stand in the Saltworks' enclosure, the Director's House is the point to which you are drawn, watched by the black oculi in the triangular pediment. Almost two hundred years later, when George Orwell dreamed up the eternal presence of Big Brother, he was unconsciously echoing a surveillance cast in stone by Ledoux.

If the Director's House appears imposing and severe, it also delights by its elegance.

The Director's House at Arc-et-Senans.

235

The decorative urn, symbolizing the briny water from which salt was extracted at C.-N. Ledoux's Arc-et-Senans.

Its six columns consist of alternating cubes and cylinders, an Italian variation on the Doric column that Ledoux had seen in contemporary engravings of the new buildings in Rome. It is as if two columns, one cylindrical and one rectangular, had been fused together: the result is both solid and kinetic.

The ground floor links the Director's House with the workshops at either side. All the salt produced at Arc-et-Senans had to pass through here: symbolically, it came under the director's hold; practically, it made thieving almost impossible. From the ground floor, a straight staircase facing the entrance leads up to the first floor. Ledoux conceived this staircase not only as a means to reach the director's apartments: at the top of the broad first flight, the open landing served another purpose. On Sundays, it held an altar, and this simple addendum transformed the staircase into the nave of a church. The rest of the cross was formed by the space at the back of the landing and the two arms that extend to either side, leading into the apartments proper. A physical ascension was therefore also a spiritual one, and the workers who came to the Director's House during the week recognized that on Sundays he, being their master, was closer to God than they were. Whoever entered the house became part of a ceremony, acquiescing to an established order. Nothing in Ledoux's plan has a mere practical purpose.

Ledoux placed the workers' living quarters close to the production workshops. Each of these buildings was divided in two by a long corridor; on either side were twelve rooms, one for each family. In the centre was a communal kitchen, and at the back of each building were individual vegetable gardens. Ledoux imagined that the workers (who had to do long and complicated shifts to keep the fires roaring under

the huge brine vats) would be able to relax "communally" in front of the kitchen hearth, "protected," Ledoux wrote, "from all the costly distractions and bacchic orgies which threaten to destroy marriage and take idle people by surprise."[18]

You walk through these long, draughty halls, lightless except for the bull's-eye windows formed by the overturned urns that decorate the facade. You imagine the hundred or so workers (the same workers who, in other rags and under other names, toiled on the Great Wall of China, in the Caribbean gold mines, in England's satanic mills) under the omnipresent director's watch, lungs rotted by the wood smoke, skin cracked and bleeding from the briny air, dog-tired, in a din of angry voices, babies' cries, couples bickering, sitting night after night after night with their fellow workers, never on their own, never knowing any privacy, preparing themselves for the New Society Ledoux had designed for them.

The idea of a New Society was everywhere in the eighteenth century: in the satires of Voltaire, the essays of Diderot, the pedagogical recommendations of Rousseau, the industrial love-centred communes of Fourier, the visions of Emanuel Swedenborg, the poems of Blake, the voyages of Swift's Gulliver. (A study, by Philip Babcock Gove, of imaginary voyages in prose fiction lists 215 utopian travel books published in Europe between 1700 and 1800.)[19] And yet the French Revolution responded poorly to these ideals of social reorganization. The motto *Liberté Égalité Fraternité* remained only a motto. The promised day of glory never came.

At the time of the construction of Arc-et-Senans, Ledoux believed that his countrymen could live under one illustrious authority in peace and wisdom. Reality and politics tried to prove him wrong. Found guilty of befriending the aristocracy, Ledoux was imprisoned in 1790. In his cell in the Bastille, waiting daily for the fatal call (once his name was announced, but it was another Ledoux who was summoned to the guillotine), he began writing his *apologia pro vita sua*, a monumental essay entitled *Architecture Considered in Relation to Art, Social Customs and the Law*, which made clear what he believed were the duties of the architect. The Revolution had, if anything, strengthened his faith in the exemplary role of architecture. Vice would not be offered a landscape. He would design not simply a working place but a living place, a new world where the very walls would offer moral instruction, a round Jerusalem for the Age of Reason.[20] He named his ideal city Chaux, after the nearby forest, and

(over)
A view of Ledoux's never-completed ideal city of Chaux.

Elevation

Coupe

An ordinary
house in
Ledoux's ideal
city of Chaux.

gave it, in his cell, a tangible existence; the fact that it lay in an unattainable future was a mere chronological wrinkle in his plans.

For months and months he drew feverishly. The institute that two centuries later bears his name and that in the 1970s restored the neglected Saltworks has mounted, in one of the buildings, an exhibition of Ledoux's fabulous projects. It is a pilgrimage that anyone interested in the creative powers of utopia must make.

The semicircle of the Saltworks was to have been rounded out by its other half, and the never-completed new buildings would have encompassed every aspect of Ledoux's ideal society. What can be seen today is the factory, surrounded by its crescent wall; what Ledoux envisioned was that second complementary crescent outlining a space where the other activities of human life would have their buildings. Work, which cleanses man's soul, was to remain at the centre of Ledoux's city in the shape of the Director's House, but in the unrealized second half there would rise the visible architectural forms of a world ruled by Justice and Reason.

Ledoux, faithful to the precepts of neoclassicism, imagined that his buildings would take on the elemental shapes that Nature can portray only as small as crystals: the perfect cube, the perfect sphere,

The Cannon Forge at Chaux.

The Oikéma at Chaux.

the perfect pyramid. These are some of the buildings that never left the page: the Cannon Forge (because war is present in Ledoux's brave new world), designed as a cross of low buildings inscribed within a square at whose corners would rise blazing pyramids, like symmetrical volcanoes; the Pleasure Dome that Ledoux called simply Dwelling Place, Oikéma, a pileup of boxes and flat cylinders where the workers would listen to music and look at pictures; the House of Peace, Pacifière, where conflicts would be solved quietly by reasonable discussion; a house for the Director of Waterworks through which a tamed river would flow; a cemetery, in the shape of a gigantic half-buried sphere, visible from all over the city, to remind

The Pacifière of Chaux.

The house of the Director of the Waterworks at Chaux.

the workers that their days on this earth were, like those of everyone, numbered.

Defining what he calls *architecture parlante* ("vocal architecture"), the French philosopher Jean Starobinski points out that the primordial shapes of geometry not only fulfill a functional need in the construction of a building but develop as well a readable meaning. "Form serves function, but function is in turn reflected in the form in order to make itself visible: a symbolism of function is added to the notion of function itself.... Displaying its grandeur, a building proclaims at the same time its goal and its meaning."[21] And in particular, Starobinski adds, the architects of the Revolution would not allow the intended use of a

building to remain secret, unspoken: it becomes a matter of concern for all citizens and, therefore, its purpose must be made clear to all through the architects' ambitious imaginings.

But reality takes unkindly to an exuberant imagination. As early as 1782, within three years of the completion of Arc-et-Senans, the contractor engaged to exploit the site was complaining about the low productivity. There was enough fuel for the fires (the proximity of the forest of Chaux had been decisive in the choice of the site) but the brine had to travel through wooden conduits over twenty-one kilometres, from Salins to Arc-et-Senans, along the course of the rivers Furieuse and La Loue, and the wood proved to be far less watertight than expected: of the 135,000 litres of brine that left Salins daily, only 70 per cent reached the factory. By the nineteenth century, coal replaced wood as fuel, and new, more efficient saltworks were built in the Franche-Comté. In 1895, the factory was closed.

Walking through the Saltworks' restored splendour, one cannot help wondering whether Ledoux ever conceived what the fate of his ideal city would be beyond its actual construction and immediate occupation. Did he believe that the beauty of the stones, the symmetry of the figures, the immaculate geometry that had made Pascal more than a century earlier remark "Nature is a sphere whose centre is everywhere and whose circumference is nowhere"[22] would rub off on his fellow human beings who wallowed daily in greed, disease, envy, lust and unforgivingness? Did he imagine that like the chameleons he must have observed at the Jardin des Plantes, they would acquire the noble colours of the surroundings he had so lovingly devised for them?

Claude-Nicolas Ledoux died in 1806, only a few years after his release from the Bastille. His monumental book on architecture had appeared two years earlier, but none of the plans drawn after his imprisonment were ever executed. For many of his contemporaries, he represented the abhorred *ancien régime*; for many others, a far too daring taste for the *nouveau*. Of his buildings, few remain: other than the Saltworks of Arc-et-Senans, only four of the more than forty elegant tollhouses built for the *fermiers généraux*, two of the fifteen Parisian mansions, one château near Caen, two pavilions (that of Eaubonne and that of Louveciennes), and the magnificent facade of Madame du Barry's stables at Versailles.

Everything else returned to dust.

Peter

Eisenman

The

Image

as

Memory

*But to subsist in bones and be but pyramidally extant, is a fallacy in duration.*

Sir Thomas Browne, *Urn Burial*

Peter Eisenman's August 1998
model for the Berlin Holocaust
monument.

A BUILDING IS THE SPECIES; a monument, the individual. Like music, which is read both for the score and for the content, monuments carry a text, but a text whose several meanings exist only in our interpretation. In German, two words, *Mahnmal* and *Denkmal*, serve to remind us of this double reading. The Latin roots of their English equivalents, "memorial" and "monument," lie with the Greek goddess of memory, Mnemosyne, adopted by the Romans as Moneta, an epithet of Juno, in whose temple coins were struck, giving us the English word "money."[1] Memory becomes concrete in stones and coinage: something to serve as reminder and admonishment, and something to serve as a starting point for thought or action. Every memorial and every monument tacitly carries the inscription "Remember and think."

In a small square in the city of Buenos Aires stands a sculpture commemorating one black soldier, the "negro" Falucho, who, at the cost of his own life, saved the Argentine flag during the nineteenth-century War of Independence. The monument, modest but visible, never elicited more than a reminder of a patriotic hymn sung at national holidays, in which the heroic Falucho was briefly mentioned.

Statue of the soldier Falucho, in Buenos Aires (Augustín Cicchini).

> With Death at his heels he ran
> And lay on his flag in the slime
> And kissed it for one last time,
> The general's brave black man![2]

The monument's presence, dark above the flowing traffic, did not make me think during my high school years of the absence of black faces in our surroundings. It did not bring to mind the years of slavery, abolished by decree in 1813; it did not remind me of the black gaucho killed by the hero of our national epic, the *Martín Fierro*, in the poem's last cantos;[3] it did not make me think of the ferocious epidemic of yellow fever whose victims were in large proportion what remained of the black population. The monument had mere anecdotal value. It did not anchor my memory. It celebrated a character who seemed to me on the verge of fiction. Nothing more.

Such dearth of reading may be blamed less on the monument itself than on its beholder. Augustus' temple to Mars, erected in the Roman forum, no doubt was imposing, but we can ask ourselves whether every passerby saw in its noble marble the multiplicity of readings that Ovid lists in the fifth book of his *Fasti*: the residence of Mars Ultor, a monument to victory, a warning to the enemies of Rome, a memorial to Augustus.[4] "Magnificent is Mars and magnificent his temple. How could he have dwelt differently in the city of Romulus, his son! This building could even be a monument to victory in a battle between giants. From now on, Mars will unleash bloody wars against those who might dare provoke us in the East or refuse to submit to us in the West. Mars . . . lifts his eyes towards the temple and reads there the name of Augustus, and then the monument seems to him even more magnificent."[5]

Along the trail of the Tessali Plateau in the Algerian Sahara there are small piles of stones set up in places where travellers have met their death.[6] They carry no indication of who the victims were or when the accidents happened; in time, the wind or a scurrying lizard demolishes the small constructions, and in time, new piles are again erected. Their intention is to acknowledge human frailty and the implacable violence of this nature. They call for a moment of recollection to honour the anonymous dead, and also, perhaps, they offer conciliation with the desert itself.

Compared with the solid monument to the fallen black soldier, the stones are artless and far more ephemeral. Yet they seem more transcendental: their commemoration of any man's death weighs more profoundly than that of one folk hero, especially a folk hero deprived of his own history (the history of the blacks in Argentina) and circumstantially inserted in the official history of the nation. Stones are neutral; they belong to the place where they are set up; from quietly

Basalt statue of a lion in the site of Babylon, Iraq.

becoming a monument they return quietly to being merely stones; their construction barely requires a human gesture. This essential simplicity allows for a vaster resonance, the simple monstrosity of one man's death brought to mind by the simple piling up of a handful of stones.

Among the stones of Babylon, archaeologists found a larger stone that had been roughly cut into the figure of a lion, seemingly an attribute of a Mesopotamian god or the symbol of a long-forgotten victory. No one knows exactly what this monument commemorates.[7] Empty of reference, of memory, of authority, it is nevertheless a monument, the starting point for a question. Less like the stones of the Sahara, more like the black soldier's statue, it elicits no echoes because it stands outside history. It stands inside a semiotic vacuum.

But absence too can be a monument — a notion or conceit that became commonplace in the seventeenth century. Not an absence of *language*, in order to recognize the impossibility of communication (as in the case of Jackson Pollock or Samuel Beckett) but the deliberate building of an empty space to mirror that which has departed. Both the baroque poets Francisco de Quevedo (in Spain) and Joachim du Bellay

(in France) found in that absence a true *memento mori*, and in this sense admonished the visitor who seeks in Rome the glory of Rome and only finds it in its ruins. "That which was solid," concludes Quevedo, "has vanished, / Only the transient remains and lasts."[8] And Du Bellay: "That which is solid by time is destroyed, / And that which sifts away, stands up to time."[9] The paradox was echoed by their contemporary, the German Andreas Gryphius: "What is so boastful and defiant, will turn tomorrow to ashes and bone, / There is nothing that lasts forever, neither metal nor marble."[10]

If neither metal nor marble will last, why not then accept their transience as being, in itself, a monument? After completing the building of St. Paul's Cathedral in London, which he knew to be his crowning glory, Sir Christopher Wren, stubbornly believing in the persistence of his handicraft, added to the cathedral the following words for the future viewer in search of grandeur: *"Si monumentum requiris, circumspice"* (If you require a monument, look around you).[11] Years later, in one of his South African stories, Rudyard Kipling subverted this notion in the context of the labours of war, telling of the revenge of a Sikh soldier for the sake of his murdered English colonel. After razing to the ground the Boer farm where his "Kurban Sahib" has been killed, the faithful Sikh has Sir Christopher Wren's words cut into a great rock. "It signifies," he explains, "that those who would desire to behold a proper memorial to Kurban Sahib must look at the house. And, Sahib, the house is not there, nor the well, nor the big tank which they call dams, nor the little fruit-trees, nor the cattle. There is nothing at all, Sahib, except the two trees withered by the fire. The rest is like the desert here — or my hand — or my heart. Empty, Sahib — all empty!"[12] Emptiness, as the Romans understood when they razed Carthage, is also a memorial.

But sometimes such tactics seem insufficient. An event, or a succession of events, may seem so enormous that we confuse its enormity with complexity and take its ineffability to be in itself meaningful. At the far end of the Île de la Cité in Paris lies the Monument of the Deportation.[13] Down a flight of stairs and along an ever-narrowing corridor, the visitor reaches the tip of the monument, which is also the tip of the island. There, looking over the river, is a small barred window that allows no escape. Every visitor re-enacts (or is meant to re-enact) the moment when French citizens who were also Jews were taken from their homes and marched along the streets of Paris to the

The West front
of St. Paul's
Cathedral,
London (1702
engraving by
S. Gribelin).

trains that would take them to their death at the hands of the Nazis.
The monument is effective in the simplicity of its dramatic intention:
to put the visitor on stage. But the experience remains, of course, this
side of fiction, valuable only as a sign or a symbol. The monument does
elicit our emotion, does record one awful moment at a time of relent-
less awfulness, and is meant to honour the victims. But it does not
begin to touch the horror of a single deportation. Nothing can do that.
That horror cannot, in all its magnitude, be "read." The event itself is its
own monument.

In Argentina, some attempts have been made to record the atroci-
ties of the military dictatorship of the 1970s. A plaque, for instance, set
up at my old school, the Colegio Nacional de Buenos Aires, soberly

lists the names of the students who were kidnapped, tortured and killed. Among them are the names of several who were injected with a powerful drug, chained to one another and dropped from a military airplane into the river to drown.[14] No plaque or monument can stand in lieu of that event. We must hold it in our minds for what it is; there are no valid metaphors for it. Once again, any reading of this — the bronze plaque, for instance — can only graze the surface of the story.

Each instance of evil exists in its own terms, firmly attached to its prey like Prometheus' vulture eternally ripping at the living flesh, even if that flesh has long ceased to exist. We don't need to become universalists in order to understand evil, blurring the bloody particulars. On the contrary. The Holocaust, for instance, is its own paradigm; each other instance of evil — the torture of Argentine children by the military or the ethnic cleansing in former Yugoslavia — is only equivalent to itself. We don't need to assemble them to have a gestalt portrait of evil. Evil, like God, is in the details.

But how to live in the presence of evil, even when its actions are in the past, since evil possesses, like good, a continuum that flows from its source backward and forward through time, contaminating everything? How to carry on a day-to-day life along the street where a child was shot, at the corner where a woman was made to lick the dirt off the sidewalk, in the house where a family was beaten to death? How does one acknowledge the past and carry on with the present when that past seems to deny all possible human activity? The suffering souls of the Holocaust whose sounds echo in our present were blameless. They were not punished for their sins: they were tortured and killed for no other reason than for existing (and maybe not even because of that: evil requires no reason). How can we find something to represent this memory of evil — evil without purpose, without reason, without boundaries? How can we contain in the framework of a work of art a representation of something that, in its very essence, refuses to be contained? And why do we require such a memorial?

Almost four centuries ago, Sir Thomas Browne contended that Christianity had lent importance to funereal monuments because it believed the soul to be immortal; in this he saw a paradox, since the immortal soul requires no monument. Why, then, strive to commemorate it in stones and wood? "Christian invention," he wrote, "hath chiefly driven at Rites, which speak hopes of another life, and hints of a Resurrection. And if the ancient Gentiles held not the immortality of

their better part, and some subsistence after death, in several rites, customes, actions and expressions, they contradicted their own opinions. . . . Thus *Socrates* was content that his friends should bury his body, so they would not think they buried *Socrates*, and regarding his immortall part, was indifferent to be burnt or buried."[15] Perhaps, Browne suggested in his prefatory letter to his friend Thomas Le Gros, because in such relics we might behold "some Originals" of ourselves, reflections of vicarious glory. For that reason, he concluded, "We mercifully preserve their bones, and pisse not upon their ashes."[16]

The arguments that have raged in Germany ever since the first announcement of a plan to erect a Holocaust monument stem largely from these questions. The objections are multiple and valid: a memorial would provide an excuse not to remember; a memorial would suggest boundaries for both guilt and remembrance; no monument can represent the unrepresentable; any construction must imply an aesthetic and how can there be an aesthetic of evil? Chesterton speaks of a tower "of which the very shape was wicked,"[17] but how can such a monument be constructed? For certain critics (the novelist Günter Grass, for instance) an event such as the Holocaust cannot be remembered by means of a single monument: it is the limitations of the building that, in Grass's mind, invalidates such a project.[18] The Australian art historian Robert Hughes is more adamant, declaring precisely that "all Holocaust art is terrible." Asked what artwork should be put up at the Dachau concentration camp to commemorate the dead, he answered, "The ovens themselves are perfect. With their simple brick lines and their metal mouths, they are the supreme images of what was done to the Jews. How is an artist ever going to improve on the eloquence of the place?"[19]

And the project itself is a grammatical nightmare: what preposition can we use to name such a monument? Is it to be a monument *to* the Holocaust? *For* the Holocaust? *On* the Holocaust? *About* the Holocaust? In assembling the Holocaust in one monument or memorial, would we not be silencing its myriad individual voices, reducing its horrific complexity to a comprehensible singularity, blending its throngs of names and faces to a nameless and faceless emblem?

Then there are the private arguments. The German writer Martin Walser complained angrily that he did not want to spend the rest of his life staring out of his window, "reading" the Holocaust.[20] Though I can sympathize with Walser's plight, the decision (as Walser should know)

is not Walser's. We must all stare at the Holocaust every time we open our window: that is part of our human condition after World War II. We have not been given a choice, any more than we are given the choice to see the sun every morning. The Holocaust is there, rooted like a poisonous tree in history. It happened, and it is now one of our atrocious starting points from which we must begin yet again. And, in spite of knowing that there are no words to comprehend evil, we cannot but continue to address it.[21]

However, the discussion around a Holocaust memorial has the danger of becoming abstract, of concentrating on guilt and remorse, innocence and retribution, instead of the deliberate slaughter of human beings. The most terrible lesson of the Holocaust is that there is no lesson. That is, essentially, all that can be read in a Holocaust memorial. We need to remember simply because it happened. There are no rewards in doing this. Evil has no rewards to offer, not even to experience. Listen to Heinrich Heine, writing three years before his death in Paris, in 1856:

Cast aside your allegories
And empty hypotheses!
Give us straight answers
To the accursed questions.[22]

When the American philosopher Philip Hallie interviewed Magda Trocmé, who together with her husband had saved hundreds of Jewish children from the Nazis in their village of Le Chambon, in France, at the daily risk of their own lives, he found himself moved to say to her, "But you are good people, good." For the first time in their conversation, Mme Trocmé became vehemently angry. "What did you say? *What?* 'Good'? *'Good'?*" And then, more quietly: "I'm sorry, but you see, you have not understood what I have been saying. We have been talking about saving the children. We did not do what we did for goodness' sake. We did it for the children."[23] Any discussion that touches upon the Holocaust must bear in mind Mme Trocmé's children. Those children have no room in the open space in the middle of the city of Berlin allotted by former chancellor Helmut Kohl to condemn "evil" and honour "goodness."

Mnemosyne, daughter of Heaven and Earth, was the mother of the nine muses. We must attempt, through every means at our disposal, to

Käthe Kollwitz's memorial, *Father and Mother.*

remember, to set up memorials that, by means of an inspired craft, will act as touchstones to the past. Käthe Kollwitz's sculpture *Father and Mother* or Cynthia Ozick's story *The Shawl* help us enter the horror through the conduit of a work of art — as it were, under the protection of Virgil. They help us phrase our question, they don't provide answers, and they allow us to remember what, in a very literal sense, we never knew, because the suffering of the Holocaust belongs only to the victims; to the perpetrators belongs the *knowledge* of what was done from the almost inconceivable viewpoint of those who craft the suffering of others. Everyone else is an outsider.

In June of 1999, the German Parliament, the Bundestag, accepted one of the "aesthetic" projects to erect a Holocaust monument in Berlin: that of American architect Peter Eisenman. Until 1998, the American sculptor Richard Serra was also involved in the project; in mid-June he decided "for personal and professional reasons" to withdraw, and Eisenman remained sole designer.[24] The project, however, continued to be plagued by controversy: in January 2000, after Germany's chancellor and president had both agreed to attend the opening, the mayor of Berlin announced that he would snub the dedication of a memorial that, in his view, was "too big and impossible to protect."[25]

Peter Eisenman is certainly one of the most controversial archi-
tects of our time. His interest lies in structure, in the possibility of
revealing that which upholds, not decorates, a building. Paradoxically,
his designs, instead of stressing something comforting and sheltering
(the beams and buttresses of a building that, in a medieval church, for
instance, would both lift and sustain the whole), Eisenman introduces
into his designs elements that destabilize and rupture, threaten col-
lapse and haphazardness, making his buildings seem disturbingly
incomplete in their attempt to "mimic movement."[26] The co-author of
a book with the French philosopher Jacques Derrida,[27] Eisenman
draws his theories from outside architectural dogma, from literature
and linguistics, from Noam Chomsky and Nietzsche. His designs have
therefore been equated with texts, with "speaking architecture."[28]

According to the Bundestag, Peter Eisenman's design for the
Holocaust memorial requires an accompanying "commentary" to iden-
tify the symbols that compose it since, like all of Eisenman's designs, it
relies on literature. Literary associations were apparently a temptation
for most of the architects who submitted proposals to the Bundestag.
Two previous projects by other designers (both rejected) had sug-
gested that the monument include thirty-nine symbolic poles carrying
the word "WHY" inscribed in different languages, or eighteen giant
symbolic sandstone blocks symbolizing the bulk of Jewish history.
Eisenman, instead, proposed to erect four thousand huge stone slabs
on the site — a field of stone pillars — to indicate the weight of suffer-
ing and the extent of the devastation; later, for practical reasons, he
lowered the number to about twenty-five hundred, and added a huge
building to house an extensive archive and information centre.[29] In a
somewhat awkward turn of phrase, the architectural critic Arie Graaf-
land excuses Eisenman from any responsibility for the effectiveness of
his work. "Eisenman," he writes, "conceives the plan as a text [whose]
signification is never exhausted" and that can lead to "an erroneous
interpretation."[30] If the monument fails as a monument, Graafland
seems to be saying, the blame is on us, the viewers, who are incapable
of interpreting it correctly, not on the monument's maker.

A process may be never exhausted if its rich ambiguity allows it to
be read *ad infinitum*, or it may be never exhausted because, being un-
formed and ill supported, it allows any reading whatsoever, however
arbitrary or misconceived. Imagined as a gloss on a text not made ex-
plicitly available to the viewer, or as a system of symbols or allegories

translated exclusively into Eisenman's private Derridian vocabulary, Eisenman's proposed solution, I believe, will remain for the most part silent to the common visitor, inscrutable, a bulky memorial that requires, like so much conceptual art, "large signs in German and English ... showing what the memorial will be and explaining its significance."[31] At most, what will confront the viewer in the two hectares of prime Berlin property is the *impossibility* of representation.

Eisenman's design ignores the gravity of the debate and lends prestige to the monument itself, to the construction, to the "work of art," not to the dreadful event it is supposed to commemorate. That Eisenman gives pre-eminence to his design is something akin to enthroning Alberti's architectural model *before* it has served the purpose of developing his ideas, before it has become active in any creative way. In such cases, monuments betray their true nature. After the war, the German architect Albert Speer, who had built the Nuremberg Stadium for Hitler, revisited the abandoned site of what had been his masterpiece. Seeing a weed that had pushed its way through the stadium's steps, the seventy-year-old architect bent down and ripped it out from between the cracks. "The Führer would be furious if he knew the concrete was letting weeds through," Speer said.[32] Likewise, the Berlin Holocaust memorial ignores its context and its raison d'être. For whom is this monument being erected?

During the discussions, only one voice, it seems to me, has acknowledged the full complexity of the problem. Someone (I don't know who — I haven't been able to track down the proposer of this intelligent solution) took into consideration the various objections and concluded that a Holocaust monument, if any, needs to represent almost an infinity of individual cases demanding to be heard; it has to allow for the endless revelations that come daily from the darkness; it has to consider an ongoing dialogue intent not on solving but on affirming, questioning, recalling and informing. The aesthetic of such a monument would not concern the monument itself but the building that houses it. It would not be made of Gryphius's dead stone but of living memory. Such a monument would simply be a library. It would carry the name of Holocaust or Shoah Library, but it would not need to be a library dedicated solely to the Holocaust: it would collect, of course, as much material as possible on the Holocaust, but it could also collect all manner of historical and literary works, since the Holocaust, as I've said, while incomparable, is not limited to its own circle of horror and

Albert Speer's model for Hitler's Nuremberg Stadium.

requires to be seen, in all its inhuman detail, within the vaster human world. The American poet Richard Wilbur writes:

> It is by words and the defeat of words,
> Down sudden vistas of the vain attempt,
> That for a flying moment one may see
> By what cross-purposes the world is dreamt.[33]

A monument that is also a library would acknowledge the Holocaust as its own memorial, and, through "words and the defeat of words," help us bear the now everlasting presence of evil's labours.

Instead of a library, Eisenman designed within his monument a wall of books, 20 metres high and 115 metres long, containing one million volumes on the Holocaust — a wall of inaccessible books that, because they are largely beyond our reach and not allowed to serve the purpose for which they were conceived, are emptied of meaning, become their own shadow. Building a library, building a living monument to the power of reading, would have allowed in turn for a reading of the monument itself both as a place and as a symbol, as well as a stage upon which we could have attempted to follow something

approaching a cautionary tale. But by being nothing more than the display of a theory or a concept, by choosing to remain vaguely symbolic and not cross over into active symbolism, the Berlin Holocaust monument disallows for the viewer such cautionary readings. Eisenman's monument excludes the viewer, and so it only allows, through its intellectual design, a simulacrum of freedom that is dangerously close to indifference.

To become an image that grants us an illuminating reading, a work of art must force us into a compromise, into a confrontation; it must provide an epiphany, or at least a place for dialogue. In 1771, Denis Diderot began writing a novel, *Jacques the Fatalist*, in which we, the readers, are asked to accompany a valet and his master on their ride through France, making us take part in their dialogue and forcing us to comment on their actions as they wander from castle to inn to adventurous castle. Every authentic monument (that is to say, every monument that is both memory and reflection) must carry engraved on its portal the words Diderot has us read on the wall of one of those castles: "I belong to no one and to everyone; before entering, you were already here; here you will remain after departing."[34]

Caravaggio

The
Image
as
Theatre

*I am certain of nothing but the holiness of the heart's affections*
*and the truth of imagination — what the imagination seizes as beauty*
*must be truth — whether it existed before or not.*

John Keats, letter to Benjamin Bailey, November 22, 1817

*Theatre is the mirror of truth.*

Augusto Boal, *Caderno de Anotações*

A N   I M A G E, painted, sculpted, photographed, built and framed, is also a stage, a site for performance. What the artist places on that site and what the viewer sees performed on it lend the image a dramatic quality, as if it were able to prolong its existence through a story whose beginning the viewer has missed and whose ending the artist cannot know. The space of drama is not necessarily contained only by the stage of a theatre: the street, the entire city, can be that space, and it can be mirrored in the closed microcosm of a canvas, such as the one depicted in the central alcove of the church of Pio Monte della Misericordia, in Naples.

On May 29, 1606, in Rome, during a furious fight over the score of a tennis game, Michelangelo Merisi, known as Caravaggio, killed a man. It was not his first act of violence, but it was his most serious. Six years earlier, he was accused of beating up a fellow artist and, the year after, of wounding a soldier. In 1603, he was thrown into jail for assaulting another painter (he was released through the good offices of the French ambassador to Rome); in 1604 he was accused of upsetting a plate of artichokes over a waiter's head and later was arrested for throwing stones at a guard; in 1605 he had to escape from Rome after wounding a man in a fight over a woman. A few months later, shortly after he returned to the city, the fatal game of tennis forced him to flee again. In the early months of 1607, Caravaggio arrived in Naples, one of the most renowned and sought-after artists of his time, asking for refuge like a criminal.

Naples could offer sanctuary. Under the Spanish Habsburgs, who ruled Naples for two full centuries, from 1503 to 1704, the city changed from a busy provincial seaport to a remarkably complex cultural centre. By the end of the fifteenth century, the population of

Caravaggio, *David with the Head of Goliath*, 1605.

Naples had reached 120,000 (a number that was to double in under a hundred years), and artists from northern Italy and Spain began arriving in droves: architects were commissioned to build new churches and palazzos, while chairs of literature were established at the university to encourage poets, novelists and philosophers. To suit the city's growing prestige, the grid of streets was widened and restructured, and the waterworks and sewage improvements begun by Alfonso de Aragón were encouraged to continue.[1] "King of two worlds with his

A sixteenth-century woodcut showing the city as stage, in an Italian book on the art of stage design.

seat in Spain,"[2] as a Neapolitan poet put it, the Habsburg monarch was, to a large degree, as ineffectual as an absentee landlord. The Spanish viceroys who represented his power suspected rebellion at every turn, and while improving the city's cultural life on an increasingly meagre budget, they spent more effort holding the Neapolitans in subservience than in expanding the city's economy.

To someone newly arrived in the city, such as Caravaggio, Naples presented both the attractions of a *città nova* where everything seemed possible and, at the same time, the gloomy vistas of a *città vecchia* where most of its inhabitants made barely enough to survive. Describing the city under Don Pedro de Toledo, the viceroy who ruled Naples from 1532 to 1554, the English traveller Fynes Moryson spoke of its "four roofs high houses" and linen- or paper-covered windows, and "delicate gardens" full of "statues, laberynths, fountains."[3] At the same time, crime and poverty, always present in the city, had reached distressing proportions. The rising population of Europe at the turn of the sixteenth century led to a drastic increase in the number of the poor. Bands of mendicants roamed the countryside and invaded the towns

begging for bread or ransacking the houses of the rich. Food was so scarce during the winter of 1601 that a report from Naples in April of that year told of a peasant and his wife who had abandoned their three children at home in order not to see them starve. After three days, the neighbours decided to knock down the door. "They found two of the sons already dead, and a third dying with straw in his mouth, and on the fire was a pot with straw inside, which was being boiled in order to make it soft enough for eating."[4] Until 1770, when a Dominican priest, Father Rocco, had well-lit shrines installed at hundreds of street corners, to venture out at nighttime unprotected meant in all likelihood to be murdered.[5]

But the association between poverty and crime had not been widely recognized by the Church in the Middle Ages; instead, in the official rhetoric of the Church, the poor had been regarded as the earthly image of the suffering Redeemer. Their condition was never considered pleasant, as Chaucer's Man of Law described it: "O hateful harm, codicion of povrete!/ With thurst, with coold, with hunger so confounded!"[6] And yet, "the faithful and good poor" were thought to be dressed in "the livery of Jesus Christ Himself."[7] The sorrows of these "poor of Christ's school," as the Church called them, "their blindness, maimed limbs, bleeding sores, uncomfortable hovels, dry and insufficient bread, torn coats, putrid bandages, vile rags, sticks and crutches" were "the glorious trophies of their Christian patience, doctors for the rich, surgeons to the avaricious, cauteries to health, stairs of paradise, trustees of divine mercies, banks of celestial usuries, gate-keepers of Heaven, philosophers of the Gospel, salubrious leeches."[8]

By the end of the sixteenth century, this image of the godly poor had projected its own shadow: it was seen not only as a saintly condition but also as its reverse, the condition of the Devil himself. As the population of Europe exploded, the poor man or woman became a *déclassé*, an outlaw, a criminal, one who had decided to profit from the good graces of society in order to lead an idle and deceitful life. Also a fool. "Poverty makes men look ridiculous," wrote Agrippa d'Aubigné, the French poet and historian, in 1629.[9] Caravaggio, orphaned at the age of eleven, apprenticed in the workshop of a mediocre Milanese painter, and familiar with the life of the streets and highways in his travels through Italy on his way to Rome, thought otherwise. When in 1597, at the age of twenty-four, he obtained the commission to decorate the Contarelli Chapel in the church of San Luigi dei Francesi in

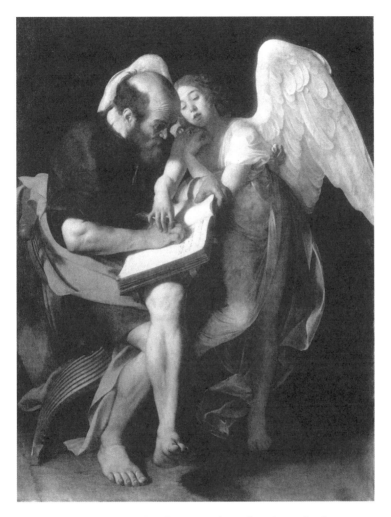

Caravaggio,
*St. Matthew
and the Angel*
(destroyed during
the bombing of
Berlin in 1944).

Rome with scenes from the life of St. Matthew, he chose for his evangelist a common beggar. The first version of *St. Matthew and the Angel* was so offensive to the canons of the Church that they refused to exhibit it. St. Matthew's large worn feet stick out of the canvas and into the face of the faithful (like the peasant's feet in Tina Modotti's photograph); the angel brutally guides Matthew's hand, as if helping an illiterate to write.

Soon the traditional tolerance of beggars became infected with fear of the vagabond, who had no fixed place in earth or in society, one who chose not to work and who pretended to be maimed, crippled, sick, blind or paralyzed in order to elicit compassion from passersby. Lacking bonds of property or ties of propriety, the

vagabond poor also had no social identity and were therefore seen as capable of every possible crime: theft, arson, rape, murder, even black magic. In 1585, a document drawn up between the Holy See and the Neapolitan government listed these vagrants as "heretics, rebels, blasphemers, falsifiers, counterfeiters, kidnappers, disturbers of the peace, thieves, assassins, killers and highwaymen."[10] "Even the gods love not the poor," wrote Alberti, recommending that the state not bother with educating them since their condition was beyond redemption.[11] In the words of Pope Sixtus V, as thundered in his 1587 bull *Quamvis infirma*, the poor who had once been "the children of God" now "roamed the land like wild beasts in search of food, thinking of nothing but of gratifying their hunger and filling their filthy bellies."[12] Since their presence within the city walls was perceived as dangerous, hospices and alms houses were built specifically to keep them away from decent society. In Naples, these lodgings came into being somewhat late: the first Royal Alms House for the Poor (Real Albergo dei Poveri) was not opened until 1751.

Every new viceroy to enter Naples was greeted by a hideous spectacle: poor, sick, ragged and even naked beggars wailing and crying out for coins or bread, and it was difficult, even for the acerbic Spaniards, to see in these revolting masses the Gospel image of their Saviour. Most poor came from the country: some joined mercenary companies or bands of ruffians; others went off to beg on their own. Once they had arrived in the city, they would sometimes seek out work as hired hands, by applying to an early morning "hiring," generally held in a square or fairground. Lodging was difficult: some lived outside the city, in the surrounding hills; others in the slums of the waterfront districts.[13] From among them, Caravaggio chose his models.

Onto these "libertine poor"(as the abbot Carlo Bartolomeo Piazza called them),[14] the Neapolitans also projected their sense of frustration, anger, ridicule and subversion. While the beggars and their kin were hounded and feared in the piazzas and the streets, their language, their gestures and their humour were rescued and translated into popular theatre. Their manners, grimaces and jokes (*lazzi*) fed into the Commedia dell'Arte, a style of street theatre improvised by professionals whose ideal, it was said, was to combine "plots from Lombardy, *lazzi* from Naples."[15] The penniless Spanish soldier, a Habsburg import, became the braggart in the Commedia under the name Matamoros or Moor Killer, a scaled-down reflection of Naples' head of state, more

interested in filling his pockets and (unsuccessfully) seducing the ladies than in questions of politics and war. Perhaps as a counterpart to Mata-moros, the great Neapolitan actor Silvio Fiorillo, who excelled in play-ing the Spanish boor, invented the character of Pulcinella,[16] the penniless hunchback whom the people of Naples recognized as one of their own. So popular did he become that one preacher, desperate for attention, set himself up next to the stage, holding up a crucifix and crying out, "Behold the true Pulcinella!"[17]

A seventeenth-century engraving showing a scene from the Commedia dell'Arte.

Throughout the late Middle Ages and into the Renaissance, those who were excluded from the seat of the powerful sought, in the inter-stices allowed by the feudal social structures, places to assert their common humanity. In festivities, carnivals, mysteries and masques, the poor, the ill, the mentally afflicted, those deprived of rights because of their sex or their faith found roles to play and rituals to perform that allowed them a presence and a voice, what the historian Jelle Koop-mans calls a "*mise en scène* of the audience itself in a festive setting."[18] So powerful was their need to be present that even in Church-vetted rep-resentations, they appeared in all their perceived brutality, sexuality and subversiveness.

Some show their ass bare to the wind,
Others fart into the air,
Others break windows and doors,
Others dump salt into the well,
Others throw straw into your face.[19]

As in the Commedia, all manner of public representations lent a platform to the society's excluded, allowing them to play fictional roles; these fictions, repeated enough times, became reality. Settings and tones varied; what remained constant was the principle of exclusion that gave them voice in "the riotous demonstrations of the young bachelors against second marriages, the lower clergy during the Feast of Fools that for a time inverted established hierarchies, in the anti-semitic scenes of the mysteries, in the straight-laced values of urban dwellers as they mocked peasants and country bumpkins."[20] In all these, the audience played an essential part, accompanying the representations along the streets and reacting to and with the actors, turning (as in Caravaggio's paintings) the whole outdoors into an immense stage.

A sixteenth-century woodcut portraying a Neapolitan charivari.

The Church, attempting to exert some degree of control over these popular spectacles, organized pageants in which the "children of God," the good poor (not the hoodlums and outlaws who refused to hear the Word), also had their part to play — "a truly pitiful and amazing spectacle," as the censor Camillo Fanucci described the one he witnessed in Rome on February 27, 1581, which Caravaggio too perhaps

attended. Behind a blood-red standard on which the Holy Trinity blazed embroidered in golden thread marched a contingent of prelates and lords dressed in red sackcloth and armed with emblematic staffs. They were followed by a barefoot crowd, also dressed in the same fiery sackcloth, bearing a huge Cross and a large number of white candles. Behind them shuffled the Brothers of the Confraternity of the Most Holy Trinity, followed by several choirs singing hymns of praise at the top of their voices. And at the rear, in a vast huddle, came the poor mendicants and beggars: the blind led by their young guides, the cripples carried in rickety carts, horse-drawn carriages full of the maimed, the lame and the sick, and mobs of men and women in their hundreds. The crowds thronged to see the show: those who witnessed it were granted absolution by His Holiness himself. Such a procession, notes the historian Piero Camporesi, "was a dress rehearsal for a spectacle that every day split into a thousand acts performed on every street corner by the ingenuity of the poor."[21] Or rather, this was the official, consecrated performance: the street theatre purged, cleansed, appropriately glossed and well contained in which the poor were plucked from their threatening and unsettled ways and given a place within the established order of society. Framed within a ritual, they were led to Mother Church by the prelates and lords for whom a display of poverty, *Pauperitas*, was a spiritual luxury, and they were accompanied by songs in which the true meaning of being poor (not as they but as the theologians understood it) was exalted as a gift from the Lord.

In order to contain the invasion of the less fortunate, refuges and hospitals began to appear, whose main purpose was summed up in three words: "Economy, Order and Method."[22] Gathered from the streets, the poor were brought with great ceremony and pomp into the lodgings erected for them. The female paupers were offered food and drink by noblewomen aspiring to a touch of saintliness; they were washed and given clean clothes, and then locked up for good, fed frugally and made to work hard, taking care they would not be "spoiled by excess."[23] The male paupers were led into their building by a young boy dressed as an angel, and after singing the Te Deum, they were offered a public supper. The tables were set up as "in the style of a theatre,"[24] with fine linen and silver, and attended by soldiers in full uniform, while the aristocracy would vie for the privilege of serving them. After dinner, they were led into the chapel for prayers, and from there to their communal cells to begin their lives of servitude in what

amounted to a state prison. For the public outside, however, it was clear that they had witnessed the enthronement of Dame Pauperitas or Mistress Poverty in her rightful place, while the noxious sin of begging was at the same time curtailed or punished.[25] This was the lesson: that poverty stemmed from the misplaced expectations the poor had of public mercy. If these illusions of rewarded idleness could be knocked out, locked away, transformed into useful labour, then the poor would be poor no more. This is the meaning, three centuries later, of Scrooge's question to the charity seekers: "Are there no workhouses? Are there no prisons?"[26]

"It is a strange thing to throw a poor person in jail, just because that person is begging alms," states Objection 29 in the pamphlet *Beggary Provided For*, published in Rome in 1693 under the auspices of Pope Innocent XII, wherein are stated the pros and cons of building a hospice for the poor. The retort to this objection, couched in the clear language of humanist rhetoric, is that since beggars everywhere importune the honest citizen, no measure of edicts and laws will prove sufficient to stem their coming. The beggars are guilty, says the pamphlet, "not only because they beg for alms [blasphemously] for the love of God, but also because they contravene the Edicts and orders of His Holiness, and because they wilfully persevere in their sins, thereby exhausting the vaguely defined freedom of begging."[27] Furthermore, the pamphlet continues, "Jesus Christ never said that we would always have beggars among us, but that the poor will always be among us, which is true." (In Argentina, the same logic was used by the torturers of Father Orlando Virgilio Yorio. During Father Yorio's detention, in the late 1970s, he was told by his interrogators not to take Christ's doctrine too literally. "Christ spoke of the poor, but when he spoke of the poor he spoke of the poor in spirit. . . . In Argentina those who are poor in spirit are the rich, who are those who really need spiritual help.")[28]

The poor were always among us, it was argued, as a test of the quality of mercy. St. Thomas Aquinas, the foremost thirteenth-century scholar on the question of mercy, had argued that this holy virtue was "the spontaneous product of charity, and yet distinguishable from it . . . the highest of all external manifestations of a person's worth, since it places the merciful person on a higher spiritual grade than the one who is assisted."[29] In fact, in keeping with the tenet of scholasticism, mercy was seen to relate to justice since, like justice, it controlled the relationship between two persons. Mercy was sparked by

the realization of suffering in another, suffering that could be either in the body or in the soul; mercy could therefore be divided according to the suffering it intended to alleviate. Christ Himself had listed (in Matthew 25:35–46) six of the corporal acts of mercy: to feed the hungry, give drink to the thirsty, clothe the naked, take in the homeless, visit the sick, assist those in prison; the seventh act of mercy, the burying of the dead, crowned the cycle of His Passion with His own Deposition. These acts were complemented by the seven acts of spiritual mercy, which read today like a tidy afterthought: to instruct the ignorant, counsel the doubtful, admonish sinners, bear wrongs patiently, forgive offences willingly, comfort the afflicted, and pray for both the living and the dead. In the popular imagination, only the first seven took root.

The knowledge of mercy lit the way for true believers, since Christ Himself had separated the faithful who acted mercifully from the unfaithful who didn't: the former were saved, the latter doomed. Those who performed an act of mercy toward another human being acted mercifully toward Christ Himself, since "inasmuch as ye have done it unto one of the least of these my brethren, ye have done it unto me."[30]

The charge, however, as St. Thomas was quick to note, though a binding precept, was not always an operative one, obliging the faithful *semper sed non pro semper* (always but not on every occasion).[31] Not everyone could, or was expected to, be merciful at all times. This cautious argument justified the treatment of the undeserving poor: the hospices, the edicts, the fear, the blame. Within certain safe settings and to public acclamation, visible to the Eye of God as well as to the scrutiny of fashion, the more fortunate clergy and nobility performed their works of mercy for the salvation of their souls and the renown of their good names. Offstage, in the dingy markets and alleys, in their hovels and slums, the poor were not to be pitied; they were to be punished, put to work or, at the most, tolerated if they kept to their proper place.

It was not clear, however, what that place should be. In August of 1601, five years before Caravaggio was to arrive in the city, seven young Neapolitan noblemen (they were all between twenty and thirty), eager "to employ themselves in the service of the poor and the needy,"[32] agreed to meet every Friday at the Hospital for Incurables (those suffering from the pox), where they would "serve and refresh the sick with cooked meals and jams bought out of their own pockets."[33] So successful

Title page of a treatise by Giulio Rosco Ortino on *The Seven Acts of Mercy*.

was their enterprise and so many asked to be part of it, that one year later, on April 19, 1602, they decided to found a society that they agreed to call Monte della Misericordia, and erect a church later to be known as Pio Monte della Misericordia, where all seven acts of corporal mercy would be performed with efficiency and regularity. Seven deputies were appointed each to oversee one of the merciful acts, encouraging all others to contribute. (The contributions were

sometimes quite specific: in February of 1604, the Marquis of Vico offered to found a hospice for the poor who suffered from rheumatic aches and required treatment in thermal baths.) As a reward for their efforts, in 1606, Pope Paul V granted a plenary indulgence and remission of every sin to all the noblemen who had become members of the Pio Monte.

There were, at the time, several other such institutions in Naples, all vying to be recognized as the best and most charitable: the congregation Dei Bianchi worked to help prisoners and to bury the dead left to rot in the streets; Christian slaves among the heathen could seek help at the Church of Our Lady of the Redemption of Captives; pilgrims were assisted at the Trinity of the Pilgrims; the undeserving poor could find assistance at the Church of the Undeserving Poor.[34] The intention of the Pio Monte della Misericordia was more ambitious: it wished to embrace all seven acts of mercy under one single domed roof, as was comprehensively depicted in the medieval allegories of Mercy, in which a pale-faced woman draws her mantle over various needy faithful while holding in her hand a flaming heart.[35]

To house the institution, the noblemen required the best their money could buy. Two buildings were bought in the Piazza di Capuana, right by the cathedral, to serve as site for the new church, and the design was entrusted to the architect Giovanni Jacopo Conforti. The resulting church was beautifully compact, and followed the Counter-Reformation ideal of all shapes containing a symbolic significance. Conforti's small but high nave gave it the form of an octahedron emblematic of the Resurrection (which took place on the eighth day after Christ's entry into Jerusalem),[36] enclosed within the perfect circle of God. The entrance to the church occupied the base, while the other sides were divided into the symbolic seven: the main altar in front and three chapels on either side.

The most reputable painters available in Naples were commissioned to illustrate the acts of mercy: Battistello Caracciolo depicted *St. Peter Freed from Jail by the Angel* (visiting the sick and those in prison); Luca Giordano, *The Deposition of Christ* (burying the dead); Fabrizio Santafede, *The Resurrection of Tabita* (clothing the naked, since Tabita was honoured for providing clothes for the poor) and *Jesus and Marta* (feeding the hungry and giving drink to the thirsty); Gian Vincenzo D'Onofrio da Forlì, *The Good Samaritan* (housing the homeless); and Giovan Bernardo Azzolino, Il Siciliano, *St. Paolino Freeing a Slave* (a task

in which the Pio Monte excelled through arduous and expensive nego-
tiations with the infidel, in whose hands Christian soldiers had fallen).
The place of honour, above the altar, was accorded to Caravaggio, in
1607, for *The Seven Acts of Mercy* (or, as it became known for a time, *Our
Lady of Mercy*). Even though Caravaggio was then wanted by the
authorities in Rome and dubiously regarded by the more staid ecclesi-
astical canons, he was still one of the most eminent painters of his day,
and the noblemen of Pio Monte could congratulate themselves on hav-
ing netted a prize catch for their church.[37]

Caravaggio began work almost immediately. He decided to include
all seven acts of mercy in a single canvas, something that had almost
never been done before in the history of religious painting.[38] Crowded
into one same space that takes on the appearance of a theatre set, the
canvas is cut in half by a dividing wall. Up above, looking upon the dark-
ness of earth and held by a pair of angels, hovers the Madonna della
Misericordia and her Child — Our Lady of Mercy, who is also Our
Lady of Purgatory, she of the redeeming milk. Below her, the bustling
human world knows nothing of her presence: human suffering goes on,
unaware of the granted gift. "In Caravaggio's painting," writes the Eng-
lish art historian Helen Langdon, "the hope of salvation remains distant,
and he suggests fear, flight, the sudden threat of death itself, in scenes so
furiously rendered that they evoke the recent dramas of his own life,
and perhaps his own need for salvation. At the same time, the picture's
hectic clamour perfectly conveys contemporary spirituality . . . that
good works were urgent, that salvation was pressing."[39]

On the bottom left of the composition, a naked man clasps his
hands together, as if in sorrow or thanks, while his companion lifts
himself from the ground to receive part of a mantle from a well-
dressed gentleman (visiting the sick and clothing the naked). He fol-
lows the example of St. Martin, the Roman soldier who, when passing
through the city gates of Amiens, was confronted by a poor, almost
naked man. "No one had given him an alms, and Martin understood
that this man had been kept for him, so he drew his sword and cut the
cloak he was wearing into two halves, giving one half to the beggar
and wrapping himself in the other."[40] The gentleman appears to be
part of a small group of pilgrims, one of whom is dressed in the attire
of St. Jacques, the saint of Compostela (witness the cockle shell on
his hat).[41] The pilgrims are being welcomed by a stout and amiable-
looking man, perhaps an innkeeper (lodging the homeless). Behind

The Virgin and
angels (detail from
Caravaggio's *Seven
Acts of Mercy*).

them, a half-naked beggar is drinking from an ass's jaw (giving drink
to the thirsty). Caravaggio's contemporaries would recognize in the
vessel a reference to Samson who, after striking down his enemies

with the ass's jaw, suffered thirst in the desert, until "God clave an hollow place that was in the jaw, and there came water thereout; and when he had drunk, his spirit came again, and he was revived."[42] To their right, a man in a white shirt and crimson hat holds up a light to another bearing a dead body (burying the dead). Finally, a young woman, her eye on the unfolding scene, suckles an old man captive behind a barred window (visiting those in prison and feeding the hungry). Unknowingly, she re-enacts the story of Cimo and Pero,[43] the classic fable of Roman *caritas*. Incarnations of these *loci classici*, the men and the woman in Caravaggio's painting have the faces and bodies of the beggars in the street.

Caravaggio's set has nothing contrived or allegorical about it. It is not the kind of set prepared by the Church for the sanctification of *Pauperitas*, nor is it staged as one of the stylized entertainments of the Commedia dell'Arte. This too is theatre, but for Caravaggio, the set on which mercy will act out its works must include the viewer if it is to tell the truth. Therefore, Caravaggio does away with the viewer as outsider; he turns the viewer into an actor; he makes him a participant in the plot that is unfolding, not in front of the viewer's eyes, from a privileged position, but all around him, at his same level; he obliges the viewer to feel responsible for his miserable brothers and sisters. Finally, Caravaggio forces the viewer into action. Compassion without action, taught St. Thomas Aquinas, is not mercy.[44] Something must be done.

The whole set is bathed in the strong yellow light that Caravaggio used so frequently in his later paintings, what the artist Francesco Albani, a few decades older than Caravaggio, called the light of "ground flesh."[45] Where does that light come from? Not from the beacon held by the man at the door, or from the room behind the innkeeper, or even from the angelic host bearing down the Mother and Child. As X-rays have revealed, this divine apparition is a later addendum.[46] The directors of the Pio Monte may have asked Caravaggio to include the Madonna once the painting was finished, perhaps because even they, avant-garde as they wished to be, felt that the *Seven Acts* reeked too strongly of humanity and required the divine presence to allay mortal fears. But the light that gives the scene its unity and touches each and every one of the participants — the needy and the giving, the mortals and the immortal — comes from elsewhere. It falls upon the angels' wings, upon the angelic shoulders to the left and the angelic breast to the right. It lights up the face of

the Virgin and of her observant Son, as it does the faces of the innkeeper, the thirsty old man, the cockled pilgrim, the merciful gentleman, the man with the torch, the woman and her prisoner. It hits the back of the fallen naked man and the feet of the corpse being brought away for burial. It comes, as I have said, from wherever we are standing, left, right or centre, as if the scene existed solely through the light that we might bring to it. In Caravaggio's painting, the light is the viewer's own; without it, the seven acts of mercy will fade back into shadows and night.

Shortly before the Council of Trent, in the mid-sixteenth century, set down the precepts that gave strength to the Counter-Reformation, the Roman theologian Silvester Prieras had stated that the book upon which the Church was founded needed to remain a mystery, interpreted only through the authority and infallible discernment of the pope.[47] The representations of sacred texts on canvas should no doubt preserve the mystery, and show the grace, beauty and refinement of those chosen by the Spirit to play a role in the affairs of Heaven. They should not bring the mystery down to earth, to a series of vulgar though miraculous events that might have taken place, any day of the week, among common people, among the dregs of society.

When Caravaggio lent the poor of Naples a stage in his sacred canvases, he was not only going against the then-ancient precepts of the Council of Trent; he was also continuing the appropriation of a public stage that the common people had begun in the streets of their city with their Commedia, their carnival and their Feast of Fools, even with the Church processions and mysteries. These poor were the actors whom Caravaggio sought out for his paintings. His St. Matthew that so shocked the Roman canons, his filthy adorers in the *Madonna di Loreto* painted for the Church of Sant'Agostino in Rome who raise their grubby eyes to Our Lady, his *Death of the Virgin* painted for the Carmelites, supposedly using as his model a young pregnant prostitute who had drowned herself in the Tiber and whose corpse he is said to have laid out in his studio — all these were portraits of the poor whom Caravaggio saw daily on the streets, and all were refused by the authorities who had commissioned them. Only after Rubens urged his patron, the Duke of Mantua, to buy *The Death of the Virgin* was the painting displayed (but just for a week) to the artistic community of Rome, and then removed to the duke's palace, away from the eyes of the common viewer.[48]

The noblemen of Pio Monte della Misericordia had wanted the best, the most original, the most fashionable of all painters for their church. It isn't certain that they got what they expected. For Caravaggio, mercy was to be practised between brothers, not from the scornful heights of the ecclesiastic or bourgeois nobility; mercy was to follow the instructions left by Christ in Matthew 6:1–4:

> Take heed that ye do not your alms before men, to be seen of them: otherwise ye have no reward of your Father which is in heaven.
>
> Therefore when thou doest thine alms, do not sound a trumpet before thee, as the hypocrites do in the synagogues and in the streets, that they may have glory of men. Verily I say unto you, They have their reward.
>
> But when thou doest alms, let not thy left hand know what thy right hand doeth:
>
> That thine alms may be in secret: and thy Father which seeth in secret himself shall reward thee openly.

Caravaggio's canvas stands as a reminder against hypocrisy.

Caravaggio's notions of representation were far removed from the abstractions proposed by the baroque and encouraged by the Church of the Counter-Reformation. "*Baroque* is the last epithet I'd use to describe Caravaggio," wrote the perceptive American art historian Bernard Berenson, "even though it has been given to him many times. Surely the most appropriate epithet in his case is this: *anti-baroque*."[49] Indeed. The Church spoke of the *homo operativus* (the individual capable of producing effects) as a step above the *homo dignus*, the person of dignity, but it also warned that if human intervention can heal, it can also worsen a situation.[50] According to these precepts, the labours of man are best to be guided by the authorities, and it is wiser not to take action individually and to seek betterment through prayer rather than by living among the poor. The acts of mercy performed in Caravaggio's canvas take place among real people in actual distress. The noblemen of the Pio Monte would have known (and perhaps resented) the comparison.

After Naples, Caravaggio's flight took him to Malta, where, thanks to his celebrity, he was received as a Knight of Justice, and from where, after news of his crimes reached the ears of the grand duke, he was once

more expelled. In Syracuse, in Messina, in Naples again, he sought refuge and he painted. Toward the end of 1609, at the door of a Neapolitan inn much like the one he had depicted in the *Seven Acts*, he was attacked and seriously wounded, and word reached Rome that the famous painter was dead. However, after several months of convalescence, he recovered sufficiently to sail to Port'Ercole, a Spanish possession within the Papal Estates, where he waited in vain for His Holiness's pardon. At last he decided to go and seek forgiveness at the foot of St. Peter's throne itself. As he was about to sail, he was arrested by mistake and thrown into prison. On his release, he discovered that the ship that was to take him to Rome had left, carrying with it all his belongings. Exhausted and sick, Caravaggio collapsed on the beach. He died a few days later. He was thirty-seven years old.[51]

.

# Conclusion

*First find, then search.*

Jean Cocteau, *Journal d'un inconnu*

*The World*, an illumination from
Evrad d'Espingues's *Livre des pro-
priétés des choses*, 1479–1480.

LIKE ALL MY OTHER BOOKS, this one seems to be made up essentially of missing pages. Missing are the readings of the vast arts outside Western culture; missing are the attempted readings of prehistoric art; missing are the readings of emblemata, the arcane pictorial vocabulary of the Renaissance; missing are the readings of the political iconography of the nineteenth century, of the propaganda posters of the twentieth, of the arts of graffiti, of installations, of fashion, of pornography, of madness and dreams, of so-called conceptual art; missing are the readings of billboards and neon lights, of which Chesterton said, "What a glorious garden of wonders this would be, to any one who was lucky enough to be unable to read."[1]

We live with the illusion of being creatures of action; it may be wiser to consider ourselves, as the Hindu philosophy of Samkhya suggests, spectators of an eternal display of images. According to the fourth-century *Samkhya-karika* of Ishvarakrsna, the sage Kapila argued that just as when we attend a spectacle of dance or theatre we identify with the dancers or the actors, so we who think and act in the world become identified with our own thoughts and actions. From the very moment of our birth, we watch someone perform and think, and share that someone's joys, ideas, intuitions and agonies; this intimate coexistence with ourselves creates the illusion that we are that someone.[2] The images we consciously create for our pleasure, instruction or relief extend that illusion, allowing us to imagine that a painting by Picasso or a sculpture by Aleijadinho reveals the world to us or us to the world; also, astonishingly, that in the midst of our cruelty and greed and uninspired madness, we are still capable of creating and re-creating so much beauty.

Essentially, every image is nothing but a dab of colour, a hunk of stone, a trick of light on the retina that triggers the illusion of discovery

or recollection, just as we are nothing more than a multiplicity of infinitesimal spirals in whose molecules, we are told, every one of our traits and tremors are contained. And yet, such reductions offer no explanation, no clue as to what is constellated in our mind when we see a work of art that, implacably, seems to demand reaction, translation, learning of some kind — and perhaps, if we are lucky, a small epiphany. These things appear to exceed the scope of almost any book, and most certainly the scope of this one, made of haphazard notes and indecisions.

Notes

ACKNOWLEDGMENTS
(pages ix–xi)

1. Michael Baxandall, *Patterns of Intention: On the Historical Explanation of Pictures* (New Haven & London: Yale University Press, 1985).

2. E. H. Gombrich, *Art and Illusion: Studies in the Psychology of Pictorial Representation* (Ithaca, New York: Cornell University Press, 1960); *The Sense of Order: A Study in the Psychology of Decorative Art* (Ithaca, New York: Cornell University Press, 1979); *The Image and the Eye: Further Studies in the Psychology of Pictorial Representation* (Ithaca, New York: Cornell University Press, 1982).

THE COMMON VIEWER
(pages 1–18)

1. Gustave Flaubert, "Lettre à Ernest Duplan, 12 juin 1862," in *Correspondance* (Paris: Louis Conard, 1926–33).

2. Francis Bacon, *The Essays*, ed. John Pitcher, Essay LVIII (Harmondsworth: Penguin Books, 1986).

3. Aristotle, *De anima*, trans. W. S. Hett, Book III, chapter 7:431 a 15–20 (London: Loeb Classic Library, 1936). For the sake of clarity, I have slightly revised Hett's translation.

4. William Blake, "The Marriage of Heaven and Hell," Plate 7, in *The Poetry and Prose of William Blake*, ed. David V. Erdman, 4th ed. rev. (Garden City, New York: Doubleday / Anchor, 1970).

5. Elaine Scarry, *On Beauty and Being Just* (Princeton, New Jersey: Princeton University Press, 1999). In other words: "Life is the non-representable origin of representation" (Jacques Derrida, quoted by John Stoke in "Higher Gateway," *The Times Literary Supplement*, London, 12 May 2000).

6. Søren Kierkegaard, *Fear and Trembling*, trans. Alastair Hannay (Harmondsworth: Penguin Books, 1985).

7. Wendy Steiner, *Pictures of Romance: Form against Context in Painting and Literature*

(Chicago & London: University of Chicago Press, 1988).

8. André Malraux, *Le musée imaginaire* (Paris: Gallimard, 1947). "Song of change": "le chant de la métamorphose."

9. Petronius, *The Satyricon*, trans. William Arrowsmith (Ann Arbor: University of Michigan Press, 1959).

10. Stendhal, "Rome, Naples et Florence en 1817," in *Voyages en Italie*, ed. Vittorio Del Litto (Paris: Gallimard, 1973).

11. The city of Florence has set up a special clinic to deal with these cases, of which there are close to two hundred every year.

12. Ambroise Vollard, *Renoir, An Intimate Record*, trans. Harold L. Van Doren and Randolph Weaver (New York: Alfred A. Knopf, 1925).

13. Baxandall, *Patterns of Intention*.

14. "La Forme est, dans ses figures, ce qu'elle est chez nous, un truchement pour se communiquer des idées, des sensations, une vaste poésie. Toute figure est un monde, un portrait dont le modèle est apparu dans une vision sublime, teint de lumière, désigné par une voix intérieure, dépouillé par un doigt céleste qui a montré, dans le passé de toute une vie, les sources de l'expression." Honoré de Balzac, *Le chef-d'oeuvre inconnu*, ed. Roger Laporte (Castelnau-le-Lez : Éditions Climats, 1990).

15. Rudyard Kipling, "The Conundrum of the Workshops," in *The Definitive Edition of Rudyard Kipling's Verse* (London: Hodder and Stoughton, 1940).

16. John Ruskin, "Of King's Treasuries," in *Sesame and Lilies* (London, 1865).

17. E. R. and J. Pennell, *Life of Whistler* (London: Heinemann, 1911).

JOAN MITCHELL
(pages 19–38)

1. Cf. Paul Messaris, *Visual Literacy: Image, Mind and Reality* (Boulder, San Francisco & Oxford: Westview Press, 1994). "Evidence of incomprehension of movies or TV by inexperienced viewers [leads us to believe that] a viewer needs to go through a period of visual adaptation before being able to understand the image in a movie or TV program."

2. Interview in the *New Yorker* (New York, 5 August 1950), 16.

3. Jackson Pollock, in *Arts and Architecture* (February 1944), quoted in *Readings in American Art Since 1900: A Documentary Survey*, ed. Barbara Rose (New York & Washington: Frederick A. Praeger Publishers, 1968).

4. *A Book of Surrealist Games*, ed. Mel Gooding and Alastair Brotchie (Boston & London: Shambhala Redstone Editions, 1995).

5. Eugène Ionesco, "Le mot empêche le silence de parler," in *Journal en miettes* (Paris: Mercure de France, 1969).

6. Quoted in *The Oxford Illustrated History of Christianity*, ed. John McManners (Ox-

ford & New York: Oxford University Press, 1990).

7. Robert Grigg, "Christian Iconoclasm," in *Dictionary of the Middle Ages*, ed. Joseph R. Strayer, Vol. 6 (New York: Charles Scribner's Sons, 1989).

8. In Islamic tradition, the prohibition to represent divine or living things is not made explicit in the Koran. The only references to artistic creation are implied in certain passages concerning Solomon's wealth (34:12–13), Abraham's opposition to idols (6:74) and Christ transforming a clay bird into a live one (3:43). The rise of Islam, however, coincided with the iconoclastic movement in Byzantium, and it is possible that both cultures shared at the time a common ethos as expressed in a series of Arabic, Persian and Turkish *hadith* ("traditions") that strongly condemned representational art and chastised the artist for seeing himself as a competitor of God, the sole Creator. Cf. Thomas W. Arnold, *Painting in Islam* (London, 1928).

9. Françoise Viatte and Lizzie Boubli, "Avant-propos," in *Réserves: les suspens du dessin*, Paris: catalogue of the exhibition at the Musée du Louvre, 22 November 1995–19 February 1996.

10. Rainer Maria Rilke, *Briefe über Cézanne*, ed. Clara Rilke (Frankfurt-am-Main: Suhrkamp Verlag, 1976).

11. Giovanna Franci, *L'anzia dell' interpretazione* (Modena: Mucchi, 1989).

12. Quoted in Elsa Honig Fine, *Women and Art* (Montclair and London: Allanheld & Schram/Prior, 1978).

13. Klaus Kertess, *Joan Mitchell* (New York: Harry N. Abrams, 1997).

14. Deirdre Blair, *Beckett: A Biography* (New York and London: Harvest/HBJ, 1978).

15. Ibid.

16. Quoted in Fine, *Women and Art*.

17. T. S. Eliot, "The Hollow Men" in *The Complete Poems of T. S. Eliot* (London: Faber & Faber, 1962).

18. Quoted in Michel Waldberg, *Joan Mitchell* (Paris: Éditions de la Différence, 1992).

19. Quoted in Irving H. Sandler, "Abstract Expressionism," in *Abstract Art Since 1945* (London: Thames & Hudson, 1971).

20. Miguel Hernández, *El silbo vulnerado* (Buenos Aires: Losada, 1949).

21. Paul Kay and Kempton Willett, "What Is the Sapir-Whorf Hypothesis?" in *American Anthropologist* 86(1): 65–79, 1984. Quoted in Paul Messaris, *Visual "Literacy": Image, Mind, and Reality* (Boulder, San Francisco & Oxford: Westview Press, 1994).

22. William James, *The Principles of Psychology*, Vol. II, XVII:11 (New York: Henry Holt, 1890).

23. Hugh de St. Victor, *"The Didascalicon": A Medieval Guide to the Arts*, trans. Jerome Taylor (Oxford: Oxford University Press, 1961).

24. George Ferguson, *Signs and Symbols in Christian Art* (Oxford & London: Oxford University Press, 1954).

25. Louis Ginzberg, *The Legends of the Jews*, trans. Henrietta Szold, Vol. I (Baltimore and London: Johns Hopkins University Press, 1998).

26. Roger E. Reynolds, "Liturgical Colors," in *Dictionary of the Middle Ages*, ed. Joseph R. Strayer, Vol. 3 (New York: Charles Scribner's Sons, 1989).

27. Leon Battista Alberti, *On Painting*, trans. Cecil Grayson with an introduction and notes by Martin Kemp (Harmondsworth: Penguin Books, 1972).

28. Michael Baxandall, *Painting and Experience in Fifteenth-Century Italy* (Oxford & New York: Oxford University Press, 1988).

29. Quoted in Eleanor Munro, *Originals: American Women Artists* (New York: Simon and Schuster, 1979).

30. Waldberg, *Joan Mitchell*.

31. Samuel Beckett, *Molloy* (Paris: Éditions de Minuit, 1951).

32. Balzac, *Le chef-d'oeuvre inconnu*.

33. Santa Teresa de Jesús, *Las Moradas*, "Moradas Sextas," Cap. I:1, in *Obras Completas* (Madrid: Biblioteca de Autores Cristianos, 1967).

34. J. Edward Thomas, *The Life of Buddha as Legend and History* (London: Methuen and Co., 1952).

35. Prayer Book, 26:6

36. Quoted in Kertess, *Joan Mitchell*.

ROBERT CAMPIN
(pages 39–64)

1. St. Augustine, *City of God*, trans. Henry Bettenson, Book XIV, Chapter 15 (Harmondsworth: Penguin Books, 1984).

2. Jacobus de Voragine, *The Golden Legend: Readings on the Saints*, trans. William Grager Ryan, Vol. I (Princeton, New Jersey: Princeton University Press, 1993).

3. Manfred Lurker, *Lexikon der Götter und Dämonen* (Stuttgart: Alfred Krämer Verlag, 1984).

4. These "multiple" symbols include fire, which can burn and give light, and earth, from which a body can be created (like Adam) and which in turn receives our mortal remains. Cf. Edward Hoffman, *The Way of Splendor: Jewish Mysticism and Modern Psychology* (Boulder and London: Shambhala, 1981).

5. Robert Graves, *The Greek Myths* (Harmondsworth: Penguin Books, 1986).

6. J. McManners, *The French Revolution and the Church* (London: Weidenfeld & Nicolson, 1960).

7. Jean-Jacques Lequeu, *Inscriptions révolutionnaires: Paris, 1793–1794* (Paris: Bibliothèque Nationale).

8. Amadeus of Lausanne, "From the Fourth Homily on Mary, the Virgin Mother,"

in *The Cistercian World: Monastic Writings of the Twelfth Century*, trans. and ed. Pauline Matarasso. (Harmondsworth: Penguin Books, 1993).

9. I Peter 2:2

10. *The Prayers and Meditations of Saint Anselm, with the Proslogion*, ed. and trans. Sister Benedicta Ward, S.L.G. (Harmondsworth: Penguin, 1973).

11. Valerius Maximus, *Faits et dits mémorables*, ed. and trans. Robert Combès, IX, 5:c-4 (Paris: Les Belles Lettres, 1995).

12. Marina Warner, *Alone of All Her Sex: The Myth and Cult of the Virgin Mary*, rev. ed. (London: Picador, 1990).

13. Hans Biedermann, *Knaurs Lexicon der Symbole* (Berlin: Knaurs, 1989).

14. Desiderius Erasmus, "A Pilgrimage for Religion's Sake," in *Ten Colloquies*, trans. Craig R. Thompson (New York & London: Macmillan, 1986).

15. J. A. S. Collin de Plancy, *Dictionnaire Critique des Réliques et Images Miraculeuses*, 3 vols. (Paris, 1821–22). Quoted in Warner, *Alone of All Her Sex*.

16. Susan Mart and Daniela Mondini, "Marienbrüste und Marienmilch im Heilsgeschehen," in *Himmel, Hölle, Fegefeuer: Das Jenseits im Mittelalter*, ed. Peter Jezler (Zürich: Verlag Neue Zürcher Zeitung, 1994).

17. It is interesting to note that this image of the breast-baring Mary has its shadow in Greek culture, where the mother was not necessarily regarded as both life-giver and nurturer. In Aeschylus's *Libation Bearers*, for example, Clytemnestra bares herself to her son, Orestes, who is about to kill her, asking him to pity the breasts that gave him milk. The audience knows that Clytemnestra is lying, since Orestes was suckled not by his mother but by a wet-nurse. Clytemnestra is claiming the role of the life-giver, the nurse, the nurturer. The queen usurps the role she relinquished in order to elicit, like Mary centuries later, her son's compassion. Cf. George Devereux, *Dreams in Greek Tragedies* (Oxford: Basil Blackwell, 1976) in Craig Stephenson, "The Symbol of the Snake in Three Dreams from Aeschylus' *Oresteia*," (London, *Harvest*, 2000).

18. Sally Fisher, *The Square Halo and Other Mysteries of Western Art* (New York: Harry N. Abrams, 1995).

19. Both these examples are given in ibid.

20. E. H. Gombrich, *Shadows: the Depiction of Cast Shadows in Western Art* (London: National Gallery Publications, 1995).

21. Ferguson, *Signs and Symbols*.

22. Allan B. Wolter, *Duns Scotus on the Will and Morality* (Washington, D.C.: Catholic University of America Press, 1986).

23. Jacques Le Goff, *Les intellectuels au Moyen Age* (Paris: Éditions du Seuil, 1957).

24. Erich Neumann, *The Great Mother: An Analysis of the Archetype*, trans. Ralph Manheim (New York: Farrar, Straus & Giroux, 1955).

25. For the complexity of the ibis and salamander symbols, see Wilhelm Fraenger, *Das Tausendjährige Reich* (Coburg: Winkler Verlag, 1947).

26. St. Antonino, *Summa Theologica*, III:viii, 4, quoted in Baxandall, *Painting and Experience*.

27. Macrobius, *Saturnalia*, I, 20, 13 ff, quoted in Erwin Panofsky, *Meaning in the Visual Arts* (New York: Doubleday, 1955).

28. Erwin Panofsky, "Titian's *Allegory of Prudence*: A Postscript," in ibid.

29. Isaiah 7:14

30. I discuss Mary's reading in the chapter "The Symbolic Reader" in *A History of Reading* (Toronto: Knopf Canada, 1996).

31. W. H. Auden, "Musée des Beaux Arts," in *Collected Shorter Poems 1927–1957* (London: Faber & Faber, 1966).

32. Warner, *Alone of All Her Sex*.

33. St. Augustine, "Sermon IX," 2, p. 109, in *Sermons for Christmas and Epiphany*, trans. Thomas Comerford Lawler, *Ancient Christian Writers* 15 (Westminster, Maryland & London: 1952). Christ marries Humanity, symbolized in Mary, in the same way that a man marries a woman.

34. Lorne Campbell, "History," in "*The Virgin and Child Before a Firescreen*: History, Examination and Treatment," in *Robert Campin: New Directions in Scholarship*, ed. Susan Foister and Susie Nash (London: Brepols Publishers, 1996).

35. Leo Steinberg, *The Sexuality of Christ in Renaissance Art and in Modern Oblivion*, 2d ed. (Chicago & London: University of Chicago Press, 1996).

36. Steinberg lists a large number of these paintings.

37. St. Augustine, *City of God*, trans. Bettenson, Book XIV, Chapters 14–15.

38. Julius Theodor, *Midrasch Bereschit Rabbah*, Berlin, 1907–17, quoted in *The Book of Legends: Sefer Ha-Aggadah*, ed. Hayim Nahman Bialik and Yehoshua Hana Ravnitzky, trans. William G. Braude (New York: Schoken Books, 1992).

39. Quoted in de Voragine, *The Golden Legend*, trans. Ryan.

40. Ibid.

41. Ibid.

TINA MODOTTI
(pages 65–86)

1. Pliny the Elder, *Natural History: A Selection*, trans. with an introduction by John Healy, Book XXXV:15 (Harmondsworth: Penguin Books, 1991).

2. Ibid., Book XXXV:151.

3. Ibid., Book XXXV:65.

4. Plutarch, "Were the Athenians More Famous in War or in Wisdom?" in *Plutarch's Moralia in 16 Volumes*, Vol. VI, trans. Frank Cole Babbitt (Cambridge, Massachusetts: Harvard University Press, 1972).

5. Josef Maria Eder, *History of Photography*, trans. E. Epstean (New York: Columbia University Press, 1972).

6. Edgar Allan Poe, "The Daguerreotype," in *Brevities: Pinakidia, Marginalia, Fifty Suggestions and Other Works*, Vol. 2 of *The Collected Works of Edgar Allan Poe*, ed. Burton R. Pollin (New York: Gordian Press, 1985).

7. Paul Valéry, *"Centenaire de la photographie"Discours à la Sorbonne le 7 janvier 1939* (Paris: Firmin-Didot, 1939).

8. Walter Pater, "The School of Giorgione," in *The Renaissance* (London: Macmillan & Co., 1893).

9. Charles Baudelaire, "Le public moderne et la photographie," in *Oeuvres complètes*, ed. Claude Pichois, tome II (Paris: Gallimard, 1976).

10. John Berger, "Understanding a Photograph," in *The Look of Things* (New York: Viking, 1974).

11. Julio Cortázar, "Las babas de diablo" [translated into English as "Blow-Up"] in *Final de Juego* (Buenos Aires: Sudamericana, 1956).

12. Antonio Tabucchi, *Notturno Indiano* (Palermo: Sellerio editore, 1984).

13. Edward Weston, "Seeing Photographically," in *Classic Essays on Photography*, ed. Alan Trachtenberg (New Haven, Connecticut: Leete's Island Books, 1980).

14. Ben Maddow, *Edward Weston: His Life* (New York: Aperture, 1989).

15. Patricia Albers, *Shadows, Fire, Snow: The Life of Tina Modotti* (New York: Clarkson Potter, 1999).

16. Quoted in Margaret Hooks, *Tina Modotti: Photographer and Revolutionary* (London: HarperCollins, 1993).

17. Albers, *Shadows, Fire, Snow*.

18. Quoted in Pino Cacucci, *Tina* (Milan: Interno Giallo Editore, 1991).

19. Quoted in Sarah M. Lowe, *Tina Modotti: Photographs* (New York: Harry N. Abrams, 1995).

20. Ibid.

21. Albers, *Shadows, Fire, Snow*.

22. Review in *El Universal Ilustrado*, 14 October 1926, quoted in Lowe, *Tina Modotti*.

23. Diego Rivera, "Edward Weston and Tina Modotti," in *Mexican Folkways* 17, quoted in Lowe, *Tina Modotti*.

24. Lowe, *Tina Modotti*.

25. Susan Sontag, *On Photography* (New York: Farrar, Straus & Giroux, 1974).

26. François Garnier, *Le langage de l'image au Moyen Age: Signification et symbolique* (Paris: Le Léopard d'or, 1982).

27. Alfonso Reyes, "Visión de Anáhuac (1519)," in *Antología de Alfonso Reyes* (Mexico: Fondo de Cultura Económica, 1963).

28. Jason Goodwin, *Lords of the Horizon: A History of the Ottoman Empire* (London: Chatto & Windus, 1998).

29. Joyce Cary, *The Horse's Mouth* (Harmondsworth: Penguin Books, 1954).

30. Michael C. Meyer and William L. Sherman, *The Course of Mexican History*, 3d ed. (Oxford and New York: Oxford University Press, 1987).

31. "Consejos a un muchacho," in *Mitos y literatura azteca*, selección de José Alcina Franch (Madrid: Alianza Editorial, 1989).

32. Geoffrey Hartman, "Memory.com: Tele-suffering and Testimony in the Dot Com Era," in *Raritan* 19, no. 3 (Winter 2000).

33. Quoted in Albers, *Shadows, Fire, Snow*.

34. Ibid.

35. The reports in the Mexican press are reprinted in Mildred Constantine, *Tina Modotti: A Fragile Life* (New York: Paddington Press, 1975).

36. Pablo Neruda, *Confieso que he vivido*, 3d ed. (Madrid: Plaza y Janés, 1996).

37. Cacucci, *Tina*.

38. Albers, *Shadows, Fire, Snow*.

39. Pablo Neruda, "Tina Modotti ha muerto," in *Residencia en la tierra*, 4th ed. (Buenos Aires: Losada, 1971).

LAVINIA FONTANA
(pages 87–116)

1. *Lavinia Fontana 1552–1614*, ed. Vera Fortunati (Milano: Electa, 1994). Most of the information on Lavinia Fontana and Tognina Gonsalvus comes from the exhaustive study by Professor Fortunati.

2. Laura M. Ragg, *The Women Artists of Bologna* (London: Methuen, 1907).

3. Dr. Brian Hall of Dalhousie University in Halifax, Nova Scotia, and Dr. Pragna Patel of Baylor College, Houston, are in the process of identifying the gene that causes this disease. Cf. *Nature Genetics Magazine*, June 1997.

4. Joris Hoefnagel, *The Four Elements*, "Ignis," Vol I. next to f.1 r, 1582(?), Washington, National Gallery of Art, Collection of Mrs. Lessing J. Rosenwald.

5. Manfred Staudinger (with Herbert Haupt, Thea Vignau-Wilberg, Eva Irblich), *Le Bestiaire de Rodolphe II, Cod. min. 129 et 130 de la Bibliothèque nationale d'Autriche* (Paris: Éditions Citadelle, 1990).

6. Pliny the Elder, *Natural History*. Pliny adds, however, that "I am obliged to consider — and with confidence — that the assertion that men are turned into wolves and back to themselves again is false." Virgil, in *Eclogue IX*, makes use of the belief that a wolf's gaze will strike one dumb.

7. It isn't clear why Manfred Staudinger does not agree with this identification: he argues that Ravestyn was not present at the Prague court after 1608 and yet admits that the family portrait might have been painted in Namur, at the court of Margaret of Austria, around 1580.

8. Ambroise Paré, *Animaux, monstres et prodiges*, 1573 (Paris: reprinted Club Français du Livre, 1954).

9. St. Jerome, Letter 22:18, quoted in Elaine Pagels, *Adam, Eve, and the Serpent* (New York: Random House, 1988).

10. Genesis 3:21

11. According to the *Tanhuma*, a homelitic Midrash (ed. Solomon Buber, Vilna, 1885), the six deprivations were "splendour of visage, lofty stature, life without death, perfection of the earth's fruit, the Garden of Eden, and brilliance of the luminaries in heaven. In the time-to-come, the Holy One will restore them." Quoted in *The Book of Legends: Sefer Ha-Aggadah*.

12. Staudinger, *Le Bestiaire de Rodolphe II*.

13. Ulisse Aldrovandi, *Monstrorum Historia cum Paralipomenis historiae omnium animalium* (Bologna, 1642).

14. Ibid.

15. Aristotle, *De partibus animalium* (3Y.3.4.665a.20-21).

16. Giovanni Batista della Porta, *De humana physiognomia* (Naples, 1586).

17. Charles Le Brun, "Homme/loup," in the Département des arts graphiques, Musée du Louvre, Paris (inv. 6724/28171). In a talk given in 1687, Le Brun said, "If it is true that there exists a portion of the body wherein the soul reacts immediately, and that this portion is the brain, we can say that the face is the portion of the body which shows most clearly what it feels." "Conférence sur l'expression générale et particulière des passions" (Verona, 1751).

18. Dante Alighieri, *Commedia*, "Inferno," Canto XVIII, ed. Emilio Pasquini and Antonio Quaglio (Milan: Garzanti, 1987).

19. Jean de Sponde, *Commentary upon Homer*, folio, Basel, 1583, quoted in Montague Summers, *The Werewolf* (London: Kegan Paul, 1933). If a human face can hide a bestial character, the reverse must be true as well. It is tempting to quote John Masefield's "Epilogue": "I have seen flowers come in stony places/And kind things done by men with ugly faces,/And the gold cup won by the worst horse at the races,/So I trust, too." John Masefield, *Poems* (London: Macmillan, 1946).

20. Cf. Joyce E. Salisbury, *The Beast Within: Animals in the Middle Ages* (New York & London: Routledge, 1994).

21. St. Bonaventure, "The Life of St. Francis," in *The Soul's Journey into God. The Tree of Life. The Life of St. Francis*, trans. E. Cousins (New York: Paulist Press, 1978).

22. The Roman she-wolf is the ancestor of a whole pack of kind-hearted literary wolves, from the ones that nursed a child according to the 1304 chronicle of the Benedictine Abbey of Erfurt (cf. Gherardo Ortalli, "Animal exemplaire et culture de l'environnement: permanences et changements," in Jacques Berlioz and Marie Anne Polo de Beaulieu, eds., *L'animal exemplaire au Moyen Age* [Rennes: Presses Universitaires de Rennes, 1999]) to the wolves who brought up Mowgli in Rudyard Kipling's *Jungle Books* and those that raised the Wild Boy of Averoye, made famous in François Truffaut's 1969 film *L'enfant sauvage*.

23. Sigmund Freud, "From the History of an Infantile Neurosis (The 'Wolf Man') (1918 [1914])" in *Case Histories II*, Vol. 9 of The Pelican Freud Library, ed. Angela Richards (Harmondsworth: Penguin, 1979).

24. Habbakuk 1:8

25. Matthew 7:15

26. Geoffrey Chaucer, "The Parson's Tale," *The Canterbury Tales*, in *Complete Works*, ed. Walter W. Skeat (Oxford: Oxford University Press, 1912).

27. Vincenzo Cartari, *Le Imagini de i dei de gli antichi*, 1571 (Vicenza: reprinted Neri Pozza Editore, 1996).

28. Strato, "Epigram," in Salvatore Quasimodo, *Dall'Antologia Palatina* (Milan: Einaudi, 1968).

29. Juvenal and Persius, *Works*, ed. G. G. Ramsay (Cambridge, Massachusetts & London: Loeb Classical Library, 1988).

30. Jean de Meun and Guillaume de Lorris, *Le Roman de la Rose*, ed. D. Poirion (Paris: Gallimard, 1973).

31. Pliny the Elder, *Natural History*.

32. Charles Perrault, "Le petit chaperon rouge" in *Histoires ou contes du temps passé* (Paris, 1697). Iona and Peter Opie have remarked how extraordinary it is that no version of the story has been found prior to Perrault's manuscript of 1695. Iona and Peter Opie, *The Classic Fairy Tales* (Oxford: Oxford University Press, 1974).

33. Marina Warner, *From the Beast to the Blonde: On Fairytales and Their Tellers* (London: Chatto & Windus, 1994).

34. Alexander Pope, *The Rape of the Lock*, ed. John Bailey (London & Edinburgh: Thomas Nelson & Sons, n/d).

35. Daniel 4:33

36. *Myths from Mesopotamia: Creation, The Flood, Gilgamesh and Others*, ed. and trans. Stephanie Dalley (Oxford: Oxford University Press, 1996).

37. Chrétien de Troyes, *Le roman de Perceval, ou le conte du Graal*, ed. William Roach (Geneva: Droz, 1959).

38. A. Dickson, *Valentine and Orson: a Study in Late Medieval Romance* (New York: Charles Scribner's Sons, 1929).

39. *Wolfdietrich* in *Deutsches Heldenbuch*, Vol. III, ed. O. Jänicke (Berlin, 1866–73).

40. Diego de San Pedro, *Cárcel de Amor* (Barcelona: Ateneo, 1904).

41. Edmund Spenser, *The Faerie Queene*, VI: 4 : 2–16, ed. J. C. Smith and E. de Selincourt (Oxford: Oxford University Press, 1912). In Spenser, the distinction between the redeemable savage nature of the wild man and the irredeemable savagery of soulless beasts is made explicit: the wild man "that neuer till this houre/ Did taste of pittie, neither gentlesse knew" is suddenly touched by a wronged lady's plight (the "vnfortunate Matilde") and "contrarie to her feare,/ Came to her creeping like a fawning hound"; while immediately afterwards a "cruell Beare" steals away her babe to devour it.

42. Jeanne-Marie, Mme Leprince de Beaumont, *Contes de fées tirés du magasin des enfants* (Paris, 1883).

43. *La Belle et la Bête*, written and directed by Jean Cocteau (Paris, 1946).

44. Lord Herbert of Cherbury (1583–1648), "A Description," in *Baroque Poetry*, ed. J. P. Hill and E. Caracciolo-Trejo (London: Dent, 1975).

45. Thomas W. Lacqueur, "Amor Veneris, Vel Dulcedo Appeletur," in *Fragments for a History of the Human Body*, Part Three, ed. Michel Feher with Ramona Naddaff and Nadia Tazi (New York: Urzone, 1989).

46. Ibid.

47. Jules Michelet, in *La sorcière* (Paris: Hetzel, 1862), notes that not until 1306 does the Church allow the public dissection of a woman's body. It was, says Michelet, "the discovery of a world (more than Christopher Columbus was to achieve). Fools trembled and shouted. And wise men fell on their knees." The *locus classicus* of this comparison between the two discoveries is of course John Donne's "O my America! my new-found-land," Elegie XIX "To His Mistress Going to Bed" in *The Complete English Poems* (New York: Alfred A. Knopf, 1991). The Argentine writer Federico Andahazi makes use of the story in his novel *El Anatomista* (Buenos Aires: Planeta, 1997). Andahazi changes the name Renaldus Columbus to Mateo Columbus.

48. Dominique-Martin Méon, *Blasons, poésies anciennes* (Paris: P. Guillemot, 1807–8). "Mon gentil jardinet . . . revêtu d'une riche toison/ De fin poil d'or en sa vraie saison." In English, Spenser excelled in the art of the *blason*, as in this example included in his *Epithalamion* (1595):

> Her goodly eyes like sapphires shining bright,
> Her forehead ivory white,
> Her cheeks like apples which the sun has rudded,
> Her lips like cherries charming men to bite,
> Her breast like to a bowl of cream uncrudded,
> Her paps like lilies budded,
> Her snowy neck like to a marble tower,
> And all her body like a palace fair.

49. Louise Labé, *Oeuvres complètes*, ed. Enzo Giudici (Geneva: Droz, 1981). From Sonnet XXI: "Quelle grandeur rend l'homme vénérable?/ Quelle grosseur? quel poil? quelle couleur?"

50. Leslie Fiedler, *Freaks: Myths and Images of the Secret Self* (New York: Simon & Schuster, 1978).

51. Alfonso E. Pérez Sánchez and Nicola Spinosa, *Jusepe de Ribera 1591–1652* (New York: The Metropolitan Museum of Art, 1992). There is a letter from the Venetian ambassador to Naples in which he describes visiting Ribera's studio as he was working on this painting. According to the ambassador, the woman had "a completely masculine face, with a beautiful black beard more than a *palmo* long and a very hairy chest." The painting now hangs in the Palacio Lerma in Toledo, Spain.

52. Magdalena and Uncumber are both described in a book by Jean Nohain and

François Caradec, *La femme à barbe* (Paris: La Jeune Parque, 1969), which chronicles the life of a modern bearded beauty, Clementine Delait. Recently, an American feminist association tried to change St. Valentine's Day to St. Uncumber Day, considered to be less sexist. Christina Lamb, "Feminists Want Bearded Lady to replace St. Valentine," in *Daily Telegraph* (London), 25 April 1999.

53. This note, together with many others, was collected posthumously and published in book form. Cf. Leonardo da Vinci, *Treatise on Painting*, ed. A. P. McMahon (Princeton, New Jersey: Princeton University Press, 1956).

54. *Queen Christina*, dir. Rouben Mamoulian (1933).

55. Isidoro de Sevilla, *Etimologías*, ed. Manuel C. Díaz y Díaz (Madrid: Biblioteca de Autores Cristianos, 1982–83).

56. David Gordon White, *Myths of the Dog-Man* (Chicago & London: University of Chicago Press, 1991).

57. G. Oretti, *Pittori*, Vol II.

58. Marcello Oretti, *Pittori*, t. II, Gozzadini ms. 122, quoted in Ragg, *The Women Artists of Bologna*.

59. C. C. Malvasia, *Felsina pittrice* (Bologna, 1678 [republished, Bologna, 1841]).

60. Lodovico Frati, *La vita privata di Bologna dal secolo XIII al XVII*, (Nicola Zanichelli, Bologna, 1900).

61. J. N. D. Kelly, *The Oxford Dictionary of Popes* (Oxford: Oxford University Press, 1986).

62. Rome, Accademia Nazionale di San Luca.

63. Vera Fortunati, "Lavinia Fontana. Una pittrice nell'autunno del Rinascimento," in *Lavinia Fontana 1552–1614*.

64. Giorgio Vasari, *Le vite de più eccellenti Pitori, Scultori e Archittori* (Florence, 1568 [ed. Milan, 1963]).

65. Giulio Cesare Croce (1550–1609) is quoted by Angela Ghirardi, "Lavinia Fontana allo spechio. Pittrici e autoritratto nel secondo Cinquecento," in *Lavinia Fontana 1552–1614*.

66. Giovanni Gozzadini, "Di alcuni gioelli notati in un libro di ricordi del secolo XVI e di un quadro di Lavinia Fontana," 9.10.1935 (London: brochure in the National Art Library).

67. Nico H. Frijda, *The Emotions* (Cambridge and Paris: Cambridge University Press & Éditions de la Maison des Sciences de l'Homme, 1986).

68. James Boswell, *The Life of Samuel Johnson* (London, 1791).

69. Lavinia Fontana, "Ritratto della famiglia Gozzadini" (1584), Bologna: Pinacoteca Nazionale.

MARIANNA GARTNER
(pages 117–150)

1. Synod of Arras, Chapter 14, in *Sacrorum Nova et Amplissima Collectio*, ed. J. D. Mansi (Paris & Leipzig, 1901). Quoted in Umberto Eco, *Il problema estetico di Tommaso d'Aquino* (Milan: Fabbri, 1970).

2. David Sylvester, *Magritte* (New York: Frederick A. Praeger, 1969), quoted in Annie Dillard, *Living by Fiction* (New York: Harper & Row, 1982).

3. Suzi Gablik, *Magritte* (London: Thames & Hudson, 1985).

4. Quoted in *The Book of Legends: Sefer Ha-Aggadah*. Hegel mentions how the traveller James Bruce, on his journey to Abyssinia, showed paintings of fish to a Turk who, amazed at first, asked him, "If this fish shall rise up against you on the last day, and say, 'You have created for me a body, but no living soul,' how will you defend yourself against such an accusation?" G. W. F. Hegel, *Introductory Lectures on Aesthetics*, Chapter 3, Part II, trans. Bernard Bosanquet (Harmondsworth: Penguin Books, 1993).

5. 2 Kings 21:11–13; Ezekiel 24:3,9,11; Zechariah 12:2,3,6 and 13:2; Jeremiah 19:11 and 22:24, all quoted by Elaine Scarry, *The Body in Pain: The Making and Unmaking of the World* (New York & Oxford: Oxford University Press, 1985).

6. Ibid.

7. Quoted in Eamon Duffy, *The Stripping of the Altars: Traditional Religion in England 1400–1580* (New Haven & London: Yale University Press, 1992).

8. Gombrich, *The Image and the Eye*.

9. Both aesthetic and scientific conventions. The French critic Hippolyte Taine was the first to argue that artistic representations had a scientific basis. In the introduction to his *History of English Literature* (1863–64), he wrote: "There is a cause for ambition, for courage, for truth, as there is for digestion, for muscular movement, for animal heat. Vice and virtue are products, like vitriol and sugar."

10. Cf. Hans Belting, *Likeness and Presence: A History of the Image before the Era of Art*, Chapter 1, trans. Edmund Jephcott (Chicago: University of Chicago Press, 1994).

11. Jorge Luis Borges, "El simulacro," in *El Hacedor* (Buenos Aires: Emecé, 1960).

12. Josef Škvorecký, *The Bass Saxophone* (Toronto: Anson-Cartwright Editions, 1977).

13. José Ortega y Gasset, *La Deshumanización del arte* (Madrid: Revista de Occidente, 1925).

14. Gustave Flaubert, "Un coeur simple," in *Trois contes* (Paris: Gallimard, 1962).

15. Lewis Carroll, *Through the Looking-Glass*, Chapter VII, in *The Annotated Alice*, ed. Martin Gardner (Harmondsworth: Penguin Books, 1965).

16. Scarry, *The Body in Pain*.

17. Quoted in ibid.

18. St. Augustine, *Confessions*, Book IX:12, trans. R. S. Pine-Coffin (Harmondsworth: Penguin Books, 1961).

19. Quoted in Scarry, *The Body in Pain*.

20. Fiedler, *Freaks*.

21. De Voragine, *The Golden Legend*.

22. In a detail from the altarpiece of San Francisco de Valladolid, in Spain, *c.* 1560.

23. Cf. Antoine Schnapper, *Le géant, la licorne, la tulipe: collections françaises au XVIIe siècle* (Paris: Flammarion, 1988).

24. Robert Enright, "Anomalous Art," in *Border Crossings* (Winter 1995).

25. Helen Langdon, *Caravaggio: A Life* (London: Chatto & Windus, 1998).

26. G. P. Bellori, *Le vite de' pittori, scultori ed architetti moderni* (Rome, 1672), quoted by H. Hibbard, *Caravaggio* (London: HarperCollins, 1993).

27. Cf. Paul Binski, *Medieval Death: Ritual and Representation* (Ithaca, New York: Cornell University Press, 1996).

28. Philippe Ariès, *Essais sur l'histoire de la mort en Occident du Moyen Age à nos jours* (Paris: Éditions du Seuil, 1975).

29. Wilhelm Fraenger, *Das Tausendjährige Reich* (Coburg: Winkler Verlag, 1947).

30. Miguel de Unamuno, *Ensayos* (Madrid: Alianza, 1973).

31. Ecclesiastes 1:8

PHILOXENUS
(pages 151–176)

1. In a Greek version of Alexander's life printed in Venice in 1750 but based on a much earlier text (*The Life and Deeds of Alexander*, attributed to the Pseudo-Callisthenes), the prophet Jeremiah appeared to Alexander in a dream and told him that he would vanquish Darius as long as he paid homage to the Christian God. Unconcerned with anachronism, Alexander awoke, the anonymous biographer tells us, "all smiles." Cf. *Nacimiento, hazañas y muerte de Alejandro de Macedonia*, trans. Carlos R. Méndez, with an introduction by Carlos García Gual (Madrid: Gredos, 1999).

2. Arrian, *Anabasis Alexandri*, Book II, trans. P. A. Brunt, 2 vols. (London & Cambridge, Massachusetts: Loeb Classical Library, Harvard University Press and William Heinemann Ltd., 1976).

3. Quintius Curtius Rufus, *The History of Alexander* III 11:27, trans. John Yardley (Harmondsworth: Penguin, 1984). Curtius seems to have exaggerated a little. Though there is general agreement about the Persian casualties, Alexander's losses appear to have been higher. Arrian, for instance, says that during the battle 120 notable Macedonians were killed (Arrian, *Anabasis Alexandri*, II 10:7).

4. The First Book of Maccabees, 1:3, in *The Jerusalem Bible*, gen. ed. Alexander Jones (New York: Doubleday, 1966).

5. Patrick Leigh Fermor, *Mani: Travels in the Southern Peloponnese* (London: John Murray, 1958).

6. Pliny the Elder, *Natural History*, XXXV:110.

7. A. de Franciscis, *Musaici antichi del Museo Nazionale di Napoli*.

8. Stefano De Caro, *Il Museo Archeologico Nazionale di Napoli* (Napoli: Electa, 1996).

9. Quoted in ibid.

10. *Beowulf*, ed. Kevin Crossley-Holland and Charles Keeping, line 2661 (Oxford and New York: Oxford University Press, 1982).

11. Richard Broxton Onians, *The Origins of European Thought about the Body, the Mind, the Soul, the World, Time, and Fate* (Cambridge: Cambridge University Press, 1951).

12. Cicero, *De Republica*, II, 21:37, trans. Clinton W. Keyes (London & Cambridge, Massachusetts: Loeb Classical Library, Harvard University Press and William Heinemann Ltd., 1968).

13. J. R. Green, *Theatre in Ancient Greek Society* (London & New York: Routledge, 1994).

14. Aeschylus, *Isthmiastae*, lines 5–21 of fragment 1, quoted in ibid.

15. Diogenes Läertius, *Lives*, II:33, vol. I, trans. R. D. Hicks (London & Cambridge, Massachusetts: Loeb Classical Library, Harvard University Press and William Heinemann Ltd., 1972).

16. Pausanias, *Guide to Greece, Vol. 2: Southern Greece*, book VIII, 465, trans. Peter Levi, rev. ed. (Harmondsworth: Penguin Books, 1979).

17. Plato, "The Sophist," 266 d, trans. F. M. Cornford, in *The Collected Dialogues*, ed. Edith Hamilton and Huntington Cairns, Bollingen Series LXXI (Princeton, New Jersey: Princeton University Press, 1973).

18. Plato, "The Republic," X 596 d-e, trans. Paul Shorey, in ibid.

19. Socrates called the poet "an imitator," removed three times from the truth (the poet creates the "poetic form"; the first two are the "ideal form" and the "natural form"). In Plato, "The Republic," X 597 e, trans. Paul Shorey.

20. In the Princeton Art Museum, ex-collection Stroganoff, 51–1.

21. Domenico Rea, *Pompei e la sua pittura* (Novara: Instituto Geografico De Agostini, 1981).

22. The Romans practised two forms of divination by reflection: "catoptromancia," in which the future is foretold by the image appearing in a mirror; and "lecanomancia," in which the image appears on a liquid surface. Gilles Sauron lists the various specialists who have discussed this image, both embracing and rejecting the idea of a fearsome reflection. Cf. Gilles Sauron, *La grande fresque de la Villa des Mystères à Pompeii* (Paris: Picard éditeur, 1998).

23. Borges, "Los espejos," in *El Hacedor*.

24. Borges, "Arte poética," in *El Hacedor*.

25. John Lydgate, text in the north cloister of Old St. Paul's Cathedral, London, *c.* 1430. Quoted in Paul Binski, *Medieval Death: Ritual and Representation* (Ithaca, New York: Cornell University Press, 1996).

26. "Parean l'occhiale anella senza gemme:/ chi nel viso de li uomini legge 'omo'/ ben avria quivi conosciuta l'emme." Dante Alighieri, "Purgatorio," XXIII: 31–33, in *Commedia*, a cura di Emilio Pasquini e Antonio Quaglio (Milano: Garzanti, 1987).

27. Roger Caillois, *Le mimétisme animal* (Paris: Gallimard, 1963).

28. George Berkeley, *A Treatise Concerning the Principles of Human Knowledge*, London, 1710. Berkeley wrote that *"esse est percipi,"* which he expanded to "to be is to be perceived and to perceive" in the revised 1734 edition. George Berkeley, *Philosophical Works*, ed. M. R. Ayers (London: J. M. Dent & Sons, 1975).

29. Jacques Lacan, *Séminaire 2* (Paris: Éditions du Seuil, 1966).

30. Daniel N. Stern, *The Interpersonal World of the Infant: A View from Psychoanalysis and Development Psychology* (New York: Basic Books/HarperCollins, 1985).

31. Cf. Freud's lecture "Anxiety and Instinctual Life," in Sigmund Freud, *New Introductory Lectures on Psychoanalysis*, trans. James Strachey, ed. James Strachey and Angela Richards (London: The Hogarth Press, 1964).

32. Pausanias, 9:31.7–9

33. C. A. S. Williams, *Outlines of Chinese Symbolism and Art Motives*, 3d rev. ed. (New York: Dover Publications, 1976).

34. Oscar Wilde, *The Picture of Dorian Gray* (London, 1890).

35. Matthew 8:20–22, Mark 5:25–34 and Luke 8:43–48

36. Marie-José Baudinet, "The Face of Christ, the Form of the Church," in *Fragments for a History of the Human Body*, Part I, ed. Michel Feher (New York: Zone Books, 1989).

37. Manlio Brusatin, *Storia delle immagini*, Chapter V (Torino: Einaudi, 1992).

38. De Voragine, *The Golden Legend*.

39. *Canti carnavaleschi del Rinascimento*, ed. Singleton (Bari, 1936), 407. Quoted in Dora Thornton, *The Scholar in His Study: Ownership and Experience in Renaissance Italy* (New Haven & London: Yale University Press, 1988).

40. J. Baltrusaitis, *El Espejo* (Madrid: Miraguano, 1988).

41. Bram Dijkstra, *Idols of Perversity: Fantasies of Feminine Evil in Fin-de-Siècle Culture* (New York & Oxford: Oxford University Press, 1986).

42. Alfred, Lord Tennyson, *Poems*, selected by Kingsley Amis (Harmondsworth: Penguin, 1973).

43. Thornton, *The Scholar in His Study*.

44. St. Augustine, "Ennaratio in Ps. 103," in *Ennarationes in Psalmos*, trans. G. Humeau (Paris: Corti, 1947).

45. "Si l'homme veut encore soy-mesme mirer/ S'il veut de son esprit la grandeur admirer/ Il faut qu'il jette l'oeil dans ce miroir du monde." Joseph de Chesnes,

*Miroir du monde* (Paris, 1587), quoted in S. Melchior-Bonnet, *Histoire du miroir* (Paris: Imago, 1994).

46. Quoted in Thornton, *The Scholar in His Study*.

47. Meister Eckhart, "Sermon XVI," in *The Sermons of Meister Eckhart*, ed. and trans. C. de B. Evans (London: John M. Watkins, 1927).

48. W. B. Yeats, "The Two Trees," in *The Collected Poems* (London: Macmillan, 1979).

49. Dante, "Inferno," XXX:18, in *Commedia*, ed. Pasquini and Quaglio.

50. "Cele les vis de mort enivre, / Mais cete fait les morz revivre," in de Meun and de Lorris, *Le Roman de la Rose*, v. 20625–26.

51. Boccaccio, *De Claris Mulieribus*, MS fr. 12420, f. 101v, Paris: Bibliothèque Nationale.

52. Ernst van de Wetering, "The Multiple Functions of Rembrandt's Self Portraits," in *Rembrandt by Himself*, ed. Christopher White and Quentin Buvelot (London & The Hague: National Gallery Publications Ltd. and Royal Cabinet of Paintings, Mauritshuis, 1999).

53. Quoted in ibid.

54. The photo is now in the collection of the Anthropos Institute, Sankt Augustin, Germany.

55. Jackson Pollock, "My Painting," in *Possibilities* 1 (Winter 1947–48).

PABLO PICASSO
(pages 177–196)

1. Roland Penrose, *Picasso: His Life and Work* (London: Gollancz, 1958).

2. Françoise Gilot (with Carlton Lake), *Life with Picasso* (New York: McGraw-Hill, 1964).

3. John Berger, *Successes and Failures of Picasso* (New York, 1965). The point is also made by M. Holloway in the essay "Painting as if to Possess," in the catalogue of the *Picasso* exhibition (Melbourne: National Gallery of Victoria, 1984).

4. André Malraux, *La tête d'obsidienne* (Paris: Gallimard, 1974).

5. Judi Freeman, *Picasso and the Weeping Women: The Years of Marie-Thérèse Walter and Dora Maar* (New York: Rizzoli, 1994).

6. Gilot, *Life with Picasso*.

7. Roy MacGregor-Hastie, *Picasso's Women* (London: Harpenden: Lennard Assoc., 1988).

8. Quoted in Alan Riding, "Picasso's Weeping Dora," in *New York Times*, 10 September 1998.

9. Quoted in James Lord, *Picasso and Dora: A Memoir* (New York: Farrar, Straus & Giroux, 1993).

10. The reverse of Picasso's relationship with Maar took place in fiction, in a film made in 1988 by the late Polish director Krysztof Kieslowski. In *A Short Film about Love*, an adolescent boy falls in love with an older woman whom he watches through a telescope from his bedroom window. To distract the pain of his unrequited love — he has heard that the pain of a burn can take the mind off toothache — he lays his hand open on his desk and blindly aims a pair of scissors at the space between his fingers, until he wounds himself. When at last the woman asks him what he wants of her — a kiss, sex, a weekend away — the boy answers that he wants nothing. He loves her perfectly, on her own terms.

11. In a letter to Alfred H. Barr Jr., 29 May 1947, Picasso says, "These are animals, massacred animals. That's all, so far as I'm concerned. It's up to the public to see what it wants to see." In the typescript of a symposium on *Guernica* (New York: The Museum of Modern Art, 25 November 1947).

12. Michel Leiris, "Faire-part," *Cahiers d'art* 12, nos. 4–5 (Paris, 1937).

13. Berger, *Successes and Failures of Picasso*. Picasso's old friend Sabartés was absolutely right when he said that of all the "-ists," Picasso was never an Expressionist. Jaime Sabartés, *Picasso: Portraits et souvenirs* (Paris: L. Carré and M. Vox, 1946).

14. André Gide, *Thésée* (Paris: Gallimard, 1946).

15. This notion, that public conflict might give birth to a private and brutal act, confirms the suggestion of the Canadian novelist Nancy Huston that women's tears are one of the very goals of war ("l'un des buts de l'activité guerrière"). Nancy Huston, "Pleureuses et rieuses," in *Les Temps Modernes* (Paris, 1999).

16. Jean Cocteau, "Des moeurs," in *La difficulté d'être* (Monaco: Éditions du Rocher, 1957).

17. Jeremiah 31:15

18. Cf. Anne Vincent-Buffault, *Histoire des larmes: XVIIIe–XIXe siècles* (Paris, 1986).

19. Jean-Jacques Rousseau, *Les Confessions*, Vol. I (Paris, 1782–84).

20. Jean-Jacques Rousseau, "Letter to Diderot of 16 March 1757," in Denis Diderot, *Correspondance 1713–84* (Paris: Éditions de Minuit, 1955–77).

21. G. E. Lessing, *Laokoon* (Berlin, 1766).

22. "Expulsion from Paradise," on the entrance arch of the Brancacci Chapel, Carmelite Church, Florence (c. 1450).

23. As in the right wing of the painted crucifix at the Palazzo Ducale, Urbino, by a follower of Pietro da Rimini (fourteenth century).

24. Anon., *Poema del Mio Cid* (early eighteenth century), ed. Menéndez Pidal (Madrid: Clásicos Castellanos, 1913).

25. Dante, *La Divina Commedia*, Canto VI, ed. Pasquini and Quaglio.

26. John Bunyan, *The Pilgrim's Progress*, ed. Roger Sharrock (Harmondsworth: Penguin, 1965).

27. Homer, *The Odyssey*, Book IX, trans. Robert Fagles (New York: Viking, 1996).

28. William Shakespeare, *King Lear*, II.iv.272–73.

29. In Argentina's national poem, the nineteenth-century *Martín Fierro* by José Hernández, the distinction between men's tears and women's tears is one of private versus public, sincerity versus a game: "La junción de los abrazos,/ de los llantos y los besos/ se deja pa las mujeres,/ como que entienden el juego;/ pero el hombre, que compriende/ que todos hacen lo mesmo,/ en público canta y baíla,/ abraza y llora en secreto." José Hernández, *El gaucho Martín Fierro y La vuelta de Martín Fierro*, edición revisada y anotada por Santiago M. Lugones (Buenos Aires: Centurión, 1926).

30. Patrick O'Brian, *Picasso* (London: Harvill, 1997).

31. Walter Benjamin, "A Short History of Photography," 1931, trans. Phil Patton, *Artforum* 125 (February 1977).

32. Gilot, *Life with Picasso*.

33. Elisabeth Roudinesco, *Jacques Lacan: Esquisse d'une vie, histoire d'un système de pensée* (Paris: Gallimard, 1993).

ALEIJADINHO
(pages 197–221)

1. Robert C. Smith, "The Gilt Wood Retable in Portugal and Brazil," in Ida E. Rubin, ed., *Latin American Art, and the Baroque Period in Europe: Studies in Western Art, Acts of the Twentieth International Congress of the History of Art*, Vol. III (Princeton, New Jersey: Princeton University Press, 1963).

2. Mário de Andrade, "A Arte Religiosa no Brasil em Minas Gerais," in *Revista do Brasil* 14, no. 54 (1920).

3. Myriam Andrade Ribeiro de Oliveira, "Discussion du concept d'identité nationale dans l'art de la région de Minas Gerais/Brésil au XVIIIe siècle," in Irving Lavin, ed., *World Art: Themes of Unity in Diversity: Acts of the XXVIth International Congress of the History of Art*, Vol. III (University Park & London: The Pennsylvania State University Press, 1989).

4. Richard Burton, *The Highlands of the Brazil* (London: Chapman & Hall, 1869), Chapter 13.

5. Robert Southey, *History of Brazil: Part the Second*, 1822 (New York: reprinted by Lennox Hill Pub., 1970).

6. Sérgio Buarque de Holanda, ed., *História Geral da Civilização Brasileira*, I:1, "A Época Colonial: Do Descobrimento a Expansão Territorial" (São Paulo: Difusão Européia do Livro, 1963).

7. C. R. Boxer, *A idade de ouro do Brasil* (São Paulo: Cia. Editora Nacional, 1962).

8. The first two orders consisting of ordained priests and contemplative nuns. Cf. James-Charles Noonan Jr., *The Church Visible: The Ceremonial Life and Protocol of the Roman Catholic Church* (New York: Viking, 1996).

9. Cf. the case of the Irmandade de Nossa Senhora do Rosario dos Homens Pretos,

which was elevated to the category of Third Order on 15 December 1899 by a decree issued by the archbishop of Bahia and primate of Brazil. In A. J. R. Russell-Wood, "Prestige, Power and Piety in Colonial Brazil: The Third Orders of Salvador," in *Society and Government in Colonial Brazil 1500–1822* (Aldershot, England & Brookfield: Variorum, 1992).

10. Archives of the Third Order of St. Francis, Salvador, *Livro do acordãos, 1754–1809*, fol. 49, quoted in ibid.

11. Myriam Andrade Ribeiro de Oliveira, *Aleijadinho: Passos e Profetas* (São Paulo: Editora Itatiaia Limitada/ Editora da Universidade de São Paulo, 1984).

12. Germain Bazin, *Aleijadinho et la sculpture baroque au Brésil* (Paris: Gallimard, 1963).

13. "Tambem tem alma, como os brancos; e que Christo Senhor nosso tambem padeceo, e morreu por elles; e que nas Igrejas, senhores, e escravos, todos comungão na mesma meza" Pe. Manoel Ribeiro Rocha, *Ethiope Resgatado, Empenhado, Sustentado, Corregido, Instruido e Libertado. Discurso Theologico-Juridico*, Oficina Patriarcal de Francisco Luiz Ameno, Lisboa, 1758. Quoted in Raymond S. Sayers, *The Negro in Brazilian Literature* (New York: Hispanic Institute in the United States, 1956).

14. The subject is fully developed in the magisterial book (from which these quotations are taken) by Lilia Moritz Scwartz, *O Espétaculo das raças, Cientistas, Instituições e Questão Racial no Brasil 1870–1930* (São Paulo: Companhia das Letras, 1993).

15. Rodrigo José Ferreira Brêtas, "Traços biográficos relativos ao finado Antônio Francisco Lisboa (o Aleijadinho)," in *Correio Oficial de Minas*, nos. 169 & 170 (1858).

16. Marcos Gusmão, "O mal do mestre," in *Veja* (25 March 1998).

17. Brêtas, "Traços biográficos."

18. John Ruskin, *The Stones of Venice*, Vol. I (London, 1851).

19. *Encarnação* was the technical term to describe the obligatory task of lending the sculpture the appearance of human flesh; *santo de roca* the name given to images of which only the face, hands and feet were sculpted, the rest being merely a wooden frame that was later covered in cloth. The existence of these terms suggests that they were technical afterthoughts, demands of the baroque dogma.

20. As an example, Germain Bazin reproduces a series of engravings printed in Florence in the fifteenth century depicting the prophets, similar in many details to the sculptures of Aleijadinho. Cf. Bazin, *Aleijadinho et la sculpture baroque au Brésil*.

21. The distinguished ophthalmologist Patrick Trevor-Roper, in a classic book on artists and their problems of sight, noted that Aleijadinho gave "a gross divergent squint to most of the saints he depicted, often supplemented by a broadening of the nasal bridge (an occasional congenital anomaly, called 'hypertelorism'), which recalls the eye-disposition of most lower animals." Trevor-Roper suggested that this trait might be "the result of the artist's affectation, rather than his realism." Cf. Patrick Trevor-Roper, *The World Through Blunted Sight*, rev. ed. (London: Souvenir Press, 1997).

22. I am grateful for this information given by the guide to the Church of São Francisco de Assis in Ouro Preto, Marcelo José Dias Hypólito.

23. Bazin refers to him as "the dancing master." Bazin, *Aleijadinho et la sculpture baroque au Brésil*.

24. Cf. Robert Smith, *Congonhas do Campo* (Rio de Janeiro, 1973) and Hans Mann, *The Twelve Prophets of Antônio Francisco Lisboa, "Aleijadinho"* (Rio de Janeiro, 1958).

25. In the Christian typology of the Middle Ages, the prophets of the Old Testament correspond to the four evangelists and the twelve apostles in the New. The major prophets (Isaiah, Jeremiah, Ezekiel and Daniel) are all represented in Congonhas; of the twelve others, Aleijadinho chose only eight, replacing Micah with Baruch, Jeremiah's disciple and not traditionally considered a prophet. What his reasons were for the choice and for the substitution, we can only guess. In any case, the twelve form an extraordinarily powerful and dynamic unity.

26. Vasari, "Michelangelo Buonarroti," in *Le vite de più eccellenti Pitori*.

CLAUDE-NICOLAS LEDOUX
(pages 223–244)

1. "The Grave" in *The Anglo-Saxon Anthology of Poetry*, ed. S. A. J. Bradley (London and Toronto: Dent, 1982).

2. Apollodorus, *The Library of Greek Mythology*, trans. Robin Hard (Oxford: Oxford University Press, 1997).

3. Leon Battista Alberti, *L'architettura*, trans. G. Orlandi, 2 vols. (Milan), 1966, quoted in Henry A. Millon, *The Renaissance from Brunelleschi to Michelangelo: The Representation of Architecture* (New York: Rizzoli, 1997).

4. R. Hammerstein, *Die Musik der Engel* (Bern: Taurus, 1962).

5. Revelation 21:1–27

6. M. M. Davy, *Initiation à la symbolique romane* (Paris: Flammarion, 1977).

7. Hegel, *Introductory Lectures on Aesthetics*, Chapter 5:CX, trans. Bosanquet.

8. Douglas Johnson, ed., *French Society and the Revolution* (Cambridge & New York: Cambridge University Press, 1983).

9. Philippe Sers, *L'architecture révolutionnaire* (Paris: Aline Elmayan, 1973).

10. Most of the information on Ledoux comes from Anthony Vidler, *Claude-Nicolas Ledoux: Architecture and Social Reform at the End of the Ancien Régime* (Princeton, New Jersey: Princeton University Press, 1987).

11. Claude Saint-André, *King's Favorite: Madame du Barry and Her Time* (London: Herbert Jenkins, 1915).

12. "Après les éblouissantes orgies de forme et de couleur du dix-huitième siècle, l'art s'était mis à la diète, et ne se permettait plus que la ligne droite." "On avait

poussé le noble jusqu'au fade, et la pureté jusqu'à l'ennui. La pruderie existe en architecture."Victor Hugo, *Quatrevingt-treize* (Paris: Gallimard, 1962).

13. Allan Braham, *L'architecture des lumières: de Soufflot à Ledoux* (Paris: Berger-Lev-rault, 1982).

14. "Les batisseurs de ce temps-là prenaient la symétrique pour du beau." Hugo, *Quatrevingt-treize*.

15. Quoted in Annie Jacques and Jean-Pierre Mouilleseaux, *Les architectes de la liberté* (Paris: Gallimard, 1989).

16. Quoted in Michel Gallet, *Claude-Nicolas Ledoux: 1736–1806* (Paris: Picard, 1980).

17. *Unesco World Heritage List* (Paris: Unesco Publications, 1999).

18. Quoted in Vidler, *Claude-Nicolas Ledoux*.

19. Philip Babcock Gove, *The Imaginary Voyage in Prose Ficton* (New York, 1941).

20. Cf. Georges Jean, *Voyages en Utopie* (Paris: Gallimard, 1994).

21. "La forme sert la fonction, mais la fonction se réfléchit à son tour dans la forme pour s'y rendre manifeste: une symbolique de la fonction se surajoute à la fonction même." Jean Starobinski, 1789, *Les emblèmes de la raison* (Paris: Gallimard, 1973).

22. Blaise Pascal, *Pensées*, ed. Michel le Guern, 2 vols. (Paris: Gallimard, 1977).

PETER EISENMAN
(pages 245–262)

1. *Lemprière's Classical Dictionary of Proper Names Mentioned in Anciént Authors Writ Large*, 3d ed. (London, Boston, Melbourne & Henley: Routledge & Kegan Paul, 1984).

2. "Y ya próximo a su fin, / viendo en tierra su bandera, / ¡la besó por vez postrera/ el negro de San Martín!"

3. José Hernández, *El gaucho Martín Fierro y la vuelta de Martín Fierro*, ed. Santiago M. Lugones (Buenos Aires: Centurión, 1926).

4. Cf. Paul Zanker, *Augustus und die Macht der Bilder* (Munich: C. H. Beck'sche Verlagsbuchhandlung, 1987).

5. Ovid, *Fasti*, ed. and trans. Sir James G. Frazer (Cambridge, Massachusetts & London: Loeb Classic Library, 1958).

6. I described the trail in my piece "The Painted Desert," in George Galt, ed., *The Saturday Night Traveller* (Toronto: HarperCollins, 1990).

7. Joan Oates, *Babylon*, rev. ed. (London: Thames & Hudson, 1986).

8. Francisco de Quevedo, "A Roma sepultada en sus ruinas," in *Poesía completa* (Madrid: Clásicos Españoles, 1965). [*"Huyó lo que era firme, y solamente/ lo fugitivo permanece y dura."*]

9. Joachim du Bellay, "Sonnet," in *Les regrets, précédé par les antiquités de Rome*, ed. Samuel S. de Sacy (Paris: Gallimard, 1975). [*"Ce qui est ferme est par le temps détruit, / Et ce qui fuit, au temps fait résistance."*]

10. Andreas Gryphius, *Werke* (Munchen: C. H. Beck, 1980). [*"Was itzt so pocht und trozt ist Morgen Asch und Bein, / Nichts ist, das ewig sei, kein Erz, kein Marmorstein."*]

11. Christopher Wren Jr., *Parentalia* (London: Methuen, 1910).

12. Rudyard Kipling, "A Sahib's War," in *Traffics and Discoveries*, Vol. XVII of the *Bombay Edition of the Works of Rudyard Kipling* (London: Macmillan and Co., 1914).

13. *Le Monument de la Déportation* (Paris: Ville de Paris, 1986).

14. Cf. *Nunca Más: Informe Sobre los Desaparecidos* (Buenos Aires: Editorial Universitaria de Buenos Aires, 1984).

15. Sir Thomas Browne, "Hydriotaphia, Urne-Buriall, or, A Discourse of the Sepulchrall Urnes lately found in Norfolk," Chapter 4, *The Major Works*, ed. C. A. Patrides (Harmondsworth: Penguin, 1977).

16. Browne is quoting Horace: "Has the villain pissed on his father's ashes?" *Ars Poetica*, 471.

17. G. K. Chesterton, *The Man Who Was Thursday*, Chapter 6 (Harmondsworth: Penguin, 1937).

18. Associated Press, *New York Times*, 4 June 1998.

19. Quoted in David Hare, *Acting Up: A Diary* (London & New York: Faber & Faber, 1999).

20. Martin Walser, "Dankesrede," in *Börsenblatt*, Frankfurt-am-Main, 13 October 1998. Cf. Reinhard Mohr, "Total normal?" in *Der Spiegel* 49 (30 November 1998).

21. Theodor Adorno's remark that there can be no poetry after Auschwitz is countered by Paul Celan's: "There's nothing in the world for which a poet will give up writing, not even if he is a Jew and the language of his poems is German." In Paul Celan, "Letter to his relatives, 2 August 1948."

22. Heinrich Heine, "Zum Lazarus," in *Gedichte*. [*"Laß die heil'gen Parabolen, / Laß die frommen Hypothesen — / Suche die verdammten Fragen / Ohne Umschweif uns zu lösen."*]

23. Philip Hallie, *Tales of Good and Evil, Help and Harm* (New York: HarperCollins, 1997).

24. Associated Press, *New York Times*, 4 June 1998.

25. *International Herald Tribune* (Zurich), 18 January 2000.

26. Quoted in Sanford Kwinter, "The Eisenman Wave," in *Eisenman Architects: Selected and Current Works* (Mulgrave: Images Publishing Group, 1995).

27. Peter Eisenman and Jacques Derrida, *Chora L Works*, ed. Jeffrey Kipnis and Thomas Leeser (New York: The Monacelli Press, 1990).

28. Quoted in Philip Johnson and Mark Wigley, *Deconstructivist Architecture* (New York: New York Museum of Modern Art Publications, 1988).

29. Reuters, *Detroit Free Press*, 22 January 1999.

30. Quoted in Kwinter, "The Eisenman Wave," in *Eisenman Architects*.

31. *International Herald Tribune* (Zurich), 18 January 2000.

32. This anecdote was told by Robert Hughes to David Hare. Cf. Hare, *Acting Up*.

33. Richard Wilbur, "An Event," in *New and Collected Poems* (San Diego, New York & London: Harvest/HBJ, 1988).

34. Denis Diderot, *Jacques le Fataliste et son maître*, in *Oeuvres*, ed. André Billy (Paris: Bibliothèque de la Pléiade, Gallimard, 1951).

CARAVAGGIO
(pages 263–286)

1. Gino Doria, *Storia di un capital: Napoli dalle origine al 1860*, 5th ed. rev. (Napoli: Electa, 1968).

2. Giulio Cortese, *Poesia* (Bari, 1762).

3. Quoted in Lacy Collison-Morley, *Naples through the Centuries* (London: Methuen, 1926).

4. Piero Camporesi, *Il pane salvaggio* (Milan: Il Mulino, 1980).

5. Doria, *Storia di un capital*.

6. Chaucer, "The Tale of the Man of Lawe," *The Canterbury Tales* in *Complete Works*, ed. Skeat.

7. John of Ford, "The Life of Wulfric of Haselbury," *c.* 1150, in *The Cistercian World*, trans. and ed. Matarasso.

8. Quoted in Camporesi, *Il pane salvaggio*.

9. Agrippa d'Aubigné, *Sa vie à ses enfants* (Paris, 1629).

10. Quoted in Rosario Villari, *La rivolta antispagnola a Napoli* (Milan: Laterza, 1967).

11. Leon Battista Alberti, *Momus; o, Del principe*, ed. G. Martini (Milan: Einaudi, 1942).

12. C. Russo, "La storiografia socio-religiosa e suoi problemi," in *Società, chiesa e vita religiosa nell'ancien regime* (Naples: Guida Napoli, 1976).

13. Michel Mollat, *Les pauvres au Moyen Age* (Paris: Hachette, 1978).

14. Quoted in Camporesi, *Il pane salvaggio*.

15. Benedetto Croce, *Teatri di Napoli* (Naples, 1910).

16. A name derived from *pulcino*, a chicken, with a black mask, hooked nose, pointed cap and cackling voice. Cf. Croce, *Teatri di Napoli*.

17. Benedetto Croce, *Storie e leggende napoletane*, ed. Giuseppe Galasso (Milan: Adelphi Editore, 1990).

18. Jelle Koopmans, *Le théâtre des exclus au Moyen Age: Hérétiques, sorcières et marginaux* (Paris: Imago, 1997).

19. "Li un moutret son cul au vent, / Li autre rompet un auvent, / L'un cassoit fen-estres et huis, / L'autre getoit le sel ou puis, / L'un getoit le bren aus visages." *Le Roman de Fauvel par Gervais du Bus*, ed. A. Långfors (Paris, 1914–19).

20. Koopmans, *Le théâtre des exclus au Moyen Age*.

21. Camporesi, *Il pane salvaggio*.

22. *La mendicità proveduta, nella città di Roma coll'ospizio publico fondato Dalla Pietà, e Benificenza Di Nostro Signore Innocenzo XII, Pontefice Massimo: Con le risposte all'o-biezioni contro simili fondazioni*, Gio. Giacomo Komarek (Roma, 1693).

23. Ibid.

24. *Stabilmento dell'Ospizio generale della carità nella città di Vercelli* (Turin: Radix & Mairesse, 1719). Quoted in Camporesi, *Il pane salvaggio*.

25. We should not be too alarmed at these ancient attempts at ridding the city of the poor. Today in Canada, for instance, members of the Royal Canadian Mounted Police in Saskatoon were charged with picking up poor Natives off the streets and driving them outside the city limits where, in freezing tempera-tures, they are left to fend for themselves.

26. Charles Dickens, *A Christmas Carol* (London, 1843).

27. *La mendicità proveduta*, etc.

28. Testimony of Father Orlando Virgilio Yorio, file No. 6328, in *Nunca Más: Informe sobre los desaparecidos*, Comisión Nacional sobre la Desaparición de Personas (Buenos Aires: Editorial Universitaria de Buenos Aires, 1984).

29. St. Thomas Aquinas, *Suma Teológica*, 2.2.q. XXX (Madrid: Biblioteca de Autores Cristianos, 1912).

30. Matthew 25:40

31. St. Thomas Aquinas, *Suma Teológica*, 2.4.q. XXX.

32. G. Sersale, *Alcune notizie storiche sopra i primi gentiluomini che fondarono il Monte della Misericordia*, Napoli, 1865. Quoted in Vincenzo Pacelli, *Caravaggio: Le sette opere di Misericordia*, 2d ed. (Salerno: Edizioni 10/17, 1993).

33. C. De Lellis, "Aggiunta alla Napoli Sacra del D'Engenio," ms. *c.* 1654–89. Quoted in Pacelli, *Caravaggio*.

34. Pacelli, *Caravaggio*.

35. Ferguson, *Signs and Symbols*.

36. Ibid. And, as in the case of the octagonal tile under Mary's foot in *The Virgin and Child before a Firescreen*, an allusion to the day of Christ's circumcision, when He received the name of Jesus.

37. M. Grazia Leonetti Rodinò, *Il Pio Monte della Misericordia: la storia, la chiesa, la quadreria* (Naples: Pio Monte, 1991).

38. Walter Friedlander, *Caravaggio Studies* (Princeton, New Jersey: Princeton Uni-versity Press, 1955). Friedlander points to two examples of the subject in Northern paintings (by Martin de Vos and by Bernard van Orley) but dismisses them as of no consequence for Caravaggio's invention.

39. Helen Langdon, *Caravaggio: A Life* (London: Chatto & Windus, 1998).

40. De Voragine, "Saint Martin, Bishop," in *The Golden Legend*.

41. Friedlander suggests the figure is that of a pilgrim Christ, Maurizio Marini that it is St. Roch. There seems no reason to suppose it isn't simply St. Jacques, whose cockle-hat and staff the pilgrim carries.

42. Judges 15:19

43. See page 49 for the story of Cimo and Pero.

44. St. Thomas Aquinas, *Suma Teológica*. G. K. Chesterton, seven centuries after Aquinas, had this to say: "Mercy does not mean not being cruel or sparing people revenge or punishment; it means a plain and positive thing like the sun, which one has either seen or not seen." In "A Piece of Chalk," in *Tremendous Trifles* (London: Methuen & Co., 1917).

45. Maurizio Marini, *Caravaggio: Michelangelo Merisi da Caravaggio "pictor praestantissimus,"* 2d. ed. (Rome: Newton Compton Editori, 1989).

46. Friedlander, *Caravaggio Studies*.

47. Heiko A. Oberman, *Luther: Mensch zwischen Gott und Teufel* (Berlin, 1982).

48. Marini, *Caravaggio*.

49. Bernard Berenson, *Del Caravaggio: Delle sue incongruenze e della sua fama* (Milan: Leonardo Editore, 1994).

50. José Antonio Maravall, *La cultura del barroco* (Madrid: Editorial Ariel, 1975).

51. Marini, *Caravaggio*.

CONCLUSION
(pages 287–292)

1. G. K. Chesterton, "A Meditation on Broadway," in *What I Saw in America* (London: Hodder & Stoughton, 1922).

2. Sir Sarvepalli Radhakrishnan and C. A. Moore, eds., *A Sourcebook in Indian Philosophy* (Princeton, New Jersey: Princeton University Press, 1957).

# Plate Credits

© National Gallery, London; P. 63 Author's collection; P. 67 Courtesy of Patricia Albers/Collection of Ruth and LaBrie Ritchie; P. 69 The National Gallery of Scotland; P. 70 Courtesy, American Antiquarian Society; P. 71 Author's collection; P. 72, *top*: BETTMANN/CORBIS/MAGMA; *bottom*: Library of Congress, Prints & Photographs Division, FSA/OWI Collection, LC-USZ62-95653; P. 74 New Orleans Museum of Art: Museum purchase, Women's Volunteer Committee Fund; P. 75 Photograph courtesy of The J. Paul Getty Museum, Los Angeles. Copyright 1981 Arizona Board of Regents, Center for Creative Photography; P. 76 Still courtesy of the British Film Institute; P. 77 Tina Modotti, *Number 32: Convent of Tepotzotlán, Mexico.* 1924. Gelatin-silver print. 8 13/16 x 6 13/16" (22.4 x 17.2 cm). The Museum of Modern Art, New York. Given anonymously. Copy print © 2000 The Museum of Modern Art, New York; P. 78 Tina Modotti. *Calla Lily.* Gelatin-silver print. 8 11/16 x 7 1/16" (22 x 18 cm). The Museum of Modern Art, New York. Anonymous gift. Copy print © 2000 The Museum of Modern Art, New York; P. 79 Chantilly, Musée Conde/Giraudon; P. 81 Scala/Art Resource, NY; P. 83, *top*: © 2000 Banco de México Diego Rivera & Frida Kahlo Museums Trust. Av. Cinco de Mayo No. 2, Col. Centro, Del. Cuauhté-moc, 06059, México, D.F.; *bottom*: Courtesy of Throckmorton Fine Art, New York; P. 89 © Photo RMN — Michèle Bellot; P. 92 Kunsthistorisches Museum, Vienna; P. 93 Kunsthistorisches Museum, Vienna; P. 94, *top and bottom*: Kunsthistorisches Museum, Vienna; P. 95, *top and bottom*: Gifts of Mrs. Lessing J. Rosenwald, Photograph © 2000 Board of Trustees, National Gallery of Art, Washington; P. 96 Courtesy of the Österreichische National Bibliothek, Vienna; P. 98 Photo courtesy of the Centre for Reformation and Renaissance Studies, Victoria University, University of Toronto; P. 100 Author's collection; P. 101, *top*: Courtesy of Sigmund Freud Copyrights, London; *bottom*: Author's collection; P. 102 Author's collection; P. 103, *top*: Author's collection; *bottom*: Author's collection; P. 104 © Comité Jean Cocteau; P. 105 © Photo RMN — Hervé Lewandowski; P. 106, *left and right*: courtesy of the Stadarchiv Worms; P. 107 Author's collection, Fundación Casa Ducal de Medinaceli; P. 108 Author's collection; P. 109 Still courtesy of the British Film Institute, QUEEN CHRISTINA © 1934 Turner Entertainment Co. A Time Warner Company. All Rights Reserved; P. 110 Cliché Bibliothèque nationale de France, Paris; P. 111 Author's collection; P. 112 Scala/Art Resource, NY; P. 115 Archivio Pinoteca Nazionale di Bologna. Su concessione del Ministero per i beni e le attività culturali; P. 119 Collection of Jared Sable, reproduced courtesy of Marianna Gartner; P. 122 © Estate of Max Ernst/SODRAC (Montreal) 2000; P. 123 Photograph by Zoltan Varadi, Author's collection; P. 125 Courtesy of the Museo Ebraico di Venezia; P. 126 © Musée Dapper, Paris — photo Mario Carrieri; P. 127 © Photo RMN — Hervé Lewandowski; P. 129 All rights reserved © Museo Nacional del Prado — Madrid; P. 131 Collection of Michael and Sandra Lawrence, reproduced courtesy of Marianna Gartner; P. 133 Private collec-

© Júnior Vieira; Pp. 224–25 Author's collection, Photothèque Institut Claude-Nicolas Ledoux, Arc-et-Senans, © Institut Claude-Nicolas Ledoux; P. 228 Author's collection; P. 229 Author's collection; Pp. 230–31 Scala/Art Resource, NY; P. 231, *top*: Author's collection; P. 232, *top*: Copyright holder unknown; *bottom left*: Photothèque Institut Claude-Nicolas Ledoux, © Institut Claude-Nicolas Ledoux; *bottom right*: Photothèque Institut Claude-Nicolas Ledoux, Vue aérienne de la Saline Royale d'Arc-et-Senans, © Institut Claude-Nicolas Ledoux; P. 235 Photothèque Institut Claude-Nicolas Ledoux, Élévation de la Maison du Directeur à Arc-et-Senans, © Institut Claude-Nicolas Ledoux; P. 236 Photothèque Institut Claude-Nicolas Ledoux, Urne renversée, © Institut Claude-Nicolas Ledoux; Pp. 238–39 Author's collection, Photothèque Institut Claude-Nicolas Ledoux, © Institut Claude-Nicolas Ledoux; P. 240 Photothèque Institut Claude-Nicolas Ledoux, Maison des gardes agricoles de Maupertuis, © Institut Claude-Nicolas Ledoux; P. 241, *top*: Photothèque Institut Claude-Nicolas Ledoux, Forge à cannon, © Institut Claude-Nicolas Ledoux; *bottom*: Author's collection; P. 242, *top*: Author's collection; *bottom*: Photothèque Institut Claude-Nicolas Ledoux, Maison des directeurs de la loue, © Institut Claude-Nicolas Ledoux; Pp. 247–48 AP/Wide World Photos; P. 249 Author's collection; P. 251 Photograph by David Oates, copyright held by Joan Oates, McDonald Institute, University of Cambridge; P. 253 Courtesy Sir John Soane's Museum; P. 257 Author's collection; Pp. 260–61 © Bildarchiv Preussischer Kulturbesitz, Berlin, 2000, Kurt Grimm, Nuremberg; P. 265 Scala/Art Resource, NY; P. 268 Erich Lessing/Art Resource, NY; P. 269 Author's collection; P. 271 Author's collection; P. 273 Author's collection; P. 274 Author's collection; P. 278 Author's collection; P. 281 Detail from *The Seven Acts of Mercy*, Scala/Art Resource, NY; P. 289 Cliché Bibliothèque nationale de France, Paris.

# Index

Abstract expressionism, 27

*Achilles Lamenting the Death of Patroclus* (Flaxman), *192*

Adams, Ansel, 74

*The Adoration of the Magi* (Bosch), 146, *147*

Aeschylus, 159

Albani, Francesco, 282

*Alberta Treasury Mural* (Gartner), *123*

Alberti, Leon Battista, 33, 228, 259, 272

Aldrovandi, Ulisse, 97–98, *137*

Aleijadinho, *199*, 205–21, *209–11*, *216*, *218–19*, 291

Alexander the Great, 155–57

Allan, David, *69*

*Allegory of Hope* (di Andrea), *53*

*Allegory of Prudence* (Titian), 57, *58*

Amatrice, Filotesi della, *50*

Amazon (woodcut), *47*

Amedeus of Lausanne, 49

*The Anatomy Lesson* (de Keyser), 145, *145*

André, Rogi, *194*

Andrea, Alesso di, *53*

Andrew, Saint, 215

*And We Too Shall Be Mothers, Because . . .* (Lequeu), *47*, 49

Angaman Is. inhabitants (anon.), 110

Anselm, Saint, 49

Antonino, Saint, 55

Apollo inspecting vases (Catari), *52*

Apollodorus, 228

Aquinas. *See* Thomas Aquinas, Saint

Aragón, Alfonso de, 268

Arcadia, 108

Arc-et-Senans, 227. *See also* Saltworks of Arc-et-Senans

architectural models, history of, 228–29

architecture
    failures of, 230–231
    idea of, 229–32, 237
    "vocal", 242

Ariadne, 186

Ariès, Philippe, 146

Aristotle, 6, 98

Arp, Hans, 26

Arrianus, Flavius, 155

*The Artist at the Spinet* (Fontana), *112*

*The Artist Open-Mouthed* (Rembrandt), *173*

Atget, Eugène, 7

Aubigné, Agrippa d', 270

Augustine, Saint, 44, 61, 139, 170

*Aurora consurgens*, a chromatic scheme, *33*

author
    early images recalled by, 5
    summary impressions of the, ix, 291–92

automatic painting, *26*

automatic writing (illustrated), *26*

Azzolino, Giovan Bernardo, 280

Babylonian lion statue (anon.), *251*

Bacon, Francis, 6, 12

Balthus, 130

Balzac, Honoré de, 15, 35

Barbusse, Henri, 78

Baroque style, spread of, 212–14

Batista, João Gomes, 207

*The Battle of Issus*, mosaic (anon.), *152–53*, *157*

*The Battle of San Romano: Bernardino della Ciarda Unhorsed*, (Uccello), 157, *157*
Baudelaire, Charles, 71
Baxandall, Michael, ix, 14
Bazin, Germain, 207
Beaudin, André, 183
Beckett, Samuel, 15, 20, 27, 30, 35, 251
Bellay, Joachim du, 251
*La Belle et la Bête* (film), *104*
*La Belle Roisine* (Wiertz), 145, *145*, 149
Benjamin, Walter, 193
*Beowulf*, 158
Berenson, Bernard, 284
Berger, John, 72, 182, 186
Berkeley, (Bishop) George, 162
Berlin Holocaust Monument, model of (Eisenman), *247*
Bernard, Saint, 62–63
Bernard de Clairvaux, Saint, 49
Bernini, Giovanni, 213
Bête. *See La Belle et la Bête*
Bey, Khalil, 105
Bioy Casares, Adolfo, 15
Blake, William, 9, 237
*blason*, 106
*The Blessed Virgin Chastising the Infant Jesus* (Ernst), *46*
Blondel, Jacques-François, 233
*Blue Pot and Bottle of Wine* (Cézanne), *29*
Boal, Augusto, 264
Boccaccio, Giovanni, *172*, 173
Bonaparte, Napoleon, 235
books
    as universal mirrors, 170
    visual symbolism of, 57–59
Borges, Jorge Luis, 9, 40, 160–61
Borromeo, Carlo, 111
Bosch, Hieronymus, 55, *55–56*, 146, *147*
brain, its representation of the body, *188*
Bramante, Donato d'Agnolo, 228
*branqueamento*, 207, 215–16, 220–21. *See also* myth of racial whitening
breasts as symbols, 45–51
Brendan, Saint, 9
Breton, André, 7, *46*
Broccos, Modesto, *206*
Browne, Sir Thomas, 246, 254

Brueghel, Pieter, 231
Brunelleschi, 228
*Brutus Sees Caesar's Ghost* (Fuseli), *16*
Bueno da Silva, Bartolomeu, 203
Bunyan, John, 190
Buoncompagni, Ugo. *See* Gregory XIII (Pope)
*The Burning of the Hindenburg* (Shere), *72*
Burton, Captain Richard, 202
butterflies, 143–45

Caesar, Julius, *16*, 227
Caesar, Tiberius, 165
Cage, John, 27
Caillois, Roger, 162
*Calla Lily* (Modotti), *78*
Calvin, John, 51
Calvino, Italo, 7
Campin, Robert, *41*, 43
Camporesi, Piero, 275
Capra, Robert, 85
Caracciolo, Battistello, 279–80
Caravaggio, 49, 80, *81*, 142–43, *144*, 214, 265, 267–71, *268*, *271*, *273*, 280–85
Carlot, Jean, 76
Carvalho, Geraldo Barroso de, 207
Cary, Joyce, 80
Cassander, 156
Castle of Crossed Destinies, 7
Catari, Vincenzo, *52*, *58*
Caterina Vigri, Saint, 113
Cézanne, Paul, 14, 28, *29*
Chagall, Marc, 26
chance, images and, 9
Chapel of the Carrying of the Cross (Aleijadinho), *210*
Chapel of the Last Supper (Aleijadinho), *209*
charivari, woodcut (anon.), *274*
Charles V, 12
Chaucer, Geoffrey, 101
Chaux
    Cannon Forge at, *241*
    Ledoux's dream city of, 237–42, *238–39*
    Oikéma at, *241*
    ordinary house at, *240*

Pacifière at, *242*
  Waterworks at, *242*
Chesnes, Joseph de, 170
Chirico, Giorgio de, 231
Chomsky, Noam, 258
Christ, Jesus, 27–28, 49, 52, 60–63, 80,
  82, 143–46, 165, 211, 276–77, 284
*Christ Suckles Catherine of Siena* (after Vanni),
  *63*
Christ washing the feet of His disciples,
  illumination (anon.), 79
Cicchini, Augustín, *249*
Cicero, 158
circumcision, symbolic significance of, 62–63
clitoris, 105
The Cloth of the Veronica, 165, *166*
Cocteau, Jean, 189, 288
Coleridge, Samuel Taylor, 73
collage, 26
colours
  linguistic distinctions among, 32
  symbolic meanings of, 32–34
Columbus, Renaldus, 105
comic strips, 10
Commedia dell'Arte scene (anon.), *273*
Conforti, Giovanni Jacopo, 279
Congonhas, sanctuary of, 209, *209*, 216,
  *216–17*
Conrad le Salique. *See* legend of Conrad le
  Salique
Constantine V (emperor of Byzantium), 27
*Convent of Tepotzotlán* (Modotti), 77
*The Conversion of Mary Magdalen*, 169, *169*
Cortázar, Julio, 66
Cortés, Hernán, 80
Cosmas, Saint, 139, 141, *141*
Courbet, Gustave, 105–106
cowries, sculpted (Aleijadinho), 216
Crawford, Joan, 45
Croce, Giulio Cesare, 113
Cunningham, Imogen, 74

Da Rocha, J. L., *140*
da Vinci, Leonardo, 108
Daguerre, Louis J. M., 70–71
Dalí, Salvador, 26
Damian, Saint, 139, 141, *141*

Dante, 15, 99, 162, 190
Darius III (of Persia), 155–57
David, Jacques-Louis, 182, *190*
*David with the Head of Goliath* (Caravaggio),
  *268*
de Kooning, Willem, 29
de Voragine, Jacobus, 45, *102*, 165
*The Death of the Virgin* (Caravaggio), 283
death by water, 170
decalcomania, 26
Della Porta, Giovanni Batista, 99–100
Derrida, Jacques, 258
d'Espingues, Evrad, *289*
d'Este, Lionello, 34
*Diabolo Baby* (Gartner), 131, *131*
Diderot, Denis, 34, 190, 237, 260–61
Dijkstra, Bram, 170
*Distributing Arms* (Rivera), *83*
Dix, Otto, 130
dogs, images of, 115
D'Onofrio da Forlì, Gian Vincenzo, 279
Dos Passos, John, 85
drape for the Holy Ark, *125*
du Barry, Comtesse, 233
Duns Scotus, John, 54
Dürer, Albrecht, *168*

Easter Island, 9
Eckhart, Meister, 171
Einstein, Albert, 78
Eisenman, Peter, *247*, 257
*The Elective Affinities* (Magritte), *122*
Eliot, T. S., 29
Éluard, Paul, *46*, 183, 193
"Éluard, Paul" (character in novel), 7
Enckell, Magnus, *163*
Ernst, Max, 26, *46*
*Expulsion from Paradise* (Masaccio), *191*

face (logo), *162*
faces, 91, 99–100, 107–109, 126–27,
  174–75
  significance of, 157–67
Falucho, statue of (Cicchini), *249*
*Family Portrait* (Broccos), *206*
Fanucci, Camillo, 274
*Father and Mother* (Kollwitz), *257*

feet, symbolic significance of, 79–82
Ferreira Brêtas, Rodrigo José, 207
*Festa do Divino in Minas Gerais*, watercolour
    (anon.), *204*
Fiorillo, Silvio, 273
Flaubert, Gustave, 6, 136
Flaxman, John, *192*
Florence Cathedral, model of dome
    (Brunelleschi), *228*
Fontana, Prospero, 110
Fontana De Zappis, Lavinia, *89*, 91–93,
    110–111, *116*, 121, 136–37, 139
Fortunati, Vera, 113
Fouquet, Jean, 47
*Four Men Standing* (Gartner), *119*, 146
Fourier, François Marie Charles, 237
Fraenger, Wilhelm, 147
Franci, Giovanna, 29
Francis, Saint, 100–101, 216
Freud, Sigmund, 101
Frijda, Nico H., 114
*frottage*, 26
Frye, Northrop, 128
*fumage*, 26
Fuseli, Henry, 15, *16*

Garbo, Greta, 108
    still from *Queen Christina*, *109*
*Garden of Earthly Delights* (Bosch), 55,
    *55–56*
Gartman, Viktor, 15
Gartner, Marianna, *119*, 122–24, *123*,
    130–48, *131*, *133*, *136*, *138*,
    *142–43*, 181
Gaudi, Antonio, 227
Gauguin, Paul, 31
genitals, symbolic significance of, 60–62
Gentileschi, Artemisia, 169, *169*
Gérard, Marguerite, *232*
Giacometti, Alberto, 31
Gide, André, 186
Gilgamesh, 104
Gilot, Françoise, 182, 193–94
Giordano, Luca, 280
Giotto, 12, 214
*Girl with Parrot* (Gartner), 134–136, *135*
Godiva, Lady, 102

Goethe, Johann Wolfgang von, 34, 156
Gombrich, E. H., ix, 126
Gonsalvus, Antonietta [Tognina]. *See* Tognina
Gonsalvus, Petrus (Tognina's father), 93
    portrait (anon.), *93*
Gonsalvus family, 93–98, 114
    portrait (anon.), *96*
    portrait (Hoefnagel), *95*
the Gorgon, 159
Gove, Philip Babcock, 237
Graafland, Arie, 258
Grass, Günter, 255
Gregory the Great (Pope), 121, 149
Gregory XIII (Pope), 112–13
Gribelin, S., *253*
Grimm's *Fairy Tales*, 5
Grosseteste, Robert, 55
Gryphius, Andreas, 252
*Guernica* (Picasso), *184–85*, *187*, 192
Guernica (town), 185

hair, meanings of, 102–103
Hallie, Philip, 256
halo images, 52–53
*Hamlet* (Shakespeare), 7
hand marks in a cave, *10*
Hanson, Duane, 212, *213*
Harris, Joel Chandler, v
Hartman, Geoffrey, 84
Hegel, G. W. Friedrich, 229
Heine, Heinrich, 256
Hemingway, Ernest, 85
Hera feeding Hercules, silver (anon.), *47*
Heraclitus, 8
Hernández, Miguel, 31
Hickson, Richard Skerret, *203*
Hindenberg (dirigible), 72
*History of Monsters* (Aldrovandi), *137*
Hoefnagel, Joris, 94, *95*, 108
Holy Trinity, 52–57, 146
Honnecourt, Villard de, *229*
Hoogstraten, Samuel van, 174
*The Horse's Mouth* (Cary), 80
Hughes, Robert, 255
Hugo, Victor, 234
*hypertrichosis universalis congenita*, 93

*Ideal City* (da Laurana), *230–31*
illustrations, arguments against, 6, 27
images, 6. *See also* chance; dogs;
    illustrations; meaning; mirrors; monu-
    ments; nursing mothers; storytelling
  advertising and, 121–22
  biblical warnings proscribing, 124–25
  blind reading of, 149
  critical commentary on, 14–17
  electronic media and, 121–22
  illusions and, 291–92
  immediacy of, 12
  meaning-free, 27
  mirrored, 159–73
  narrative and, 13
  personal experience and, 12–18
  as reminders, 249, 256–57
  requirements of, 260–61
  riddle-like nature of, 44, 63–64
  sources and meanings of, 201
  stories and, 10
  as theatres, 267, *269*
*The Incommensurable Buddha of the Forty-Eight*
  *Wishes* (anon.), *52*
Ingeborg Psalter, illumination, 79
Initiation fresco (anon. Pompeii artist), *161*
Innocent XII (Pope), 276
Ionesco, Eugène, 27
Isidore, Saint, 109
Isis breast-feeding Horus, bronze (anon.),
  *45*

Jacques, Saint, 280
James, Henry, 2
James, William, 32
Jarry, Alfred, 134
Jerome, Saint, 102
João V (king of Portugal), 201, 212
John, Saint, 215
John VII, mosaic (anon.), *53*
Johnson, Samuel, 114
Jouffroy, Théodore, 198
Julius II (Pope), 110
Juvenal, 102

Kahlo, Frida, 76, *83*
Kamala, Kisimi, 9

Keats, John, 264
Keyser, Thomas de, 145, *145*
Kipling, Rudyard, 15, 252
Kline, Franz, 29–30
Kohl, Helmut, 256
Koklova, Olga, 184
Kollwitz, Käthe, 257, *257*
Koopmans, Jelle, 273
Kwele mask (anon.), 126

La Fontaine, Jean de, 15
Labé, Louise, 106
Lacan, Jacques, 162, 193
Lacerda, João Batista, 206
Lady World (sculpture at Worms cathedral),
  *106*
Laertius, Diogenes, 159
Langdon, Helen, 280
Lange, Dorothy, *72*
Laocöon (of Troy), 190
*The Last Supper*, sculpture (Aleijadinho),
  211
Latimer, Hugh, 125
Laurana, Luciano da, *230–31*, 231
Le Brun, Charles, 99, *100*
Le Corbusier, 224, 230
Le Gros, Thomas, 255
Ledoux, Claude-Nicolas, 233–43
  portrait (Gérard), *232*
legend of Conrad le Salique, *11*
Leibovitz, Annie, 137
Leiris, Michel, 186
Leo III (emperor of Byzantium), 27
*Leopard Family* (Gartner), *138*
Leprince de Beaumont, Mme, 104
Lequeu, Jean Jacques, 48, *47*
Levi, Primo, 84
libraries, as monuments, 259
*The Lictors Bringing to Brutus the Bodies of His*
  *Sons* (David), *190*
Liebfraumilch, 49
Lisboa, Antônio Francisco. *See*
  Aleijadinho
Lisboa, Manoel Francisco (Aleijadinho's
  father), 205
Longhi, Barbara, 113
Lorris, Guillaume de, 171

Louis XV, 233
Louis XVI, 233
Luke, Saint (the Apostle), 213

Maar, Dora, 183, 192–93
    portrait (André), *194*
Macrobius, 56
*Madonna di Loreto* (Caravaggio), 80, *81*,
    283
Magdalen, Mary, 80, 82, 102, 168
    woodcut (anon.), *102*
*Magdalena Ventura, Portrait of* (de Ribera),
    *108*
Magritte, René, 122, *122*, 132, 148
Mahler, Gustav, 15
Maimonides, 62
Mallarmé, Stéphane, 27
Malraux, André, 13, 85
Mamoulian, Rouben, 108
Manet, Édouard, 132–134, *134*
Mann, Thomas, 15
Manrique, Jorge, 15
Martha (hostess to Jesus), 168
Martin, Saint, 280
*Martín Fierro*, 250
Martini, Simone, 214
Marx, Karl, 139
Mary (mother of Jesus). *See* Virgin Mary;
    *Merciful Mother Mary*
*Mary and Jesus before the Lord* (Zurich "Mas-
    ter"), *51*
Masaccio, *56*, 190, *191*, 214
masks, 126–27, 148, 162–63. *See also*
    faces
Matta, Roberto, 26
Maurício (Aleijadinho's slave assistant),
    207–8, 214
Maximus, Valerius, 49
Mazzoni, Guido, 214, *215*
meaning, 29. *See also* images, meaning-free
    the urge to impose, 28–29, 32, 37
Mehmet the Conqueror, 80
Memling, Hans, *166*
Menander, 160
    marble relief (anon.), *160*
Mendes, Feliciano, 204–5
*Las Meninas* (Velázquez), 128–29, *129*

Merciful Mother Mary, painting
    (Amatrice), *50*
mercy, 276–82
Merisi, Michelangelo. *See* Caravaggio
Meun, Jean de, 171
*Mexican Peasants Reading* El Machete (Mod-
    otti), *83*
Michaud, Yves, 31
Michelangelo, 110, 214, 220, 228
*Migrant Mother* (Lange), *72*
miracle of Saints Cosmas and Damian,
    woodcarving (anon.), *141*
mirror (T'ang Period), *164*
mirrors, 167–75. *See also* images, mirrored
Misericordia, Pio Monte della, 267, 278,
    284
Mitchell, Herbert, 29
Mitchell, Joan, *21*, 23, 29–31, *30*, 34–35,
    38, 63–64
*Modesty and Death* (Straet), *168*
Modotti, Tina, 67, *74*, 75–79, *77*, *83*, 137,
    181, 192. *See also The Tiger's Coat*
    portrait (Weston), *75*
Montesquieu, 205
Monument of the Deportation (Paris), 252
monuments, 249–61
Moore, Demi, 137
Moore, Marianne, 15
Moryson, Fynes, 269
Munsell, Albert, 34
Mussorgsky, Modest P., 15
myth of racial whitening, 206. *See also bran-
    queamento*
Narcissus, 163, 171–72
*Narcissus* (Enckell), *163*
naturalistic depiction, debate over, 125–27
Nebuchadnezzar, 103
Neruda, Pablo, 8, 84
Nerval, Gérard de, 134
New Society, idea of, 237
Nichomachus, 156
Niepce, Claude, 70
Niepce, Joseph Nicéphore, 70
Nietzsche, Friedrich Wilhelm, 258
Nike (Co.), *8*
Niobe, 189
    statue (anon.), *189*

Noronha, José Coelho, 207
Nuremberg Stadium model (Speer), *260–61*
nursing mothers, images of, 45–51

Oedipus, 80
*Old Man Weeping* (van Gogh), *192*
*The Origin of the World* (Courbet), *105*
*The Origins of Painting* (Allan), *69*
Ortega y Gasset, José, 131–32
Ortino, Giulio Rosco (title-page design), *278*
Orwell, George, 235
Oshaia the Elder, Rabbi, 62
Ostwald, Friedrich Wilhelm, 34
Ovid, 118, 250
Ozick, Cynthia, 257

Pacheco, Francisco, 60
painting, 26
Palladio, Andrea, 229, 234
Parrhasius, 69
parrots, 132–36
Pascal, Blaise, 243
Pater, Walter, 70
Paul V (Pope), 279
Pausanias, 159, 163
Penfield, Wilder G., 188
Penrose, Ronald, 182
Peter, Saint, 49
    sculpture (Aleijadinho), *199*
Philoxenus of Eretria, 156, 174
photograph of peasant's feet (Modotti), *67*
photography, 130, 192–93
    early history of, 70–72
    evils of (cartoon), *71*
    manipulations with, 72
Piazza, Carlo Bartolomeo, 272
Picasso, Pablo, *179*, 181–89, *184–85*, *187*, *188*, 192, 291
*The Picture of Dorian Gray* (Wilde), 132
*Pietà* (Mazzoni), *215*
Pilate, Pontius, 165
Piles, Roger de, viii
Pindar, 155
Piranesi, Giambattista, 231
Pius IV (Pope), 111

Plater, Felix, 97
Plato, 6–7
Pliny the Elder, 69, 72, 94, 102
Plutarch, 70
Poe, Edgar Allan, 70
    daguerreotype of, *70*
Pollock, Jackson, 24–31, *25*, 38, 175–76, 251
Pompadour, Madame de, 233
Pope, Alexander, 102
Popilius, Gaius, 156
*Portrait of the Gozzadini Family* (Fontana), *116*
portrait of Marcia (anon.), *172*
*Portrait of Siriaco* (Da Rocha), *140*
portraiture, special nature of, 124, 126–29
Pound, Ezra, 29
poverty
    in early Naples, 272–76
    historical interpretations of, 269–72
Prieras, Silvester, 283
Pythagorean harmony, 229

*Quai aux Fleurs* (Atget), *7*
*Queen Christina* (film), *108*
Quevedo, Francisco de, 251

racial whitening. *See* myth of racial whitening
*Rape* (Picasso), *188*
Ravestyn, Dirk de Quade van, 95–96, *96*, 109
Ray, Man, 73, 192
realism. *See* naturalistic depiction
Rembrandt. *See* Ryn, Rembrandt van
Renoir, Auguste, 14
"reserve"
    defined, 28
    use of, 28–29
Rexroth, Kenneth, 76
Ribera, Jusepe de, 107, *108*
Richey, Roubaix de l'Abrie, 76
Rilke, Rainer Maria, 28
Riopelle, Jean-Paul, 30–31, 34
Rivera, Diego, 76, 78, *83*
Robespierre, 234
Robinson Crusoe and his parrot (magic-lantern slide), *136*

Rocha, Manoel Ribeiro, 205
Rockwell, Norman, 25
Romero, Silvio, 206
Rosset, Barney, 30–31
Rousseau, Jean-Jacques, 190, 205, 237
Rubens, Peter Paul, 283
Rufus, Quintius Curtius, 156
Rufus of Ephesus, 105
Ruskin, John, 17, 211–212
Ryn, Rembrandt van, *173*

sailor, Chinese drawing of, *105*
*Sailor Boys* (Gartner), 132, *133*
*Saint Veronica* (Hans Memling), *166*
Salas-Nicanor, Leopoldo, viii
Saltworks of Arc-et-Senans, 232, *232*,
    234–40, 243
    aerial view of, *225*
    Director's House at, *235*
    urn decoration at, *236*
Samkhya, philosophy of, 291
San Pedro, Diego de, 104
Santafede, Fabrizio, 280
Sarduy, Severo, 24
Scarry, Elaine, 9, 124, 138
*Scene at the Washing House of Gongo Soco Gold
    Mine* (Hickson), *203*
Schiele, Egon, 130
*Seated Girl with Butterfly* (Watteau), *144*
self-portraits, 173–74
Serapis and his beast (Catari), *57*
Serra, Richard, 257
Seurat, Georges, 15, 134, *134*
*The Seven Acts of Mercy*
    (Caravaggio), 49, *265*, *281*
    (anon.), *278*
Shakespeare, William, 7, 15
Shere, Sam, 72
Sherman, Cindy, 73
*Shipping Boats on the Beach* (van Gogh), *3*
silence, 27
Siqueiros, David, 76
Sixtus V (Pope), 272
Skira (Co.), 5
Škvorecký, Josef, 128
Socrates, 159
Solomon (King), 6

Sondheim, Stephen, 15
Sontag, Susan, 79
Sophists, 159
Sorel, Agnès, 47
Sotelo, José Calvo, 185
soul, seat of the, 158
Southey, Robert, 202
Speer, Albert, 259, *260–61*
Spenser, Edmund, 104
Sponde, Jean de, 99
*St. John Chrysostom as Wild Man* (anon.), *103*
*St. Matthew and the Angel* (Caravaggio), *271*
St. Paul's Cathedral, engraving (Gribelin),
    253
St. Victor, Hugh de, 32
Stalin, Josef, 72
Starobinski, Jean, 242
Stendhal, 14
Stern, Daniel N., 163
Sterne, Laurence, xi
Stevenson, Robert Louis, viii
storytelling, images and, 10
Straet, Jan van der, *168*
Strato, 102
Strobel, Marion, 29
*A Sunday on La Grande Jatte*, 134, *134*
*Supper at Emmaus* (Caravaggio), 143, *144*
*The Surrender of Breda* (Velázquez), 157, *157*
Swedenborg, Emanuel, 237
Swift, Henry, 74
Swift, Jonathan, 237
Synod of Elvira, 27

Tabucchi, Antonio, 73
Tanguy, Yves, 26
Tàpies, Antoni, 8
Tasso, Torquato, 112
Tennyson, Alfred Lord, 8, 170
Teresa, Saint, 36, 213
thanksgiving, seeing and, 38
Theophilus of Antioch, 54
Theseus, 186
Thomas Aquinas, Saint, 100–101, 276, 282
Tierra del Fuego, Native man from (anon.
    photo), *175*
*The Tiger's Coat* (film), *75*
*Tightrope Clara* (Gartner), 142, *142–43*

Titian, 12, 57, *58*, 131

Tognina, 104, 107–10, 137, 139
  *Portrait of* (anon.), *92, 98*
  *Portrait of* (Fontana), *89*

Tognina's mother, portrait (anon.), *94*

Tognina's younger brother (anon.), *94*

Toledo, Don Pedro de, 269

Toronto the Ungainly (anon. photo), *230*

*Tourists* (Hanson), *213*

transience as a monument, 252

Trinity. *See* Holy Trinity

Trocmé, Magda, 256

Tullius, Servius, 158

Twelve Prophets of Congonhas
  (Aleijadinho), *218–19*

*Two Pianos* (Mitchell), *21,* 23, 31, *34–35,*
  *37–38*

Uccello, Paolo, 157, *157*

Unamuno, Miguel de, 148

Uncumber. *See* Wilgefortis, Saint

Valentin and Orson, *103*

Valéry, Paul, 70, 88

van Gogh, Vincent, *3,* 5–6, 12, 35, *36–37,*
  192, *192*

*Vanitas*, woodcut (Dürer), *168*

Vanni, Francesco Eugenio, 63

Vasari, Giorgio, 113, 220

Velázquez, Diego, 128–29, 136, 157, *157*

Ventura, Magdalena, 107. *See also*
  *Magdalena Ventura*

Venus at her toilette, mosaic (anon.), *167*

Vico, Marquis of, 279

Virgil, 257

*The Virgin, Anne and Child* (Masaccio), *56*

Virgin and Child, early images of, 44–45

*Virgin and Child before a Firescreen* (attributed
  to Campin), *41,* 43–44, *43–44,* 52, 54,
  57–64, 136, 148

Virgin Mary, 43–44, 49–53, 57–60, 80,
  146

Voltaire, 237

Walser, Martin, 255

Walter, Marie-Thérèse, 184, 193

Warner, Marina, 49

Watteau, Antoine, 144, *144*

Weeping figures, tomb painting (anon.),
  *189*

*Weeping Woman* (Picasso), *179,* 182

werewolf, 109

*Werewolf Attacking a Man* (anon.), *101*

Weston, Edward, 73, 76, 84, 181
  portrait (Modotti), *74*

Wetering, Ernst van de, 173

Weyden, Roger van der, 43

*Wheat Fields with Crows* (van Gogh), 35,
  *36–37*

Whistler, James McNeill, 18

White, David Gordon, 109–110

Wiertz, Anton, 145, *145*

Wilbur, Richard, 260

the wild man, 103–4

Wilde, Oscar, 78, 132, 163

Wilgefortis, Saint, 107
  engraving (anon.), *108*

Wolf Man's dream, drawing (Freud's
  patient), *101*

*Wolfdietrich,* 104

*Wolf-Man* (Le Brun), *100*

wolf-men, 101

wolves, 101, 109

*Woman with a Parrot* (Manet), *134*

woman's portrait from Egypt (anon.), 127

*The World* (Espingues), *289*

Wren, Sir Christopher, 252

Yeats, William Butler, 9, 152

Yorio, Orlando Virgilio, 276

Zappi, Giovan Paolo, 91

Zeuxis, 69